006.6

Photoshop Elements® drop dead fantasy techniques

DEREK LEA

ILEX

Photoshop Elements Drop Dead Fantasy Techniques
Copyright © 2006 The Ilex Press Limited

First published in the United Kingdom in 2006 by:
I L E X
The Old Candlemakers,
West Street, Lewes,
East Sussex, BN7 2NZ

Publisher: *Alastair Campbell*
Managing Director: *Stephen Paul*
Creative Director: *Peter Bridgewater*
Managing Editor: *Tom Mugridge*
Editor: *Ben Renow-Clarke*
Art Director: *Julie Weir*
Designer: *Lanaways*
Junior Designer: *Kate Haynes*

I L E X is an imprint of the Ilex Press Ltd
Visit us on the Web at:
www.ilex-press.com

This book was conceived by:
I L E X , Cambridge, England

British Library Cataloguing-in-publication data.
A catalogue record for this book is available from
the British Library.

ISBN 10 – 1-904705-81-2
ISBN 13 – 978-1-904705-81-9

Printed and bound in China

For more information on this title please visit:
www.web-linked.com/rwofuk

CONTENTS

CREATING FANTASTIC IMAGES

Welcome to Photoshop Elements Drop Dead Fantasy Techniques. Throughout this book, you'll find a series of projects that we'll walk you through step by step, creating incredible finished works of digital photographic art. There are a variety of themes and subjects to the compositions, but there are some things that each of the finished images has in common. Each one is fantastic, surreal, and loads of fun.

Every scene in this book is a composition of sorts, and every composition is unique. In each case, a variety of photographic elements are put together to create a stunning final result. The exact method by which they are combined, which elements are used, and which tools are employed, all come together in the final result. Don't worry, though, as we'll explain all of the tools and techniques used as we come across them.

You'll learn how to create a variety of different images, some very simple, and some very complex. So whether you're after something quick and fun, or you're ready to create something impressively complicated, we've got an abundance of expert tips and tricks for you. Not only will you walk away with the skills needed to create all of the fantastic images in this book, you'll also learn methods that will come in handy when you want to create your own compositions.

Left Driving Your Spaceship, page 208.

Below The Two-Handed Butterfly, page 28.

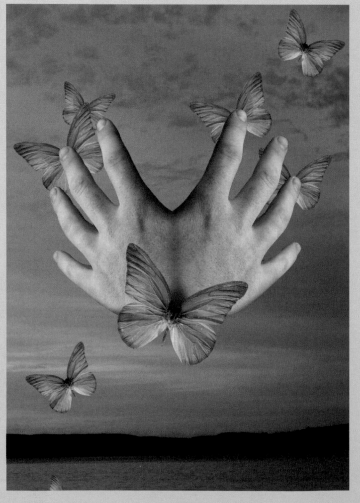

Above The Undead, page 82.

Top right The Pixelated Man, page 66.

Right A City in the Clouds, page 146.

Composition techniques

CREATING COMPOSITIONS

When people first begin to experiment with image compositions in an application like Photoshop Elements, more often than not the temptation is to go completely overboard. This excess can come in many forms, either as too many individual elements within the composition or an unwieldy mix of different colors. Adhering to the most basic rules of color and composition is what will make your finished compositions appear slick and professional. It is important to remember that although you are working digitally, you are still creating a piece of art, and a little bit of forethought is an essential step in creating a stunning composition.

It is helpful when planning your composite images to think of color and composition as the two primary building blocks. These two aspects can work together perfectly to create a wonderful image, or, if you aren't careful, compete against each other and turn your compositions into chaos. One important rule to remember is that there must be a balance when it comes to combining elements and color to create a composition. More specifically, if one is complicated, then the other must be simple. For instance, if you have created a scene with a high number of added elements, then choose a simple color scheme, keeping many of the elements within the same ranges of color. That way, your complicated composition is balanced with a simple use of color. On the other hand, if you are creating a simple composition using few visual elements, you can afford to incorporate a larger number of colors into the image, without the result appearing too busy or overly chaotic.

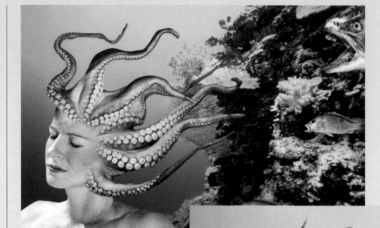

Left As you can see in this image, by the time we put it all together, it looked a little busy. It isn't too bad because there aren't too many different elements, but they do compete against each other. The woman is a different color from the background, the tentacles are a different color from her skin, and the fish add yet another color variant.

Right Adjusting the color of the various elements brings it all together. The entire scene is easier on the eye and looks intentional instead of simply pasted together. The tentacles look attached to her head, and altering the fish to the same color as the octopus woman gives the feeling that all of this is actually occurring in the same space.

Left Alternatively, because this scene is so simple and has very few visual elements, we were able to use a background that contains a variety of colors without upsetting the balance of the composition.

Proper prior planning

Planning is an essential step in creating a stunning composition. There is no better way to make elements look as if they belong together than actually starting off with images that will work well with each other. If you are photographing images on your own, envisage the end result and ensure that there is consistency to the lighting. If you are using stock images or images from a variety of sources, try to find images in which the lighting is consistent.

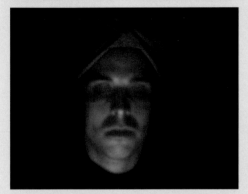

Above These three images, which were photographed separately, used consistent lighting for each shot. Because we had visualized the end result before we started shooting, we knew that we could save time and effort by photographing them this way.

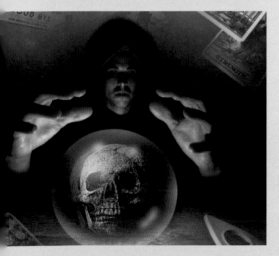

Above The separate images were added to the composition with a minimum of fuss. The result is also much better than it would have been if the light had not been coming from below in each case.

Compensating for inconsistencies

Because we live in a cruel world, there will always be instances where images with consistent lighting simply aren't available, or the contrast and exposure of your photographic elements are far from the same. As you work your way through the projects in this book you'll notice that there is always a way to simulate light and shadow, alter contrast, and darken or lighten various elements so that they look as if they were designed to be together.

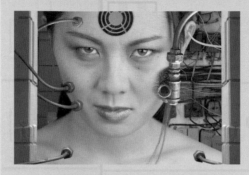

Above Here is an example where realistic lighting isn't really an issue, but the finished composition lacks depth due to the lack of shadows.

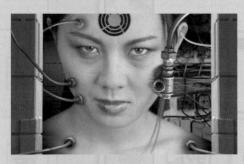

Above Doing something as simple as adding a series of gradients between elements on various layers can add the necessary depth and shading required. This will make the elements within the composition look as if they belong together in the finished scene.

TIP

Using selections

Each fantastic scene in this book is the result of a layered file. Every layered file is comprised of a number of images, or sections of images. In order to bring these image components into our working files, they first need to be selected. Photoshop Elements offers up a number of selection tools ranging from basic Rectangular and Elliptical Marquees through to tools like the Magic Wand that automatically generate selections based upon ranges of color.

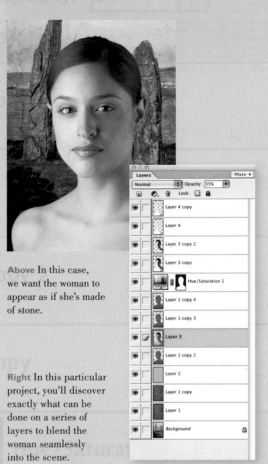

Above In this case, we want the woman to appear as if she's made of stone.

Right In this particular project, you'll discover exactly what can be done on a series of layers to blend the woman seamlessly into the scene.

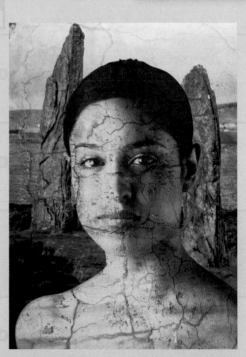

Above The results are astounding, and as you'll find when you make your way through the projects in this book, the only thing limiting you is your imagination.

SELECTION TOOLS AND TECHNIQUES

They key to effectively creating selections is to recognize which tool is appropriate for which selection problem. For instance, if you need to select something round, you can use the Elliptical Marquee tool. If you want to isolate a complicated shape from a background, you need to try something a little more advanced, like the Magic Wand or the Magnetic Lasso. Each tool has a range of options that make it more suitable for different situations. However, once you've created an initial selection, you don't need to stop there. As we will discover, there are a vast number of options for editing and fine-tuning your selections.

Below Clicking on the Add to selection button in the Options Bar (or holding down the Shift key) changes the behavior of the Magic Wand tool. With this feature enabled, we clicked on another range of color on the octopus to add it to the existing selection. Alternatively, you could perform a variety of selection tasks with this tool by choosing another button like subtract or intersect, should you wish to perform different operations.

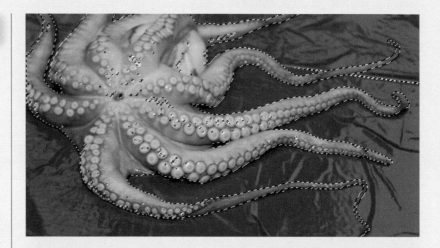

Above The Elliptical Marquee tool options displayed here are typical of most selection tools. In addition to creating a new selection, the first set of buttons allows you to add to, subtract from, and intersect existing selections. The second set of options allows you to automatically feather the edges of a selection. This creates a gradual blend at the edges of your selection. The Anti-aliased feature allows you to soften edges and avoid jagged borders when you create selections.

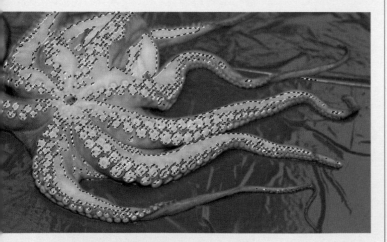

Above Another thing you'll notice as you work your way through the projects in this book is that often the best way to select an area is to quickly generate an automatic selection and then refine it. Here we've clicked on a pink area of the octopus with the Magic Wand tool, generating a selection around that particular range of color.

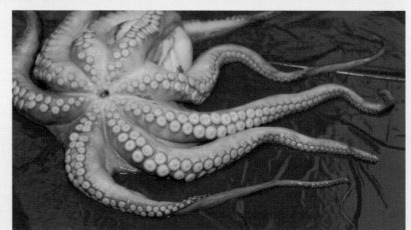

Above In order to achieve precise selections around complicated shapes and ranges of color, you'll need to refine your selections. The Selection Brush tool is ideally suited to tasks like this. When you choose this tool and select the mask mode, the selection border is temporarily converted to a mask. You can refine the selection by painting the mask. This is probably the most flexible and accurate method for refining selections and as a result, you'll see it appear again and again throughout this book. Practise this method and you will be able to accurately select anything under the sun.

Storing selections

When you have a selection active, especially one that you've spent a lot of time creating and refining, you can save it for later use. The Select menu offers a set of features that allow you to save existing selections, reload them, or delete saved selections. Although this is an excellent feature, few people think to look around within their files for selections that are already stored.

Selections from layers

The Layers palette is a less-than-obvious selection storage area, but it is a useful place to generate selections from layer content. Simply Ctrl+click (Cmd+click on a Mac) on any layer thumbnail and you can generate a selection from the content of that layer. Alternatively, you can perform the same task by Right-clicking (Ctrl+clicking on a Mac) on a layer thumbnail in the Layers palette. Choosing Select Layer Transparency from the pop-up menu will generate a selection based on the layer content.

Multiple ways to perform similar tasks

There are a variety of different ways to generate selections and work with them in Photoshop Elements. For instance, if you wish to subtract an area from an existing selection, use one of the selection tools, with the Subtract from selection button enabled to remove a portion of the active selection. Alternatively, you can subtract an area defined by the content of a layer by clicking on the layer thumbnail while holding down the Ctrl and Alt keys (Cmd and Opt on a Mac). Yet another way to subtract an area from a selection is to load a saved selection from the Select menu and then choose the Subtract from Selection operation.

You'll begin to notice common things like Add, Subtract, and Intersect options appearing in a number of different areas. When you're using a selection tool, these options appear in the Options Bar. When you load a selection in the Select dialog menu, it appears in the Operation section of the dialog box. Perhaps the most nebulous appearance of these functions is when you're generating selections from layer content. With no menu as a guide, you simply need to be familiar with the keyboard commands. Ctrl+Shift+click (Cmd+Shift+click on a Mac) on a layer thumbnail to add an area based upon the content of the layer to the currently active selection; Ctrl+Alt+click (Cmd+Opt+click on a Mac) to subtract it; and Ctrl+Alt+Shift+click (Cmd+Opt+Shift+click on a Mac) to perform an intersection.

As you work your way through the projects in this book, you'll notice that we've made an effort to use different methods for performing similar tasks. The more time you spend within Elements, the more methods you'll experiment with and you'll learn which methods you prefer. The way you work is a subjective thing that is molded through your own experiences. Although we'll showcase a variety of ways to do something, you will eventually end up working the way that suits you best.

USING LAYERS

Arguably the most important tool in any Photoshop Elements composition is layers. Layers allow us to separate all of the elements within our scene, adding a non-linear flexibility to our compositions. We can stack our composition elements in a pile and choose to move things up or down within the stack at any point. Another advantage of keeping things separate is that you can alter individual portions of your composition without affecting the rest of the scene.

When you paste an image or a portion of an image into another file, it is automatically added to the file as a new layer. Working through the projects in this book, you'll see that we've taken the hint that Elements is giving us here and adopted it as our method of working. You'll notice that if we're going to add a color gradient to the scene, we'll first create a new layer and then add the gradient, rather than adding the gradient over the content of an existing layer. The advantage of this is that we can always switch the layer off further on in the compositing process if we decide it was a mistake, or alter the tone, color, or actual pixel content of the layer without affecting the rest of the image.

Blending modes and opacity

Each layer has its own blending mode and opacity setting. The blending mode controls how the layer blends with the color of the visible underlying layers and the opacity controls how transparent or opaque the layer is, determining to what degree the underlying imagery remains visible. Again, these individual layer functions just emphasise the need to keep files separated into individual layers. You can always go back and increase or reduce the opacity of an individual layer within your composition without affecting the rest of the image, and the same goes for the blending mode.

Layer blending modes and opacity lend themselves to an innovative composition technique we use throughout this book that involves duplicate layers, varying opacity settings, and altering blending modes.

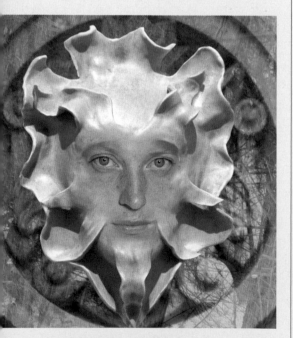

Above Here you can see that we've added a portion of the woman's face to the scene. The problem here is that she lacks contrast when compared to the rest of the image.

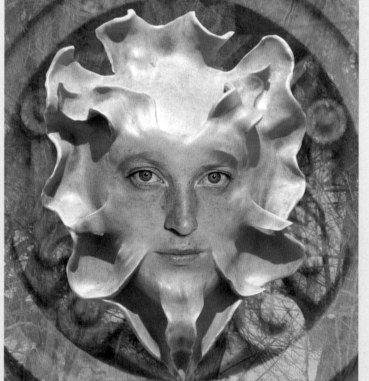

Above Perhaps a less than obvious way of altering the color and contrast of the layer is to duplicate it and then change the blending mode of the duplicate layer to soft light.

Left When the duplicate layer blends with the underlying layer, the adjustment is exactly what we need. More importantly, if it was a little too strong, we could always reduce the opacity of the layer, altering the intensity of the effect.

Using Adjustment layers

Adjustment layers allow you to perform tonal and color adjustments, add solid color gradients or patterns, and create effects on layers within your files. While there are the obvious benefits of using adjustment layers instead of performing adjustments directly to your existing imagery (like the ability to change things later on and keep your adjustments separate like your image layers), there are a number of other useful features and options offered by adjustment layers that makes them ideally flexible.

For example, you can double-click an adjustment layer's thumbnail at any point to alter the adjustment you've applied. There is no limit to how many times you can perform an alteration and because the adjustment is not applied directly to the underlying pixels, there is no image deterioration. Adjustment layers can be changed, meaning that if you create a Levels adjustment layer and then decide you'd rather have a Hue/Saturation adjustment layer, all you need to do is target the desired adjustment layer in the Layers palette and change the content via the layer menu.

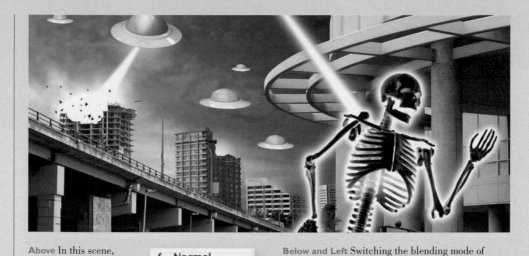

Above In this scene, we've got a Hue/Saturation adjustment layer altering the sky in the background.

Below and Left Switching the blending mode of the layer to color burn completely changes the way the Hue/Saturation adjustment is applied to the underlying pixels, creating an entirely different feeling within the scene.

Adjustment layers, like other layers, allow you to alter individual layer blending modes and opacity settings. Again, the advantages are obvious, but really think about what this implies. This combination of adjustment and layer functions creates a multipurpose tool that allows you to do things within your images that you simply wouldn't be able to achieve by directly adjusting the pixel content

Not only can you affect underlying imagery by using an adjustment layer, but you can also change the way that a particular adjustment is blended into the color of the underlying layers by altering the blending mode. Experimentation with blending modes and adjustment layers can reveal surprisingly good results that perhaps would never have seemed possible or even occurred to you to try. And remember, you can always increase or decrease adjustment layer opacity to control the intensity of your effect, as well as building up stacks of duplicate adjustment layers with various blending modes, just like you'd do with ordinary layers.

Above and Left Creating a duplicate of the existing Hue/Saturation adjustment layer and then changing the blending mode to screen takes things a step further. You can probably see where we're going with this. Have some fun experimenting with adjustment layers and blending modes. You never know what you might discover.

LEVELS ADJUSTMENT LAYERS

Whenever you create an adjustment layer, it automatically has a mask linked to it. You can use any of the Elements paint tools to edit the mask. Adjustment layer masks only recognize grayscale and you'll notice that when you target a mask in the Layers palette, your foreground and background colors automatically change to black and white. White areas are visible; black areas are completely masked. Grayscale values allow you to create partially visible areas within the mask.

One particularly useful trick to restrict the effects of your mask is to have a selection active when you create an adjustment layer. When you do this, the mask that is attached to the layer will mask the layer according to the selection that was active during its creation.

Right The levels adjustment is completely restricted to the face area. This technique of restricting your adjustment layers is a quick and easy way to achieve flawless effects.

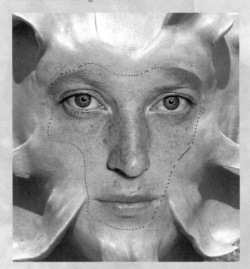

Above Here we generated a selection from the "face" layer's content by Ctrl+clicking (Cmd+clicking on a Mac) on the layer thumbnail in the Layers palette.

Right With the selection active, we created a new Levels adjustment layer. You can see by looking at the mask thumbnail that the adjustment layer is masked according to the selection.

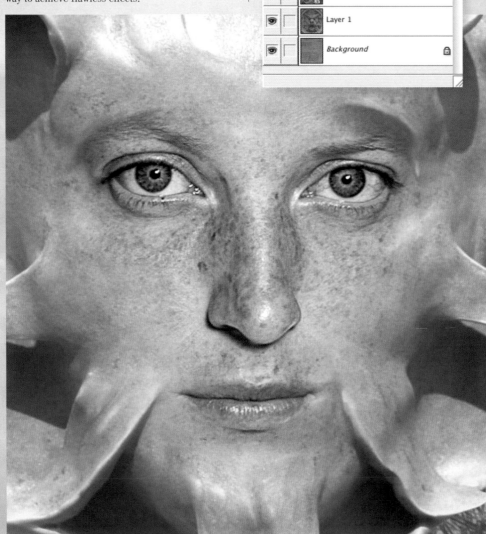

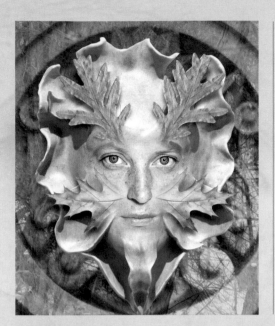

Face in the Trees final image
You can see from the final image what a difference the adjustment layers make. The green tint on the face ties it in with the rest of the picture.

Left By generating a selection of the adjustment layer mask, it's easy to create a new layer that will fit the mask precisely.

Selections from masks

As with layers, you can also make selections from adjustment layer masks by simply Ctrl+clicking (Cmd+clicking on a Mac) on the layer mask thumbnail in the Layers palette. Pure white areas are completely selected, pure black areas are not selected, and grayscale values fall into place in varying degrees of selection.

Using the method above, we clicked on the adjustment layer mask thumbnail in the Layers palette to generate a selection. With the selection active, we created a new layer in the Layers palette and filled the active selection with a green foreground color sampled from the image. The blending mode of the layer was then changed to Color. In a few seconds we were able to alter her face color to match the rest of the scene. Generating a selection from the layer mask made this simple process possible.

Again, these methods of working allow you to go back at any point and alter your compositions, because when you keep your elements separated onto a series of image and adjustment layers, there isn't a point of no return where things are permanently fused together. Well, unless you flatten your image or merge layers together, but we'll explain a few methods for getting around that, too.

Right Once a selection is generated, it's a simple matter to pick a green from the rest of the image and use it to fill the selection.

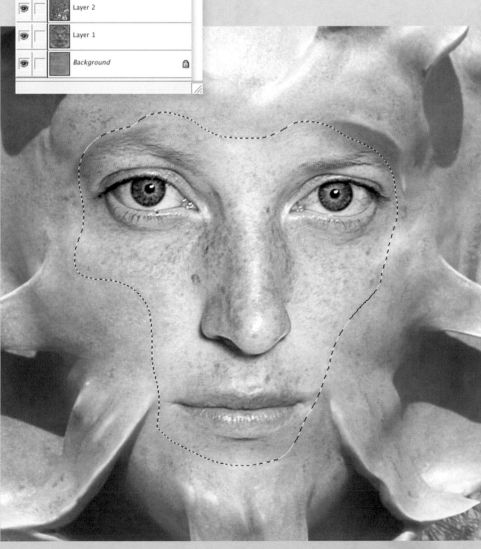

FLATTENING AND MERGING LAYERS

Flattening and merging doesn't have to be as final as it sounds. There are always ways to perform seemingly irreversible tasks and preserve flexibility within your files, if you're resourceful and willing to think outside the box.

Occasionally you'll run into a function or feature that will not operate on a blank layer. When this happens, the easiest course of action is to flatten the image. The only problem is that once you flatten your image, you lose all the flexibility you've gained by creating the composition on multiple layers.

The solution is to simply save a copy of your file under a different name with all of the layers intact. That way, you can flatten the file you're working on and proceed with the desired function, safe in the knowledge that you have a layered backup file should you wish to drastically alter the image later on. Also, because your backup file is exactly the same resolution and dimensions, you can actually drag layers from the original file into the flattened file in perfect position by holding down the Shift key.

To apply the lens flare filter to the multi-layered image below we had to flatten the layers. Because we invested so much time in getting to that point, and because we want the flexibility to change things later on, we chose to save a layered back up file before flattening the working file.

The same sort of logic applies when you're thinking about merging a few layers together. Before you go ahead and link them, why not create a set of duplicate layers, and simply disable the visibility of the duplicates so that they remain invisible. At least you'll still have them if you need them later.

FINISHING TOUCHES

When you've finished creating your massive layered files, there may be some remaining imperfections. Often, as a result of selection methods, the edges of elements in the scene will appear too sharp, resulting in a less-convincing composition. Rather than wading through the various layers and softly erasing or blurring the edges, we have a better solution. At the top of the stack in the Layers palette, create a new layer to use as your finessing layer.

Using the Blur tool, with the Use All Layers option enabled, paint over any hard edges that remain. The advantage to this technique is that you can blend all of the underlying layers together at once and erase any areas that exceed what you wanted to achieve.

The Clone Stamp is another tool that offers a use all layers function. Again, if there are blemishes or unwanted bits remaining when you've finished creating your composition, use the Clone Stamp on this top layer, with the Use All Layers function enabled, to perform any final repairs. Adjustment layers can be used for any last-minute color or tonal corrections.

Deciding when to stop is arguably one of the most difficult things to resolve when you're creating fantastic compositions. We'll teach you hundreds of creative tricks and techniques throughout this book, but restraint is something you'll have to learn on your own. Have a good time and don't forget to save your work!

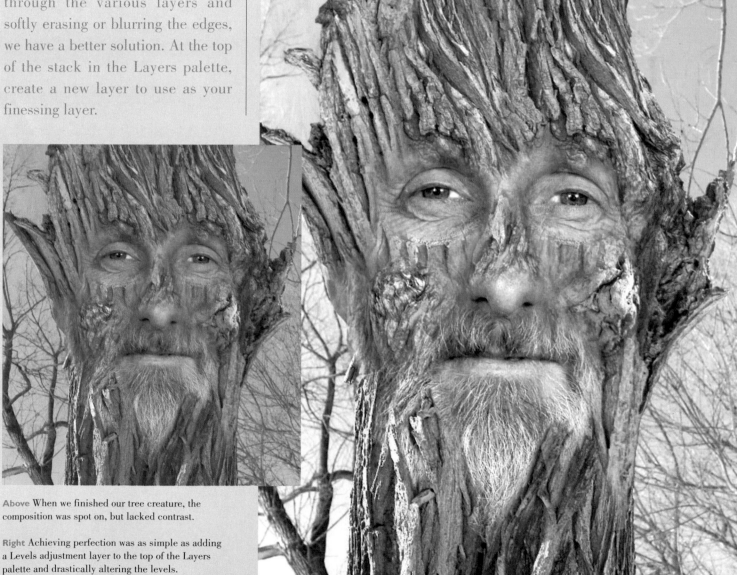

Above When we finished our tree creature, the composition was spot on, but lacked contrast.

Right Achieving perfection was as simple as adding a Levels adjustment layer to the top of the Layers palette and drastically altering the levels.

introductory projects

BOWLER HAT OR APPLE?

Simplicity can be evocative and beautiful. As proven by this surreal image, you don't need to incorporate a lot of photographic elements to create a masterpiece. This surreal scene pays homage to both the paintings of Magritte and progressive rock art of the 1970s, featured on the album covers of bands like Rush and Pink Floyd.

The creation of this image involves the use of selection tools like the Magic Wand, as well as compositing tools like layers and the options offered within the Layers palette. You'll blend your images together on a variety of layers via the Eraser tool and use the Clone Stamp to make the apple shine bright without any annoying hot spots.

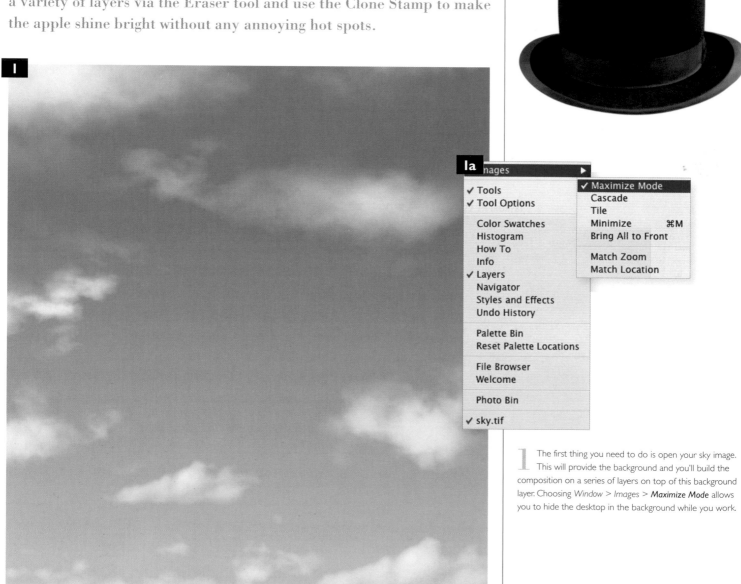

1 The first thing you need to do is open your sky image. This will provide the background and you'll build the composition on a series of layers on top of this background layer. Choosing *Window > Images > Maximize Mode* allows you to hide the desktop in the background while you work.

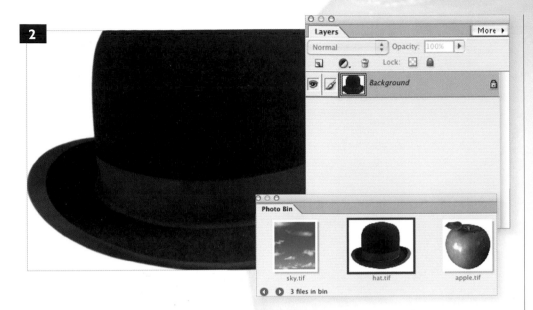

2 Open up the apple and bowler hat images. Choose *View > Photo Bin* from the menu to open the Photo Bin, allowing you immediate access to your open image files. Click on the bowler hat image to bring it to the front. Select the Magic Wand tool.

3 In the Options Bar at the top, make certain that the New selection button is selected and disable the Contiguous option. Set the Tolerance to 32 and click in the white area surrounding the hat to select it.

4 We need to make the selection a little wider to encompass all of the white area as there will be a thin line of light-colored pixels surrounding the hat that aren't included within the selection border. Choose *Select > Modify > Expand* from the menu.

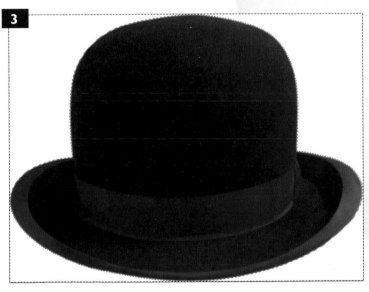

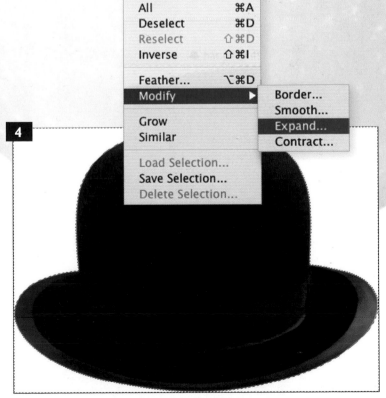

TIP

Managing images

When creating a collage like this you'll have more than one image open at a time. Ideally, you will want to devote the entire screen to your working file and only have others visible as required. The Photo Bin is handy for this and takes up very little space when you collapse the palette by double-clicking its top bar. You can expand it by double clicking the top bar again. If you don't want the Photo Bin consuming valuable real estate you can also access any open image via the Window menu.

BOWLER HAT OR APPLE?

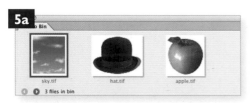

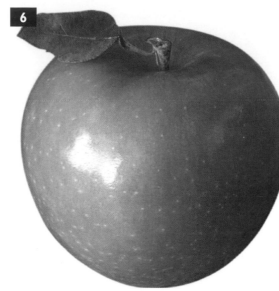

5 Enter a value of five pixels and click OK. Then choose *Select > Inverse* from the menu to invert the selection border so that it surrounds the hat. Choose *Edit > Copy* from the menu to copy the selection and then select the sky image from the Photo Bin. Choose *Edit > Paste* to paste the hat as a new layer.

6 Use the Move tool to position the hat layer so that it appears centered on the canvas area. Now go to the apple image, using either the Window menu or Photo Bin, and reselect the Magic Wand tool. In the Options Bar, enable the Contiguous option.

7 Click on the white area to select it. Expand the selection like you did previously with the bowler hat, then invert the selection in the same way as shown in step 5. Copy the image and then paste it into the working file as a new layer.

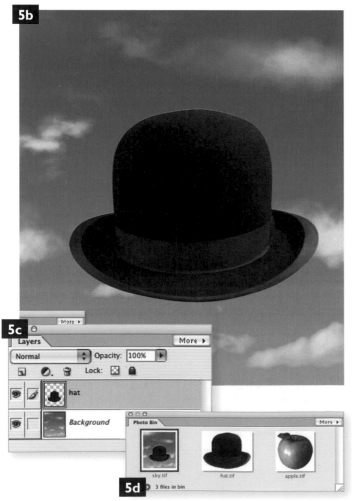

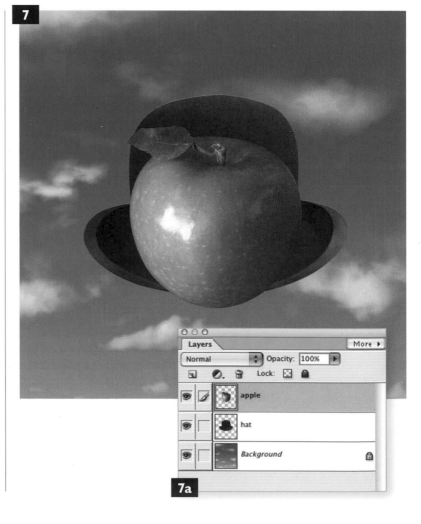

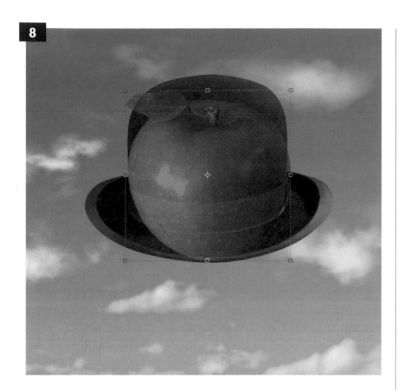

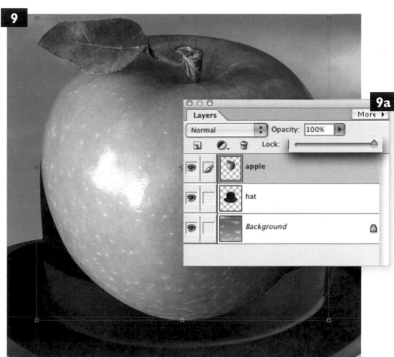

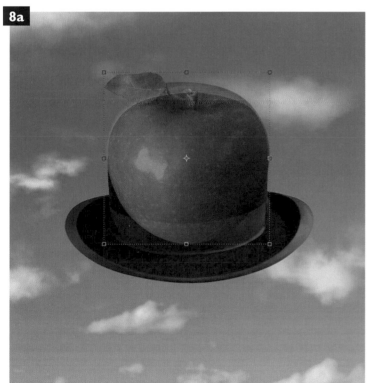

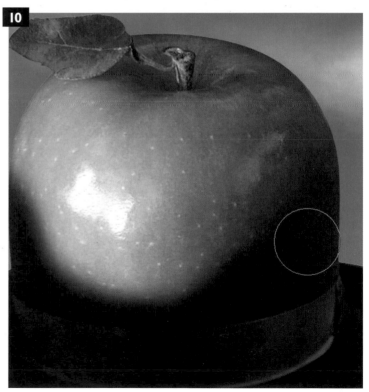

8 Reduce the opacity of the apple layer so that you can see the hat beneath it. Select the Move tool and ensure that the Show Bounding Box option is selected in the Options Bar. Use the Move tool to drag the apple upwards so that the top of the apple is slightly higher than the top of the hat.

9 Zoom in a little closer. Hold down the Shift key and drag one corner inwards, slightly reducing the size of the apple. Do this with another corner and reposition the apple as required. The idea is to edit the size and position of the apple so that it matches up with the contour of the edge of the hat underneath. Return the layer to full opacity.

10 Select the Eraser tool, then choose the soft round, 300 pixel wide brush from the list of brush presets in the Options Bar. Leave the opacity set at 100 and erase just the bottom edge of the apple.

BOWLER HAT OR APPLE?

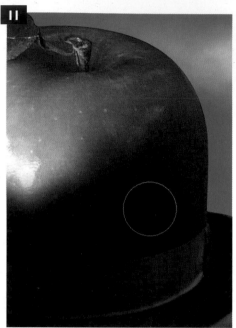

II

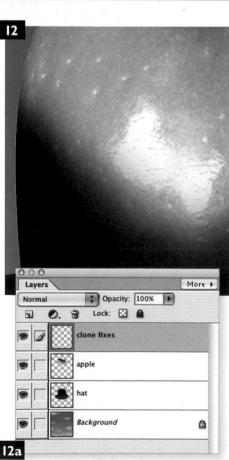

I2

I3

TIP

Contiguous
When you enable the Magic Wand's Contiguous option, it ensures that any selection you create when clicking will only contain adjacent (touching) pixels within the color range. However, when you disable the Contiguous option, any pixels in the image within the color range are included in the selection.

II Reduce the opacity of the Eraser to 25% and gently erase the parts of the apple that are adjacent to the area you just erased. Click and drag with the Eraser tool using short strokes to erase areas of the apple, creating a gentle transition between the layers.

I2 Select the Clone Stamp tool. Choose a soft round brush preset of 100 pixels from the list in the Options Bar. Enable the Use All Layers option. Click the Create a new layer button in the Layers palette. With the new layer selected, zoom in on the apple's overexposed specular highlight.

I3 Hold down the Alt/Opt key and click on an area just outside the highlight to sample it, then click and drag over the highlight to paint over part of it using the point you sampled. Sample another point and use it paint over another part of the highlight. Sampling a variety of points in this way gives a more convincing effect.

I4 Reduce the size and the opacity of the Clone Stamp and continue to sample and paint from a variety of different source points. When you are satisfied, select the clone layer in the Layers palette and then choose *Layer* > **Merge Down** from the menu to merge this and the apple layer beneath it. Finally, use the Eraser with the same large brush and low opacity setting to further blend this layer into the hat.

I4

I2a

Layers palette (clone fixes, apple, hat, Background)

I4a

Layer	Select	Filter	View

New ▶
Duplicate Layer...
Delete Layer

Rename Layer...
Layer Style ▶

New Fill Layer ▶
New Adjustment Layer ▶
Change Layer Content ▶
Layer Content Options...
Type ▶

Simplify Layer

Group Linked ⌘G
Ungroup ⇧⌘G

Arrange ▶

Merge Linked ⌘E
Merge Visible ⇧⌘E
Flatten Image

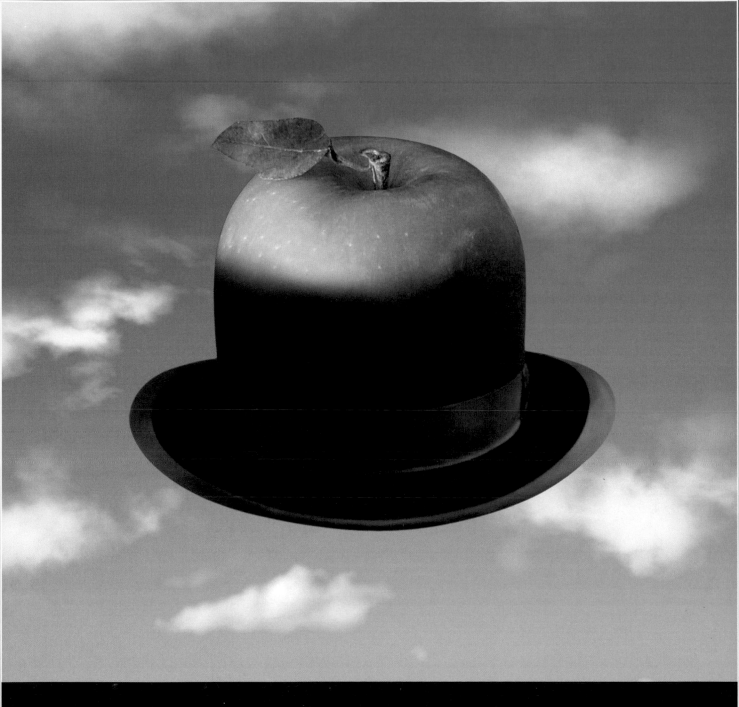

You'll be creating surreal and beautiful scenes like this one in no time.
A handful of basic selection tools as well as features available within the Layers
palette provide everything you need to become a digital surrealist. Also, a couple
of simple clone and erase techniques will enable you to simply touch up
any imperfections in your own photos.

THE TWO-HANDED BUTTERFLY

Take a look at this dream-inspired image and let your mind wander. What sort of vision is this? Is it real or is it a hallucination? Regardless of its meaning, there are some clever Photoshop Elements tricks and techniques responsible for what you see before you.

In this second project we'll revisit some fundamental selection and composition techniques used in the previous project, as well as introduce some new tools like the selection brush, layer blending modes, free-transform options, and adjustment layers.

Understanding how to use these functions and tools will help you not only reproduce the two-handed butterfly image you see before you, but also in creating different compositions from your own digital photographs. The techniques we reveal over the next few pages are essential to compositing and you'll see them appearing over and over in various combinations, and alongside countless new techniques, throughout the following pages.

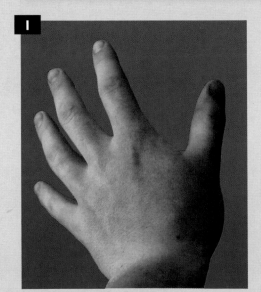

1 The first thing you'll need to do is to open up an image of a hand. Select the Magic Wand tool and set the Tolerance to 10 in the Options Bar. Disable the Contiguous option and click on the background to generate a selection around the range of color.

2 Hold down the Shift key and click on any background areas that are not included in the selection to add them to the selection. Do the same thing again until all of the background is selected. Choose *Select > Modify > **Expand*** from the menu. Enter a value of 5 and click OK.

3 Choose *Select > **Inverse*** from the menu to select the hand instead of the background. Choose *Edit > **Copy*** from the menu to copy the hand. Close the file and open an alternate background image. Choose *Edit > **Paste*** from the menu to paste the hand into this background as a new layer.

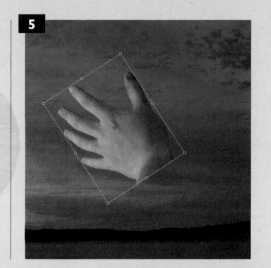

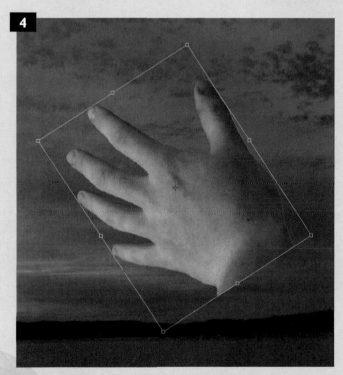

4 Select the Move tool, and ensure the Show Bounding Box option is enabled. Move the mouse pointer to just outside the box and it will change to indicate rotation. Click and drag to rotate the hand to the left.

5 Hold down Shift and drag a corner point inward to reduce the size of the hand. Click inside the box and drag it a little to the left, then select the Eraser tool. Choose a hard round brush from the preset picker and increase the size considerably.

6 Use the Eraser tool to erase the thumb and some of the lower wrist portion of the hand. Duplicate the layer by dragging it onto the Create a new layer button in the Layers palette. Choose *Image > Rotate > Flip Layer Horizontal* from the menu.

THE TWO-HANDED BUTTERFLY

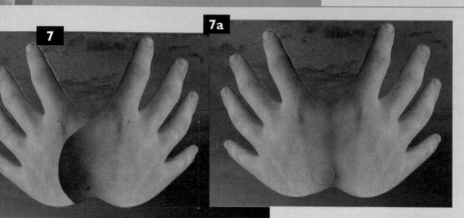

7 **7a**

8

8a
Solid Color...
Gradient...
Pattern...

Levels...
Brightness/Contrast...

Hue/Saturation...
Gradient Map...
Photo Filter...

Invert
Threshold...
Posterize...

9

✓ Place in Palette Bin when Closed

Layers Help
Help Contents

New Layer... Shift+Ctrl+N
Duplicate Layer...
Delete Layer
Delete Linked Layers
Delete Hidden Layers

Rename Layer...

Simplify Layer

Link Layers
Select Linked Layers

Merge Linked Ctrl+E
Merge Visible Shift+Ctrl+E
Flatten Image

Palette Options...

TIP

Adjustment layer masks
When you create an adjustment layer with
a selection active, the new adjustment layer
will be masked according to your selection.
The effect of the adjustment layer will
only be applied to underlying layers in the
area inside of the selection and masked
in areas outside of the selection. You can
edit an adjustment layer mask with various
Photoshop Elements paint tools, including
the Brush or Gradient tools.

9a
Color Burn
Linear Burn

Lighten
Screen
Color Dodge
Linear Dodge

Overlay
Soft Light
Hard Light
Vivid Light
Linear Light
Pin Light
Hard Mix

Difference
Exclusion

Hue
Saturation
Color
Luminosity

9b
Color Picker
Learn more about: Choosing Colors
Select foreground color:
OK
Cancel
H 326
S 52 %
B 78 %
R 199
G 95
B 164
c79f6a
☐ Web Colors

8b
Learn more about: Levels
Channel: RGB
Input Levels: 58 1.00 248
OK
Cancel
Reset
Auto
☑ Preview
Output Levels: 0 255

9c
Learn more about: Fill Layer
OK
Cancel
Contents
Use: Foreground Color
Custom Pattern:
Blending
Mode: Normal
Opacity: 100 %
☐ Preserve Transparency

7 Hold down the Shift key and use the Move tool to
drag the hand to the right. Select the Eraser, this time
choosing a brush preset with a soft round tip. Use it to erase
the area on this layer where the hands overlap.

8 Link the hand and the background layers by clicking
in the empty box next to the thumbnail in the Layers
palette, then go to *Layer > **Merge Linked***. Ctrl/Cmd+click on
the merged layer's thumbnail to generate a selection. (If it's the
background layer, you may need to double-click on it first to
convert it to a normal layer.) Create a new Levels adjustment
layer. Adjust the Input levels to increase the contrast.

9 Ctrl/Cmd+click on the layer mask thumbnail to
generate a selection from it. Create a new layer, and
switch the blending mode to color. Select a bright pink from
the picker and choose *Edit > **Fill Selection*** from the menu.

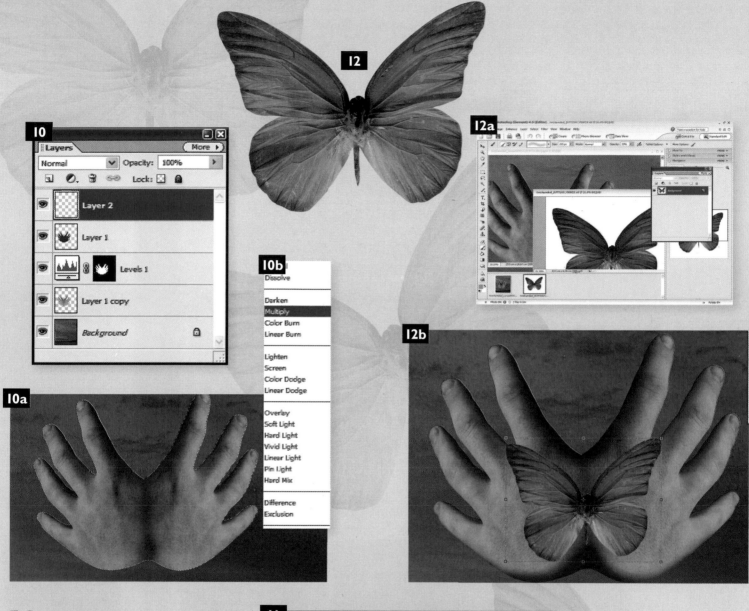

10 Reduce the opacity of the layer to 24%. With the
selection still active, create a new layer in the
Layers palette. Select the Brush tool and specify a large,
soft round brush tip in the Options Bar. Select a beige color
from the color picker, and change the blending mode of the
layer to Multiply.

11 Paint within the selection border on the new layer
along the edge, between the top fingers and along
the bottom edges. Press Ctrl/Cmd+D to deactivate the
selection when finished.

12 Find another image for the background, we're using
a butterfly, and alter your workspace so that you
can see both files at once. Select the Move tool and drag the
butterfly image into the working file.

THE TWO-HANDED BUTTERFLY

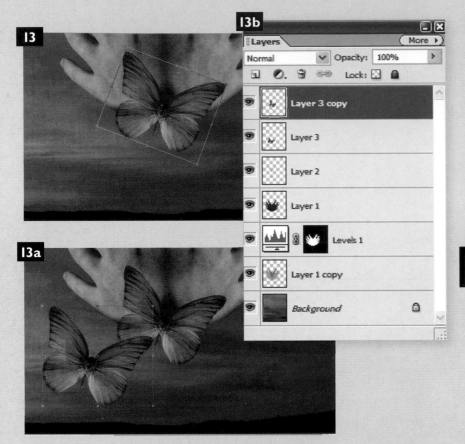

13 Once the butterfly is in the working file as a new layer, click inside the bounding box and drag it downward a little. Rotate the box by clicking and dragging just outside of it after the mouse pointer changes to indicate rotation. Press Enter on the keyboard to apply the transformation. Hold down the Alt/Opt key and click and drag on the butterfly to duplicate the layer.

14 In the Layers palette, drag the new butterfly layer beneath the hands layer. Use the Move tool to position the butterfly under one of the fingers at the left. Resize the butterfly by holding down the Shift key and dragging the corner points inward, rotate it a little and then press the Enter key.

15 Hold down the Alt/Opt key and drag the butterfly to create another copy of the layer. Position it in a different area, resize and rotate it. Use this method to add a number of different butterfly layers, placing butterflies of different sizes throughout the image. Move them up and down in the Layers palette to place them in front of or behind other layers as desired.

TIP **About duplicating layers**
As with many tasks in Photoshop Elements, there are multiple methods for duplicating layers. As you will have noticed in this project, you can click and drag an unselected object with the Move tool while holding down the Alt/Opt key. Also, you can simply drag a layer icon onto the Create a new layer button in the Layers palette. Another method is to select a layer in the Layers palette and select the Duplicate Layer option from either the Layer menu or the Layers palette menu found under the More button.

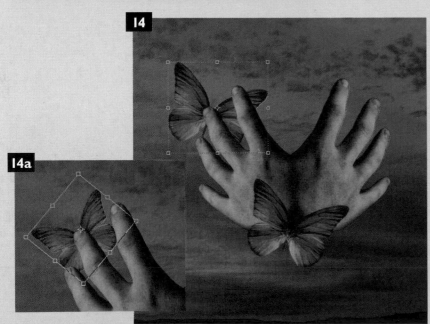

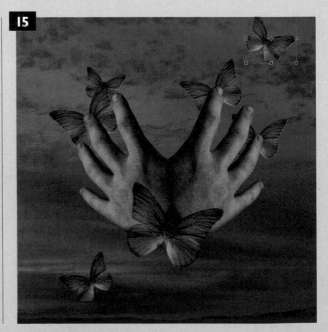

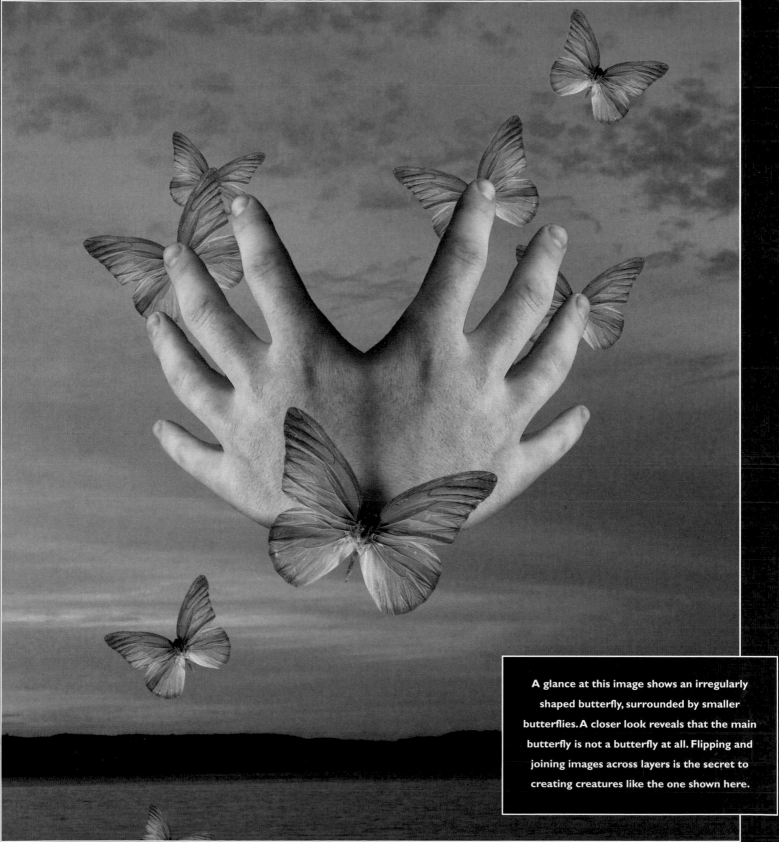

A glance at this image shows an irregularly shaped butterfly, surrounded by smaller butterflies. A closer look reveals that the main butterfly is not a butterfly at all. Flipping and joining images across layers is the secret to creating creatures like the one shown here.

THE FLYING GARGOYLE

Picture yourself immersed in dark, haunted ruins on a stormy night. The scenario is frightening indeed, but all the more so when you think you see movement out of the corner of your eye. A glance over your shoulder reveals that one of the stone gargoyles has come to life and freed itself from the wall. Worse than that, it's flying towards you!

This fearsome image can be brought to life quite easily in Photoshop Elements. Starting off with a daytime shot of some ancient Irish ruins, we'll show you how to bring in a stormy sky and add a muted black and white quality to the entire image, reminiscent of a vintage horror film. Also, the gargoyle—Perhaps the most important part of the image—needs to look as if its wings are in motion.

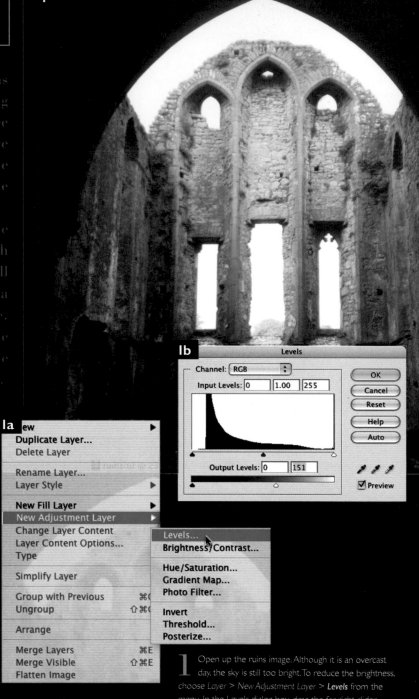

1 Open up the ruins image. Although it is an overcast day, the sky is still too bright. To reduce the brightness, choose *Layer > New Adjustment Layer > **Levels*** from the menu. In the Levels dialog box, drag the far right slider toward the left, this will darken the highlights.

2 Select the Magic Wand tool. Set the Tolerance to 20, making certain that the Contiguous option and the Use All Layers option are enabled. Click the gray sky at the top to select it, then hold down the Shift key and click on the other gray areas of the sky, like inside the window frames, to add them to the selection. Hold down the Shift key and click on the bushes outside the ruins that remain unselected, to add them as well.

3

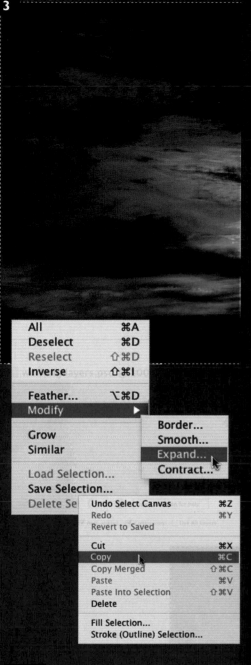

All	⌘A
Deselect	⌘D
Reselect	⇧⌘D
Inverse	⇧⌘I
Feather...	⌥⌘D
Modify	▶
Grow	
Similar	
Load Selection...	
Save Selection...	
Delete Se	

Border...
Smooth...
Expand...
Contract...

Undo Select Canvas	⌘Z
Redo	⌘Y
Revert to Saved	
Cut	⌘X
Copy	⌘C
Copy Merged	⇧⌘C
Paste	⌘V
Paste Into Selection	⇧⌘V
Delete	
Fill Selection...	
Stroke (Outline) Selection...	

TIP	**Useful shortcuts** Here are some keyboard shortcuts that you'll find useful for this project as well as almost anything else you want to do in Photoshop Elements: To select all, hit Ctrl/Cmd+A To copy, hit Ctrl/Cmd+C To paste, hit Ctrl/Cmd+V To paste into a selection, hit Ctrl/Cmd+Shift+V

4

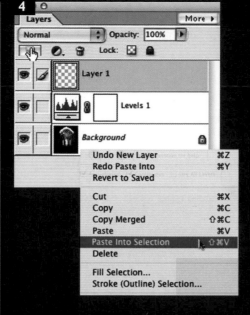

Undo New Layer	⌘Z
Redo Paste Into	⌘Y
Revert to Saved	
Cut	⌘X
Copy	⌘C
Copy Merged	⇧⌘C
Paste	⌘V
Paste Into Selection	⇧⌘V
Delete	
Fill Selection...	
Stroke (Outline) Selection...	

5

5a

3 Choose *Select > Modify > Expand* from the menu. Expand the selection by 3 pixels to ensure that all of the background scenery and sky are selected. Open up the sky image and choose *Select > All* and then *Edit > Copy* from the menu. Return to the working file.

4 With the Magic Wand selection still active, create a new layer in the Layers palette by pressing the Create a new layer button. Then choose *Edit > Paste Into Selection* from the menu to paste the copied sky image into the active selection only.

5 When you use the Paste Into Selection option, the active selection border disappears and instead you'll see a selection border surrounding the pasted image, even though it's only visible in the areas outlined by the previous Magic Wand selection. You can drag the image around within the Magic Wand selection. Double-clicking will cause the marquee to disappear, placing the image permanently.

6 Ctrl/Cmd+click on the sky layer's thumbnail in the Layers palette to select its content. With the selection active, create a new Levels adjustment layer. Drag the left slider of the Input levels to the left, darkening the shadows and creating a brooding sky.

6

6a

Levels

Channel: RGB

Input Levels: 55 | 1.00 | 255

OK
Cancel
Reset
Help
Auto

Output Levels: 0 | 255

☑ Preview

Solid Color...
Gradient...
Pattern...
Levels...
Brightness/Contrast...
Hue/Saturation...
Gradient Map...

7 Open up the gargoyle image and select the Selection Brush tool. In the Options Bar, select a hard round, brush preset. Set the Size to 30 pixels and the Mode to Selection. Zoom in close on the gargoyle and begin to paint around the inside edge with the brush.

8 Continue until you've painted a brush-stroke wide selection around the inside of the gargoyle. Because we want to select the entire gargoyle, we'll need to paint over the entire area inside the selection. Selecting a large brush, paint over the inside area until the entire gargoyle is selected.

9 Copy the selected gargoyle and then return to the working file. Paste the gargoyle into the working file as a new layer. Select the Move tool and when the bounding box appears, hold down Alt/Opt+Shift while dragging a corner point inward toward the central origin point to reduce the size of the creature.

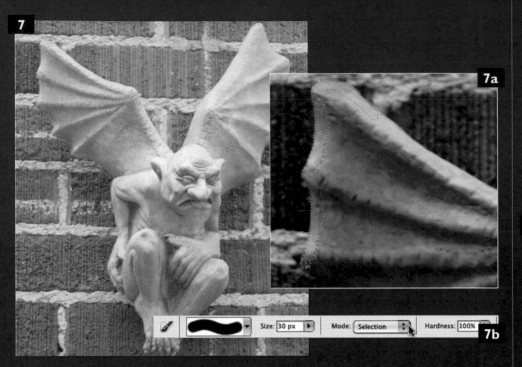

7

7a

7b Size: 30 px Mode: Selection Hardness: 100%

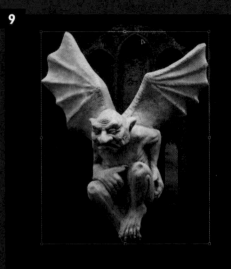

9

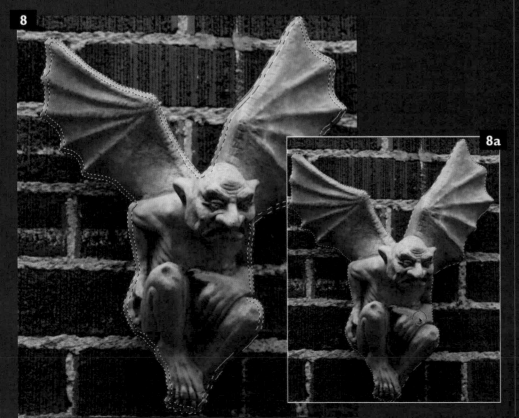

8

8a

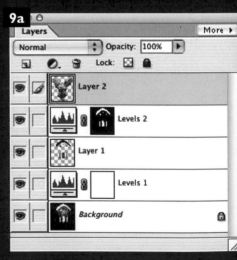

9a

Layers More ▶

Normal Opacity: 100%

Lock:

Layer 2

Levels 2

Layer 1

Levels 1

Background

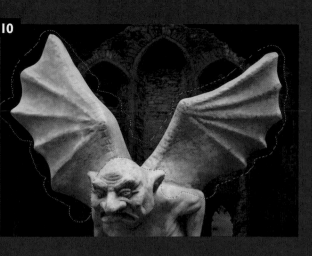

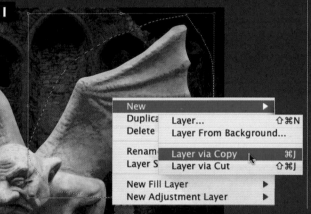

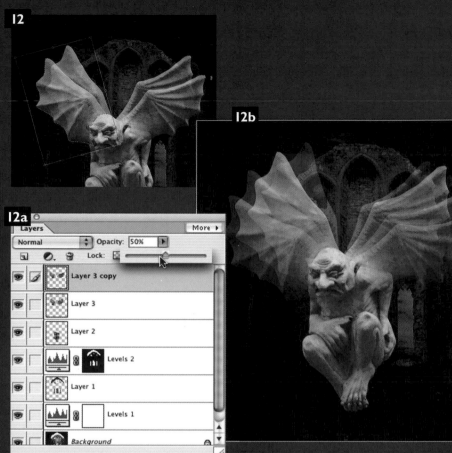

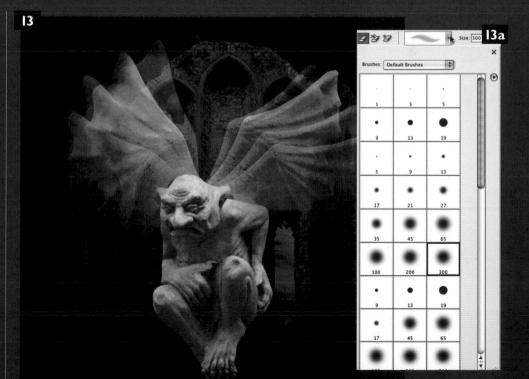

10 Choose the Selection Brush tool and use it to paint over the wings of the gargoyle, selecting them. Increase or decrease the size of the brush as needed to create an accurate selection. Don't worry about extending the selection onto the transparent areas of the layer; that's fine.

11 With the selection active, choose *Layer > New > Layer Via Cut*. This creates a new layer from the selection, removing the selected area from the previous layer. Reduce the layer's opacity to 80% and duplicate it. Use the Lasso tool to draw a rough selection around one wing on the duplicate layer. Then choose *Image > Transform > Free Transform* from the menu.

12 Rotate the selected wing and position it so that it touches the gargoyle's shoulder. Press Enter to apply the transformation. Use the same method to rotate the other wing. Reduce that layer's opacity to 50%. Continue duplicating layers and rotating the wings until you have created a sense of movement. Reduce the opacity of the layers as required.

13 Select the Eraser tool. In the Options Bar, select a large, soft round brush tip. Set the opacity quite low. Use the Eraser on the wings layers to erase areas that overlap the gargoyle's shoulders as needed. Also, remove the tips of the wings from some layers. Feel free to use varying

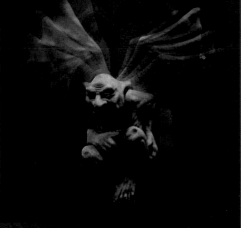

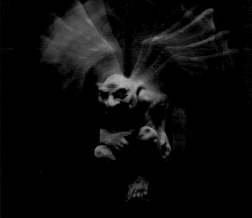

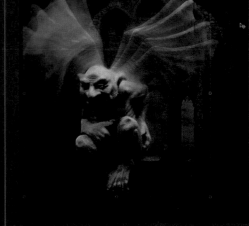

I4a

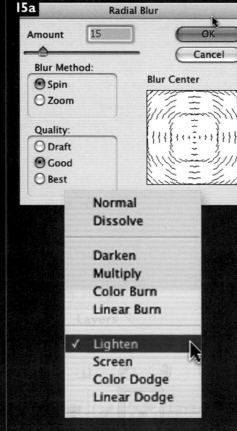

I5a

I7

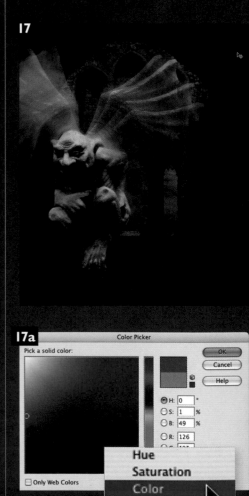

14 Link the gargoyle and wings layers in the Layers palette and merge them into a single layer. Choose *Enhance > Adjust Lighting > **Levels*** from the menu. Drag the left Input levels slider to the right to darken the shadows on the newly merged layer.

15 Duplicate the merged layer and with the duplicate layer selected, choose *Filter > Blur > **Radial Blur*** from the menu. Use an Amount of around 15 and the Spin method. Change the blending mode of the layer to Lighten. Select the Eraser tool and erase areas on the layer that overlap his body or are too strong.

16 Link the gargoyle layer and the blurred layer. Use the Move tool to position him a little to the left.

17 Create a new Solid Color layer via the Create adjustment layer button in the Layers palette. Choose a gray value from the picker and change the blending mode to Color in the Layers palette. Reduce the layer opacity to 66% to desaturate the gray.

I7a

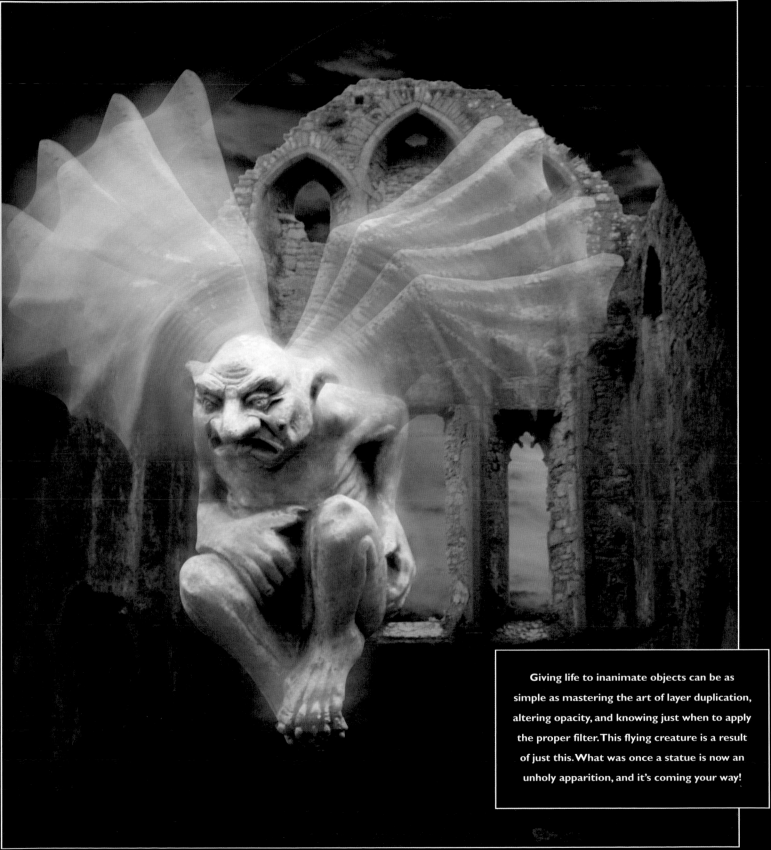

Giving life to inanimate objects can be as simple as mastering the art of layer duplication, altering opacity, and knowing just when to apply the proper filter. This flying creature is a result of just this. What was once a statue is now an unholy apparition, and it's coming your way!

faces and figures

ABDUCTED BY ALIENS

Those of you familiar with the X-Files television series, the books by UFO abductee Whitley Strieber, or the myths surrounding Area 51 in Roswell, New Mexico, will instantly recognize this final image. This is the quintessential alien, the one that visits in the night and escorts its victims, paralyzed by fear, aboard alien spacecraft.

Now, let's remove some of the frightening stigma attached to this stereotype and instead have some fun creating a version of our own. Work through this chapter and you'll learn how to transform images of your friends and family into alien beings in no time. You don't need a spacecraft, just a little Photoshop Elements know-how.

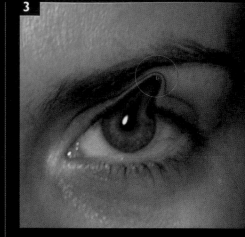

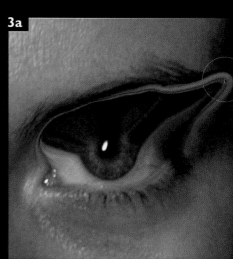

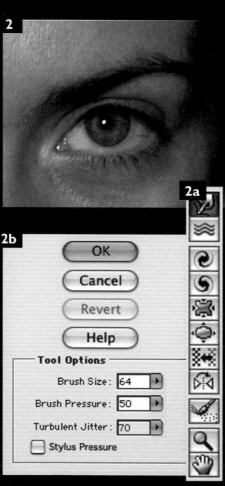

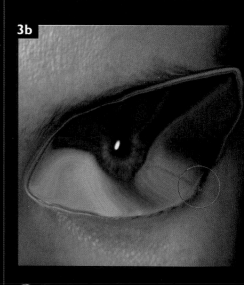

1a	
Last Filter	⌘F
Filter Gallery...	
Adjustments	▶
Artistic	▶
Blur	▶
Brush Strokes	▶
Distort	▶
Noise	Diffuse Glow...
Pixela	Displace...
Rende	Glass...
	Liquify...
	Ocean Ripple...
	Pinch...

2a

2b

OK

Cancel

Revert

Help

Tool Options

Brush Size: 64 ▶

Brush Pressure: 50 ▶

Turbulent Jitter: 70 ▶

☐ Stylus Pressure

1 Open up the half face image—this will be our starting point. Choose *Filter > Distort > Liquify* from the menu to launch the Liquify filter. This filter is great for this type of major reconstruction.

2 Choose the Warp tool from the list of available tools in the Liquify filter's interface. Start off with these basic tool option settings: Brush Size 64, and Brush Pressure setting of 50. This is a good starting point for drastic changes. Zoom in close on her eye.

3 Click within the eye, dragging upward to meet the eyebrow. Using a series of small strokes, continue to click and drag, bringing the eye upward and both left and right. Now begin to drag the bottom of the eye downward.

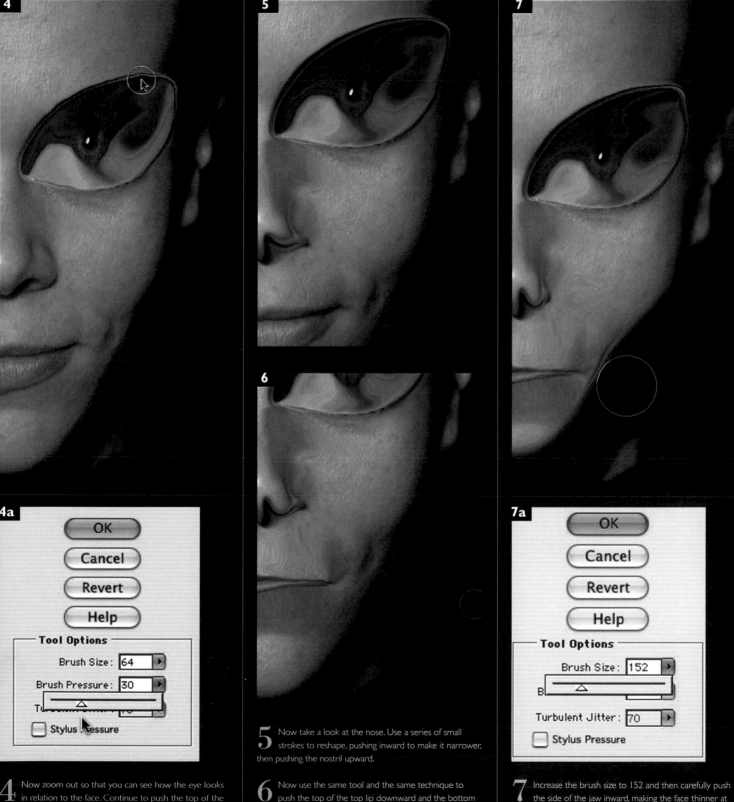

4 Now zoom out so that you can see how the eye looks in relation to the face. Continue to push the top of the

5 Now take a look at the nose. Use a series of small strokes to reshape, pushing inward to make it narrower, then pushing the nostril upward.

6 Now use the same tool and the same technique to push the top of the top lip downward and the bottom

7 Increase the brush size to 152 and then carefully push the side of the jaw inward, making the face thinner at

4a

OK

Cancel

Revert

Help

Tool Options

Brush Size: 64 ▶

Brush Pressure: 30 ▶

Tu____ ____ △

☐ Stylus Pressure

7a

OK

Cancel

Revert

Help

Tool Options

Brush Size: 152 ▶

B____ △ ____

Turbulent Jitter: 70 ▶

☐ Stylus Pressure

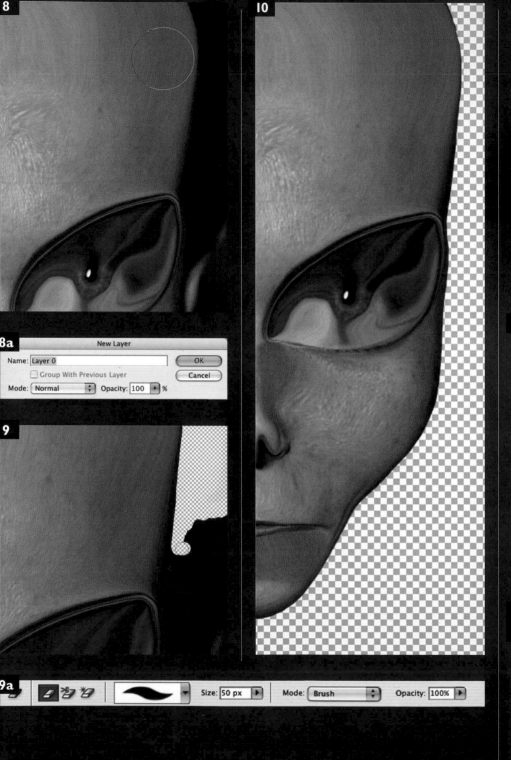

8 Push the top of the head upward so that the forehead bleeds off the top of the image area. Press OK to apply the effect and exit the Liquify workspace. Double-click the background layer icon in the Layers palette. This transforms it into a normal layer so that when you erase areas, they will become transparent.

9 Select the Eraser tool. Choose a hard, round brush tip preset in the Options Bar. Set the Size to 50 pixels and the Mode to Brush. With the Opacity set to 100, begin to erase the background from the image.

10 Taking your time, and carefully erase the area next to the face so that the edge is smooth. Completely erase the ear, neck, and shoulders so that nothing remains other than the reshaped head.

11 Select all of the alien face layer (Ctrl/Cmd+A) and copy it (Ctrl/Cmd+C). Open up a background image (we have used a brooding sky), and paste the alien into the background as a new layer (Ctrl/Cmd+V), then use the Move tool to drag the layer to the right of the image center.

11

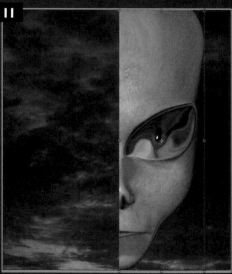

TIP **Resizing Brushes**
When you are using a tool that utilizes brush tips and sizes, for example the Eraser or the Brush tool, there is a quicker way to adjust tip size than always going back to the Options Bar. Simply press the "[" key to reduce the brush size, or press the "]" to increase the brush size incrementally.

8a

New Layer

Name: Layer 0 | OK

☐ Group With Previous Layer | Cancel

Mode: Normal Opacity: 100 %

9a

Size: 50 px | Mode: Brush | Opacity: 100%

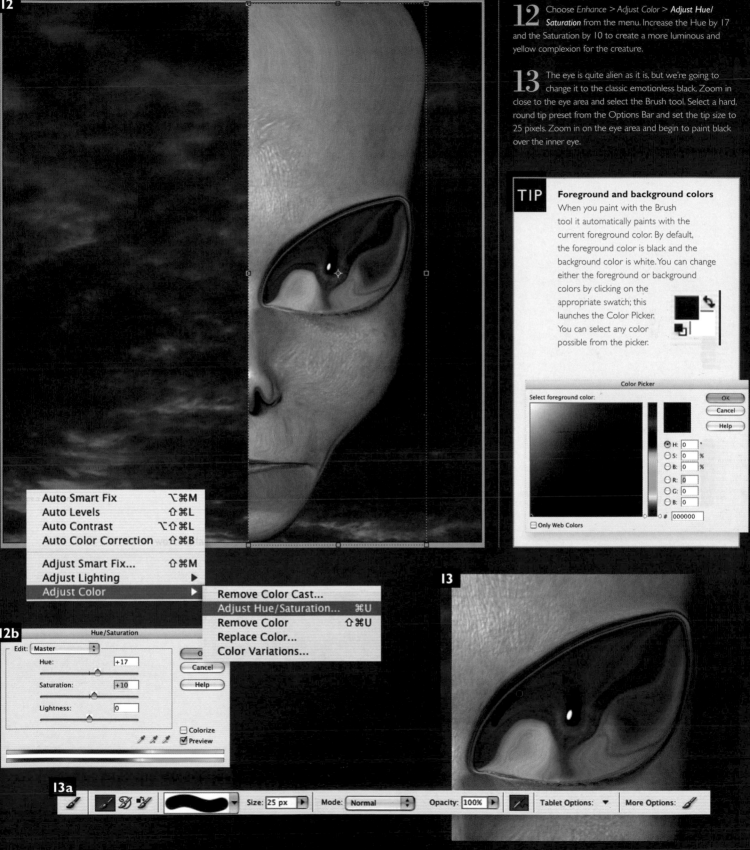

12 Choose *Enhance > Adjust Color > Adjust Hue/Saturation* from the menu. Increase the Hue by 17 and the Saturation by 10 to create a more luminous and yellow complexion for the creature.

13 The eye is quite alien as it is, but we're going to change it to the classic emotionless black. Zoom in close to the eye area and select the Brush tool. Select a hard, round tip preset from the Options Bar and set the tip size to 25 pixels. Zoom in on the eye area and begin to paint black over the inner eye.

TIP

Foreground and background colors
When you paint with the Brush tool it automatically paints with the current foreground color. By default, the foreground color is black and the background color is white. You can change either the foreground or background colors by clicking on the appropriate swatch; this launches the Color Picker. You can select any color possible from the picker.

ABDUCTED BY ALIENS

15

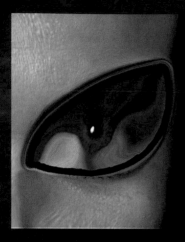

15a

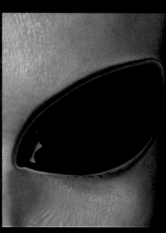

16

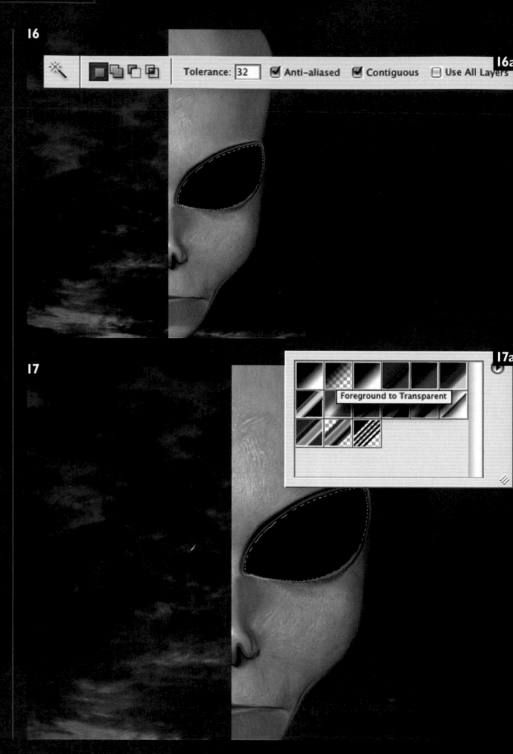

16a

Tolerance: 32 ☑ Anti-aliased ☑ Contiguous ☐ Use All Layers

17

17a

Foreground to Transparent

15 Use the brush to paint around the perimeter of the inner eye area. When you have completely surrounded the inside area, increase the size of the brush to 100 pixels and fill in the remainder of the eye area that isn't painted black already.

16 Selecting the Magic Wand tool, leave the Tolerance set to the default value of 32 and enable the Contiguous option in the Options Bar. Click on the solid black eye area and choose the Gradient tool.

17 Select the Foreground to Transparent preset from the gradient picker and select the Radial Gradient option in the Options Bar. Hold down the Alt/Opt key and click on a gray/blue area of the sky to temporarily access the Eyedropper tool.

17b

Edit Mode: Normal Opacity: 100% ☐ Reverse ☑ Dither ☑ Transparency

18 Click in the top center of the eye and drag downward to create a large gradient fill within the selection. Sample a lighter color from the sky and then reduce the gradient opacity to 50%. Click and drag in essentially the same area to add another, more subtle gradient.

19 Select the Brush tool and reset the foreground color to black. Use the brush settings that you previously used to add some shadow around the edge of the eye within the active selection. Choose *Select > Inverse* from the menu and click the Lock transparent pixels button in the Layers palette.

20 Change the brush mode to Multiply in the Options Bar and select a low brush opacity. Paint around the edges of the head to add dimension and shadow. Sample a variety of colors from within the face and use a smaller brush tip preset to add shading throughout.

TIP

Resetting and swapping colors
You can reset the foreground and background colors to their default black and white by pressing the "D" key on the keyboard. Also, you can invert the foreground and background colors by pressing the "X" key.

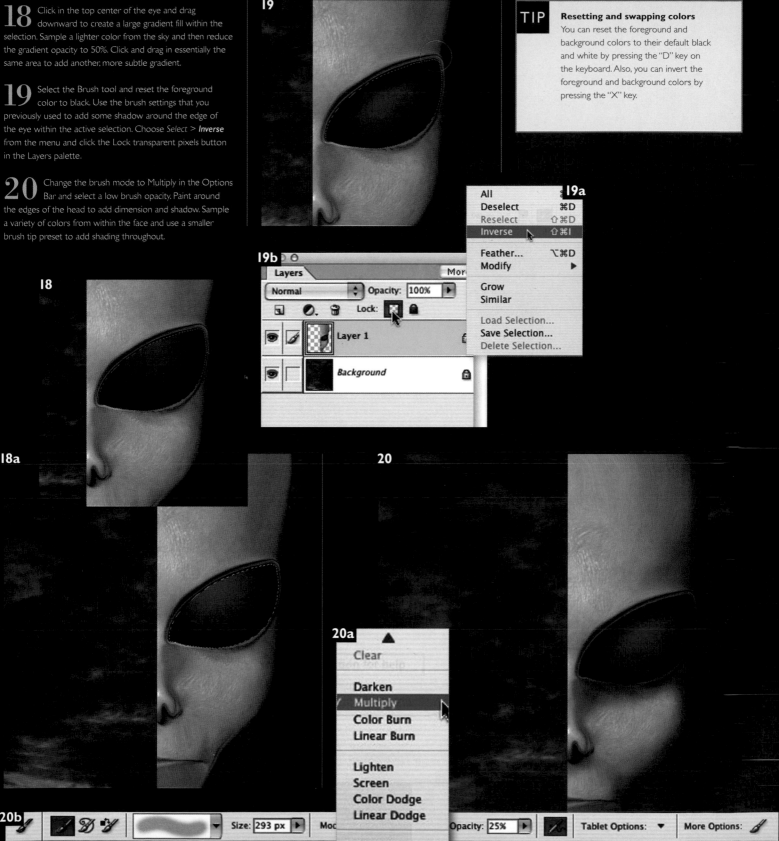

21 Select the Lasso tool and draw a highlight shape on the eye. Choose *Select > Feather* from the menu and feather the selection by 25 pixels to soften it a little. Set the foreground color to white and select the Gradient tool. Click and drag within the selection border to create a white gradient.

22 Choose *Select > Deselect* from the menu to deactivate the selection then choose *Layer > Duplicate Layer* from the menu. With the duplicate layer selected, choose *Image > Rotate > Flip Layer Horizontal* from the menu.

23 Select the Move tool, hold down the Shift key, and drag the layer to the left until the inside edges of the face meet up perfectly. Link the two face layers in the Layers palette, then choose *Layer > Merge Linked* from the menu to merge them into a single layer.

24 Enable the transparency lock on the new layer and select the Blur tool. Use this tool to smooth over any rough areas, such as where the face halves meet in the center, or any edges of the black eye area that are too sharp.

22
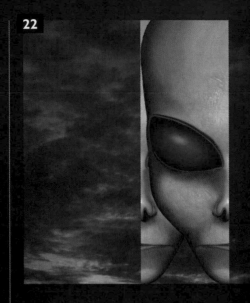

23
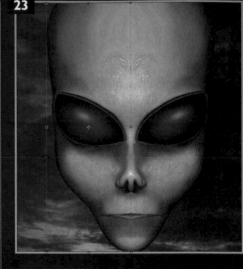

21
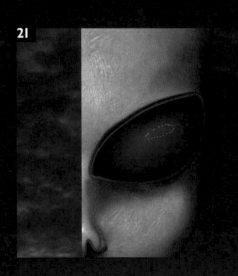

22a
	⌘A
Deselect	⌘D
Reselect	⇧⌘D
Inverse	
Feather...	
Modify	
Grow	
Similar	
Load Selection	
Save Selection	
Delete Selectic	

22b
New
Duplicate Layer...
Delete Layer

Rename Layer...
Layer Style ▶

New Fill Layer ▶
New Adjustment Layer ▶
Change Layer Content ▶
Layer Content Options...
Type ▶

Simplify Layer

22c
otate ▶
Transform ▶
Crop
Divide Scanned
Resize

Mode

22d
90° Left
90° Right
180°
Custom...
Flip Horizontal
Flip Vertical

Free Rotate Layer
Layer 90° Left
Layer 90° Right
Layer 180°
Flip Layer Horizontal
Flip Layer Vertical

Straighten and Crop Imag
Straighten Image

23a

Layers — More ▶
Normal — Opacity: 100%
Lock:

Layer 1 copy
Layer 1

Simplify Layer

23b
Group Linked	⌘G
Ungroup	⇧⌘G
Arrange	▶
Merge Linked	⌘E
Merge Visible	⇧⌘E
Flatten Image	

24
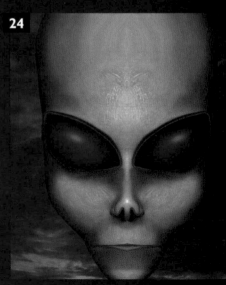

21a

Feather Selection
Learn more about: <u>Feather Selection</u>
OK
Cancel
Feather Radius: 25 pixels

21b

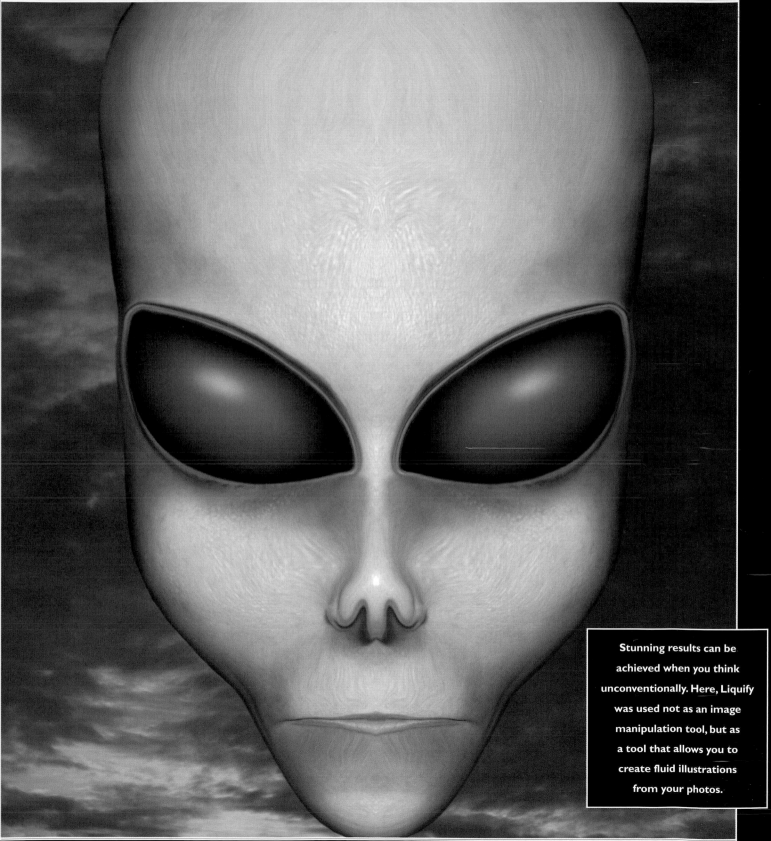

Stunning results can be achieved when you think unconventionally. Here, Liquify was used not as an image manipulation tool, but as a tool that allows you to create fluid illustrations from your photos.

FROZEN FOREVER IN STONE

Legend says that a circle of rocks in Cornwall, England, known as the Merry Maidens, is actually made up of a group of people frozen forever in stone for dancing on the Sabbath. We're not going to be as vengeful a god as back then, but we're still going to have some fun and show you everything you need to know to turn images of your friends and family into stone.

Since it's already been done in Cornwall, we'll start with a background image of standing stones from the Orkney Islands. Best of all, we'll set up a series of layers in Photoshop Elements using a still shot of cracked cement to turn a young lady into a cold, stone shadow of her former self. We'll check out a couple of different liquify tools as well as a variety of different blending modes and opacity settings.

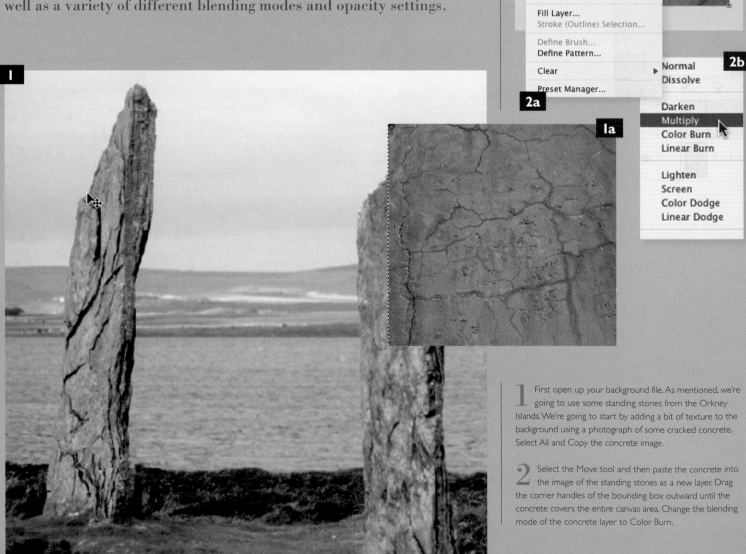

Undo	⌘Z
Redo Paste	⌘Y
Revert to Saved	
Cut	⌘X
Copy	⌘C
Copy Merged	⇧⌘C
Paste	⌘V
Paste Into Selection	⇧⌘V
Delete	
Fill Layer...	
Stroke (Outline) Selection...	
Define Brush...	
Define Pattern...	
Clear	▶
Preset Manager...	

Normal
Dissolve

Darken
Multiply
Color Burn
Linear Burn

Lighten
Screen
Color Dodge
Linear Dodge

1 First open up your background file. As mentioned, we're going to use some standing stones from the Orkney Islands. We're going to start by adding a bit of texture to the background using a photograph of some cracked concrete. Select All and Copy the concrete image.

2 Select the Move tool and then paste the concrete into the image of the standing stones as a new layer. Drag the corner handles of the bounding box outward until the concrete covers the entire canvas area. Change the blending mode of the concrete layer to Color Burn.

3

4

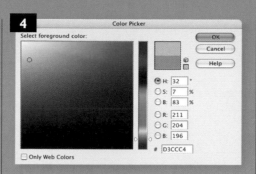

Color Picker

Select foreground color:

OK
Cancel
Help

H: 32 °
S: 7 %
B: 83 %
R: 211
G: 204
B: 196
D3CCC4

☐ Only Web Colors

4a

Layers — More ▶

Normal — Opacity: 100% ▶

Lock: ☒ 🔒

Layer 2

Layer 1 copy

Layer 1

Background 🔒

3a

Normal
Dissolve

Darken
Multiply
✓ Color Burn
Linear Burn

Lighten
Screen
Color Dodge
Linear Dodge

Overlay
Soft Light
Hard Light
Vivid Light
Linear Light
Pin Light
Hard Mix

Difference
Exclusion

Hue
Saturation
Color
Luminosity

5

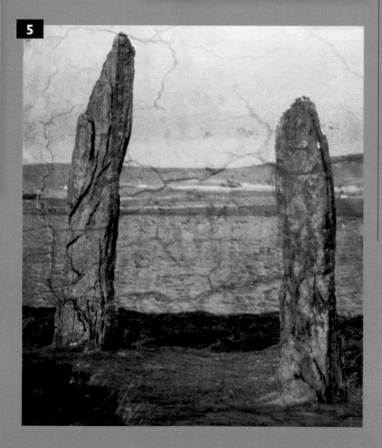

3 Reduce the layer opacity to 30% and then duplicate the layer by dragging it onto the Create a new layer button in the Layers palette. Change the blending mode of this duplicate layer to Overlay and increase its opacity to 65%.

4 Create a new layer in the Layers palette, then click on the foreground color icon to access the Color Picker. Select a light gray color from the picker as your foreground color. Select the Paint Bucket tool and click on the empty layer to fill it with your new color.

5 Change this fill layer's blending mode to Color and then reduce the opacity to 60%. That's the background ready, now open up a suitable portrait image and then switch to the Selection Brush tool. Change the brush mode to mask and choose a hard, round brush tip preset.

6 Increase the brush size and then zoom 100%. Just outside of the head area, begin to paint with the Selection Brush. Paint all of the way round the outside of the head and shoulders. Don't worry about stray hairs, just create a smooth, defined brush stroke all the way around.

6

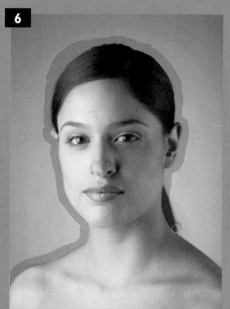

5a

Layers — More ▶

Color — Opacity: 60% ▶

Layer 2

Layer 1 copy

Layer 1

Background 🔒

5b

Size: 19 px ▶ Mode: **Selection** ✓ Mask Hardness: 100% ▶ Overlay Opacity: 50% ▶

FROZEN FOREVER IN STONE

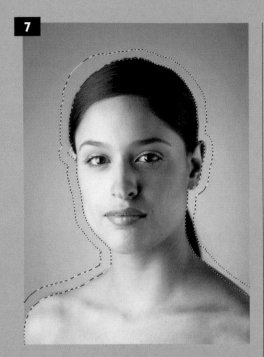

7

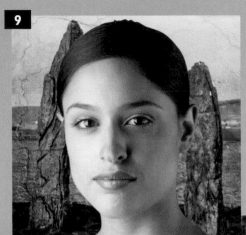

9

TIP

Viewing shortcuts
If you press Ctrl/Cmd+0 (zero) on the keyboard, your image will automatically be scaled to fit within the window. If you press Ctrl/Cmd+Alt/Opt+0, you will instantly see your file at 100% actual size.

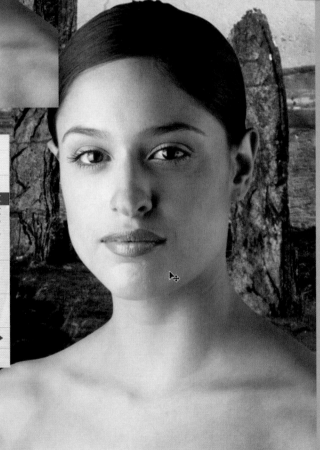

9b

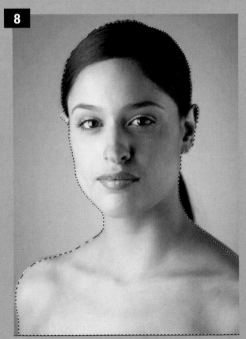

8

9a

ndo Lasso	⌘Z
Redo	⌘Y
Revert to Saved	
Cut	⌘X
Copy	⌘C
Copy Merged	⇧⌘C
Paste	⌘V
Paste Into Selection	⇧⌘V
Delete	
Fill Selection...	
Stroke (Outline) Selection...	
Define Brush from Selection...	
Define Pattern from Selection...	
Clear	▶
Preset Manager...	

7 Hold down the Alt/Opt key and paint over unwanted mask strokes to remove them. When you are finished, select the Lasso tool. The mask is converted to a selection around the model's head. We will now remove the rest of the background using the existing selection as a buffer zone.

8 Hold down the Alt/Opt key and draw rough selections around the areas of the background that remain. Using the buffer, you should be able to make selections without overlapping the model. Close selections by circling around the background edges and returning to your lasso starting point.

9 Once the background is removed from the selection, leaving only the model, copy the selected area and paste it into your working background file as a new layer. Holding down Ctrl/Cmd, click and drag on the layer to position the model lower down within the image.

10

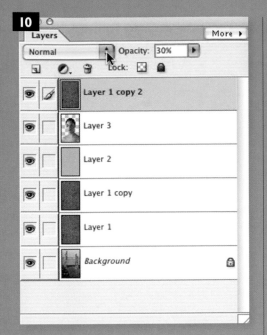

10a

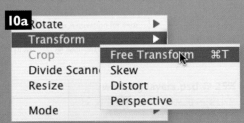

10b

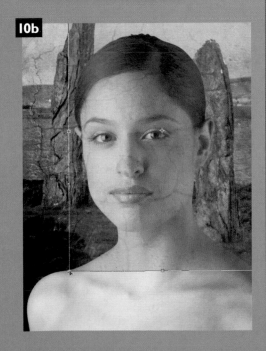

11

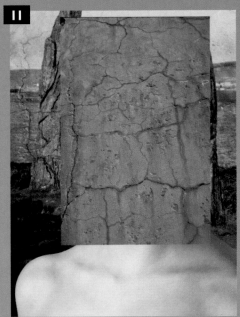

11a

12

13

13a

10 Duplicate the concrete texture layer and drag it to the top of the stack in the Layers palette. Change its blending mode to Normal. Choose *Image > Transform > Free Transform* from the menu. Holding down the Shift key, drag one of the corner points inward to reduce the size so that it will fit over the model's face.

11 Click and drag in the middle of the bounding box and position it over the face. Press Enter to apply the transformation and set the opacity of the layer to 100%. Once again, duplicate the initial concrete layer and drag it to the top of the Layers palette. Change the layer blending mode to Normal.

12 Now use *Image > Transform > Free Transform* to reduce the size of the concrete layer. We'll use this piece to cover the neck and shoulders. Drag the mouse pointer outside the box until it indicates rotation. Hold down the Shift key and rotate it 90°, then move it into place. Press Enter to apply the transformation.

13 Set the opacity of the layer to 100%, then select the Eraser tool. Choose a large, soft, round brush preset and an opacity setting of 100%. Use the Eraser to remove the hard edge at the top of this layer where it overlaps the previous layer, softening the transition between them.

FROZEN FOREVER IN STONE

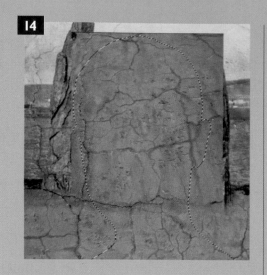

14

15

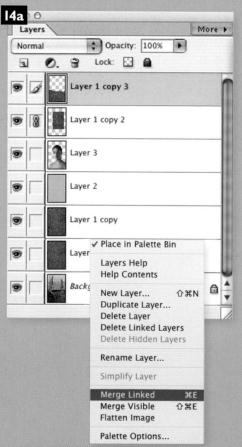

14a

Layers More ▶

Normal ▾ Opacity: 100% ▶

▣ ⬤. 🗑 Lock: ⬚ 🔒

👁 🖌 Layer 1 copy 3

👁 ⬚ Layer 1 copy 2

👁 ☐ Layer 3

👁 ☐ Layer 2

👁 ☐ Layer 1 copy

👁 ☐ Layer

 ✓ Place in Palette Bin

👁 ☐ Backg Layers Help
 Help Contents

 New Layer... ⇧⌘N
 Duplicate Layer...
 Delete Layer
 Delete Linked Layers
 Delete Hidden Layers

 Rename Layer...

 Simplify Layer

 Merge Linked ⌘E
 Merge Visible ⇧⌘E
 Flatten Image

 Palette Options...

15a

All	⌘A
Deselect	⌘D
Reselect	⇧⌘D
Inverse	⇧⌘I
Feather...	⌥⌘D
Modify	▶
Grow	
Similar	
Load Selection...	
Save Selection...	
Delete Selection...	

16

| ast Filter | ⌘F |
| Filter Gallery... | |

Adjustments	▶
Artistic	▶
Blur	▶
Brush Strokes	▶
Distort	▶
Noise	▶
Pixelate	▶
Render	▶
Sharpen	▶
Sketch	▶
Stylize	▶
Texture	▶
Video	▶
Other	▶
Digimarc	▶

16a

Diffuse Glow...
Displace...
Glass...
Liquify...
Ocean Ripple
Pinch...
Polar Coord
Ripple...
Shear...
Spherize...
Twirl...
Wave...
ZigZag...

Tool Options

Brush Size: 200 ▶
Brush Pressure: 25 ▶
Turbulent Jitter: 70 ▶
☐ Stylus Pressure

16b

14 Link the two new concrete layers in the Layers palette and then merge them into a single layer by choosing Merge Linked from the Layers palette menu. Hold down the Ctrl/Cmd key and click on the face layer to generate a selection from the content.

15 Choose *Select* > **Inverse** from the menu and, making sure the merged concrete layer is selected, delete the content of the inverted selection by pressing the Backspace key. Press Ctrl/Cmd+Shift+I to invert the selection.

16 Choose *Filter* > *Distort* > **Liquify** from the menu to launch the Liquify filter. Choose the Pucker tool, set the Brush Size to about 200, and reduce the Brush Pressure to about 25.

17 The Pucker tool pulls pixels inward toward the center of the brush. Use it to paint over areas such as the eye sockets to create a sunken effect. Be careful not to alter the edges of the shape, as it currently fits perfectly over the portrait. Gently paint over all of the areas that you think should appear slightly recessed.

17

17a

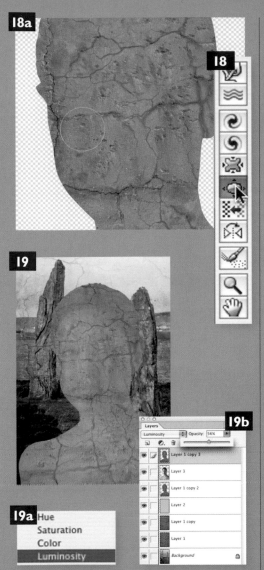

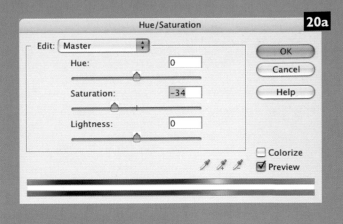

18 Select the Bloat tool. Leave the tool options set as they were. Paint over the cheeks and forehead with the Bloat tool. Because the Bloat tool pushes pixels outward from its center, these areas will appear raised. Use the Bloat tool to gently paint over any other areas you wish to appear raised, altering the brush size as required. Press OK to apply the effect when you are done.

19 Drag the face layer to the top of the Layers palette. Change the blending mode to Luminosity and reduce the opacity to 35%. Duplicate the merged concrete layer and drag it to the top of the Layers palette. Change the blending mode of this layer to Luminosity and reduce the opacity to 55%.

20 Duplicate this layer again and change the blending mode to Overlay. Increase the opacity to 77%. Hold down the Ctrl/Cmd key and click on the layer thumbnail to generate a selection from it. Create a new Hue/Saturation adjustment layer. Reduce the saturation only and then click OK.

TIP

The Liquify filter interface

1 Just like the Elements interface, the tools (in this case distortion tools), reside at the left of the Liquify interface.

2 Should you wish to remove selected areas of distortion, the Reconstruction tool allows you to paint over specific areas, reverting them to their original state.

3 Zoom and pan using these familiar tools. Standard navigation keyboard shortcuts also work within the Liquify filter interface.

4 Quickly jump to a different viewing scale by choosing a different preset from this convenient pull-down menu.

5 Once you apply your effect, this status bar lets you know just how long you'll have to wait to return to the Elements workspace.

6 Each tool allows you to set certain parameters so that you can tailor it to your specific needs.

7 Here's where you can apply the effect, revert to your original state, or simply cancel the entire liquify effect when things get out of hand.

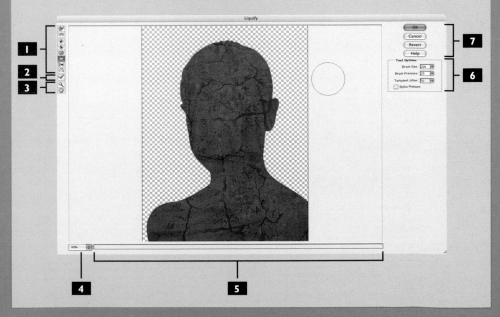

FROZEN FOREVER IN STONE

22a

Tolerance: 55 ☑ Anti-aliased

21

21a

```
uto Levels              ⇧⌘L
Auto Contrast           ⌥⇧⌘L
Auto Color Correction   ⇧⌘B

Adjust Smart Fix...     ⇧⌘M
Adjust Lighting         ▶
Adjust Color            ▶
```
```
        Remove Color Cast...
        Adjust Hue/Saturation...  ⌘U
        Remove Color              ⇧⌘U
        Replace Color...
        Color Variations...
```

22

22b

Brightness/Contrast

Brightness: +9 OK

Contrast: +62 Cancel
 Help
 ☑ Preview

23

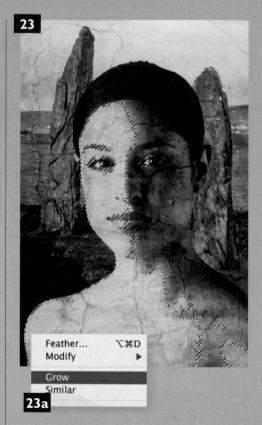

23a
```
Feather...    ⌥⌘D
Modify        ▶
Grow
Similar
```

23b

```
Layer...                ⇧⌘N
Layer From Background...

Layer via Copy          ⌘J
ayer via Cut            ⇧⌘J
```

21 Duplicate the face layer again. Drag it to the top of the Layers palette and then change the blending mode to Multiply. Choose *Enhance > Adjust Color > Remove Color* from the menu to convert the layer to grayscale. Choose *Enhance > Adjust Lighting > Brightness/Contrast* from the menu, drastically increasing the contrast and only slightly increasing the brightness.

22 Duplicate the face layer again and change the blending mode to Hard Light. Increase the opacity of the layer to 47%. Select the Magic Wand tool. Increase the Tolerance to 55, ensuring that the Contiguous option and the Use All Layers option are disabled in the Options Bar.

23 Click on a light area of the face with the Magic Wand tool. To increase the range of color included within the selection, choose *Select > Grow* from the menu. When the selection is increased, choose *Layer > New > Layer Via Cut* from the menu.

24 Change the blending mode of the new layer to Overlay. Duplicate the layer and then change the blending mode of this final duplicate to Screen. Drastically reduce the opacity of this layer to around 5% so that it just lightens the image a little.

24

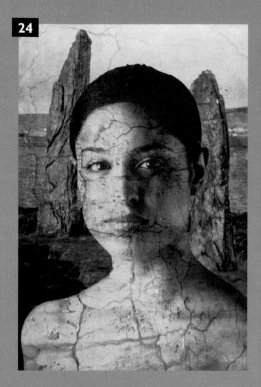

24a

24b

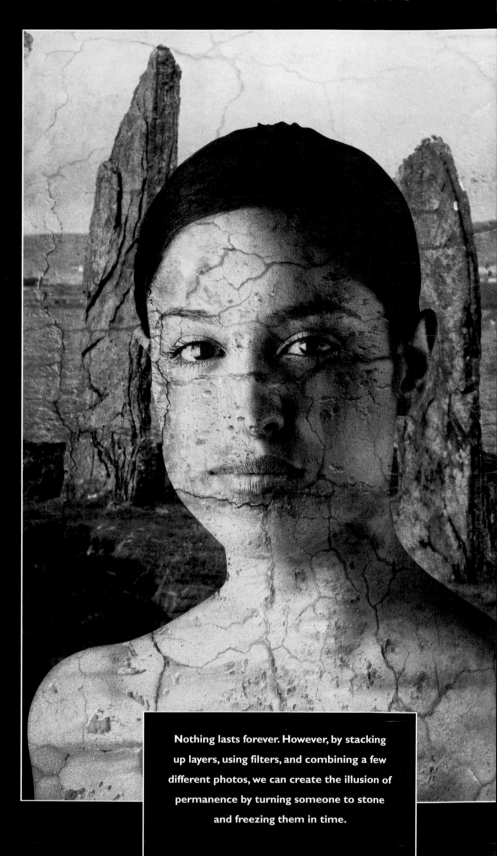

Nothing lasts forever. However, by stacking up layers, using filters, and combining a few different photos, we can create the illusion of permanence by turning someone to stone and freezing them in time.

PEOPLE OF THE TREES

Inspiration strikes when you least expect it. This image was conceived on a winter's day, while taking a leisurely stroll through the woods with friends. Being surrounded by trees got a little strange after a while, as if they were watching our every move. Taking this as our cue, we started to look more closely at the trees for any semblance of a face or facial features.

While we didn't find any particularly realistic features, we did take a number of digital snapshots, capturing sections of bark and other interesting details that could be manipulated within Photoshop Elements to produce the fantastic creature we'll create here. A careful analysis of the available images is perhaps the most important part of this process, studying each section of tree to find matches for human facial features. After that, it's time to fire up Photoshop Elements and let the fun begin.

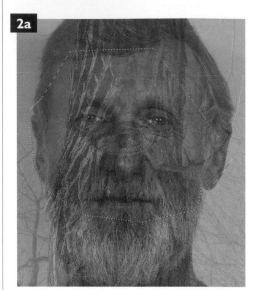

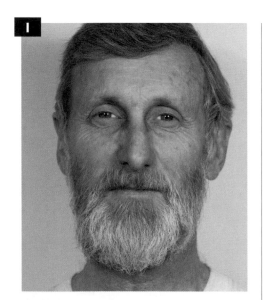

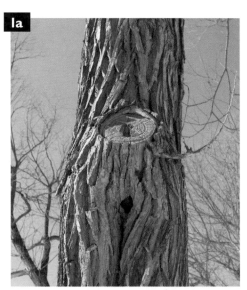

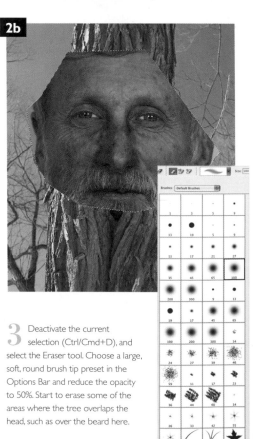

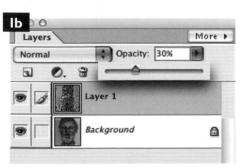

1 Start by opening the face image, as this will be the background layer for your working file, then open the main tree image. Select All (Ctrl/Cmd+A), and copy (Ctrl/Cmd+C) the tree, then paste the copied image into the face file as a new layer. Reduce the opacity of the tree layer to 30%.

2 Reducing the opacity of the layer allows you to see the face underneath. Select the Polygonal Lasso tool and draw a rough polygonal selection around the area of the face you're planning on using in the image. Delete the contents of the selection and return the tree layer to full opacity.

3 Deactivate the current selection (Ctrl/Cmd+D), and select the Eraser tool. Choose a large, soft, round brush tip preset in the Options Bar and reduce the opacity to 50%. Start to erase some of the areas where the tree overlaps the head, such as over the beard here.

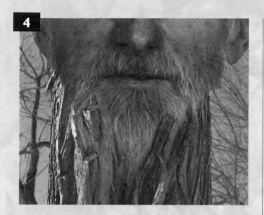

4

4a Lasso Tool L
Magnetic Lasso Tool L
Polygonal Lasso Tool L

4b Rotate ▶
Transform ▶
Crop
Divide Scanned
Resize

Mode

90° Left
90° Right
180°
Custom...
Flip Horizontal
Flip Vertical

Free Rotate Layer
Layer 90° Left
Layer 90° Right
Layer 180°
Flip Layer Horizontal
Flip Layer Vertical

Straighten and Crop Image
Straighten Image

 TIP **About Rotations**
Pay special attention to which section of
the Rotate menu you use when rotating
layer content or images, as the two
sections perform slightly different tasks.
The options in the top portion of the
menu affect the image as a whole. The
section underneath affects the current
layer's content if you have nothing selected.
If you have something selected, then the
wording in the menu changes and it will
affect your selection content.

5

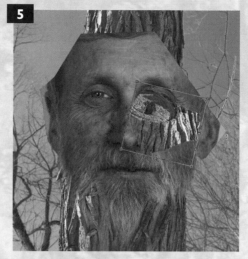

4 Increase and decrease the brush size and opacity as
required to create a smooth blend between the face
and the tree. Select the regular Lasso tool and return for a
moment to the original tree image. Choose *Image > Rotate >
Flip Horizontal* from the menu.

5 Draw a lasso selection around a portion of the tree.
We've chosen the pruned area, as the ring of bark
will work well around the eye. Ctrl/Cmd+click inside the
selection border and then drag it onto the working file as a
new layer. Select the Move tool and position the selection
under his eye, rotating it a little by clicking and dragging
outside of the bounding box until it fits.

6 Select the Eraser tool again. The brush tip and opacity
settings you used previously should be fine, unless you
used a very large brush. Reduce it if this is the case. Erase the
hard edges of the new selection, making it look as if it belongs
under his eye.

6

Size: 98 px Mode: Brush Opacity: 25%

6a

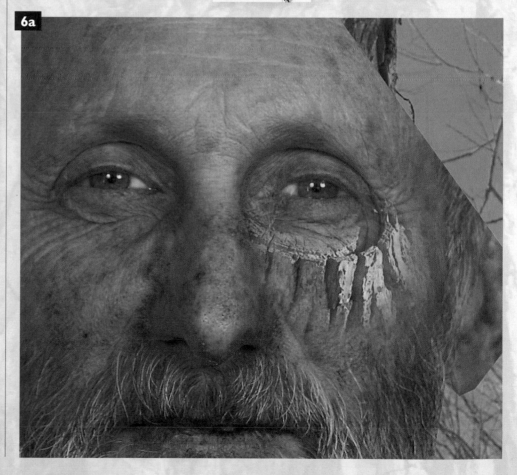

PEOPLE OF THE TREES

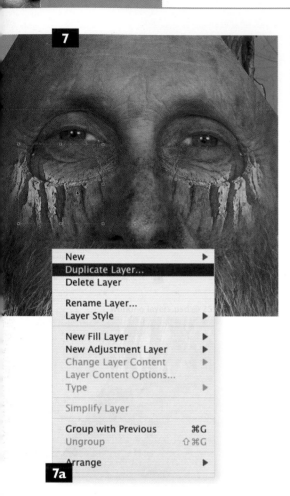

7

7a

New ▶
Duplicate Layer...
Delete Layer

Rename Layer...
Layer Style ▶

New Fill Layer ▶
New Adjustment Layer ▶
Change Layer Content ▶
Layer Content Options...
Type ▶

Simplify Layer

Group with Previous ⌘G
Ungroup ⇧⌘G

Arrange ▶

7b

Rotate ▶
Transform
Crop
Divide Scanned F
Resize

Mode

90° Left
90° Right
180°
Custom...
Flip Horizontal
Flip Vertical

Free Rotate Layer
Layer 90° Left
Layer 90° Right
Layer 180°
Flip Layer Horizontal
Flip Layer Vertical

Straighten and Crop Image
Straighten Image

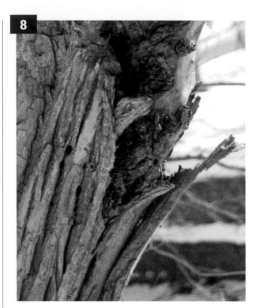

8

8a

9

Size: 13 px Mode: Brush Opacity: 100%

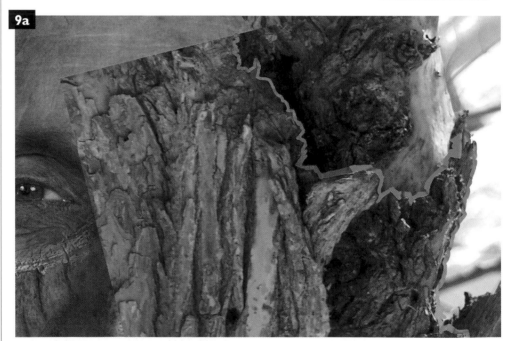

9a

7 Choose *Layer* > **Duplicate Layer** from the menu, to duplicate the bark, then use the Move tool to drag the duplicate layer content to the area under his other eye. Choose *Image* > *Rotate* > *Flip Layer Horizontal*, then use the Move tool to precisely position it

8 We're using a different image of a similar tree to create the ears. Open the image and use the Move tool to drag it into the working file. Reduce its opacity so that you can see the underlying layers, then position it so that the wood covers his left ear. Rotate it so that the bark lines up.

9 Increase the layer to full opacity. Select the Eraser tool. This time, choose a hard, round, brush tip and set it to 100% opacity. Using a small brush tip, begin to erase a fine line along the outside edge of the bark area you want to keep. Take your time here and do a good job.

10

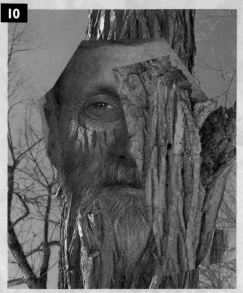

10a

11

11a

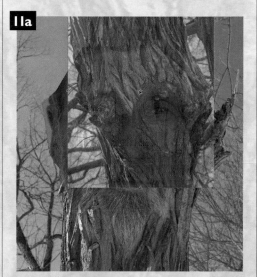

12

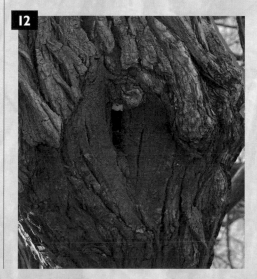

13

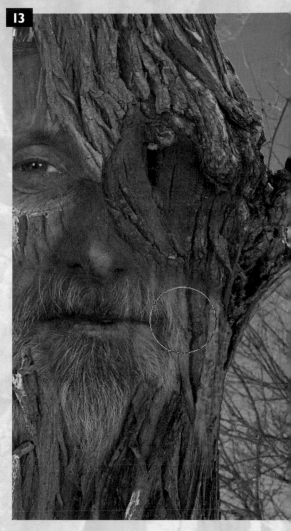

10 When you have finished, increase the brush tip size and erase the unwanted areas to the right of your narrow border. Next, select a large, soft, round brush tip preset from the Options Bar. Reduce the opacity to 50% and erase all of the unwanted areas and hard edges that overlap the face.

11 We'll use another bark photo to cover the right side of his face and forehead. Open the image and use the Move tool to drag it into your working file as a new layer. Again, reduce the opacity of the layer so that you can see the underlying layers and position and rotate the layer to get a pleasing composition with the bark lining up.

12 Select the Eraser tool again and specify a small, hard, round brush tip in the Options Bar. Set the opacity to 100% and zoom in on the new layer. Use the Eraser to remove a line along the right side, just outside of the area you wish to keep.

13 Now increase the size of the brush tip and erase all of the unwanted areas to the right of your division line. Next, select a massive, soft, round brush tip and begin to erase areas to the left and bottom.

PEOPLE OF THE TREES

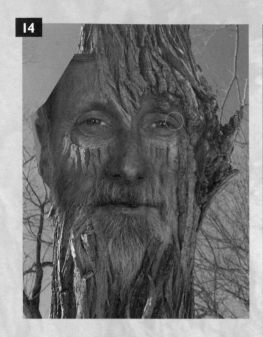

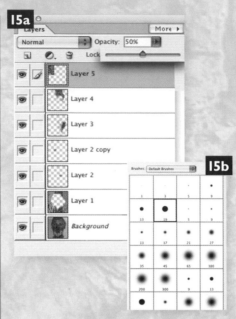

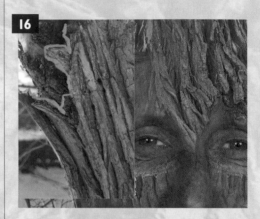

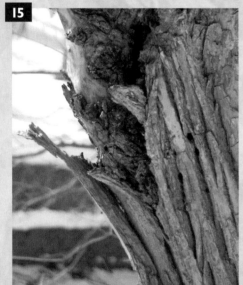

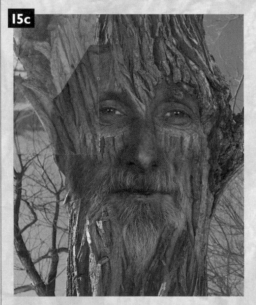

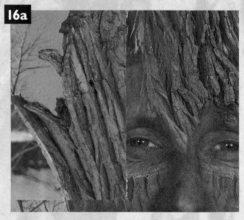

14 Reduce the size of the brush tip and the opacity of the Eraser. Carefully erase unwanted areas around the eye and over the nose using a series of small strokes until the layer blends in seamlessly.

15 We'll use another bark photo for the right ear. Open up the image and use the Move tool to drag the it into the working file as a new layer. Reduce the opacity of the layer so you can see through it. Drag it to the left so that it covers the right ear and return the opacity to 100%. Select the Eraser tool and choose a hard, round, small brush tip.

16 Set the Eraser tool to 100% opacity and again, erase a thin line just outside of the area you wish to keep. Increase the brush size and remove the unwanted area to the left of the line you just erased.

17 Select a soft, round, large brush tip preset and reduce the opacity of the Eraser to 50%. Use this to remove areas where the layer overlaps the face, again blending it seamlessly into the underlying layers.

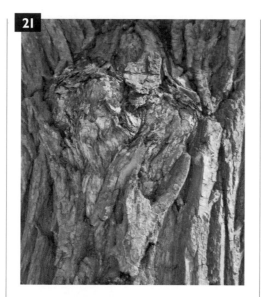

TIP

Shift+dragging
Holding down the Shift key while dragging a layer or selected area allows you to constrain the movement. While holding down Shift, the layer or selected area can only move straight up and down, sideways, or at a 45° angle.

18 In the Layers palette, select the layer containing the bark that is currently covering the left eye of the figure, and duplicate it by dragging it onto the Create a new layer button. Drag the duplicate layer to the top of the stack in the Layers palette.

19 Holding down the Shift key, drag the layer to the left with the Move tool. Drag it until the rounded area rests above the figure's right eye, just as we did for the left eye.

20 Now select the Eraser tool. Leave the brush tip and opacity settings as they are and erase areas that overlap onto the background, plus any hard edges or areas that overlap the eye, blending it in with the rest of the face.

21 We're using yet another piece of wood to cover the right cheek of the figure. Open up the new image and drag it into the working file as a new layer with the Move tool. Position it over his cheek and Ctrl/Cmd+click the layer's icon to generate a selection from the content. Choose *Filter > Distort > **Spherize*** from the menu.

22 Set the Amount to 100% to give a three-dimensional bulging effect to the wood, and click OK to apply the filter. Press Ctrl/Cmd+D to deactivate the selection and select the Eraser tool. Use the Eraser, with its current settings, to erase the edges of the layer content, blending it with the underlying layers.

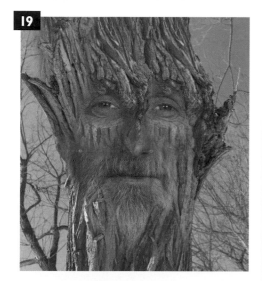

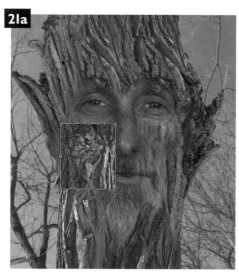

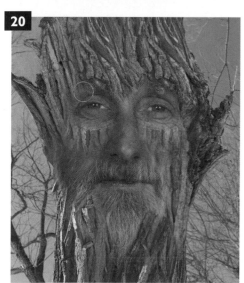

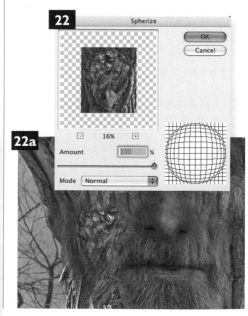

PEOPLE OF THE TREES

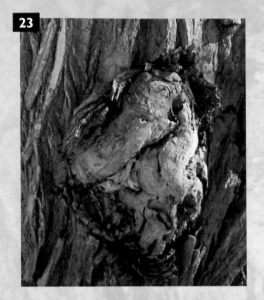

23

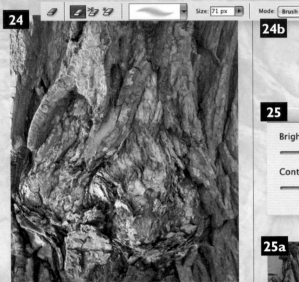

24

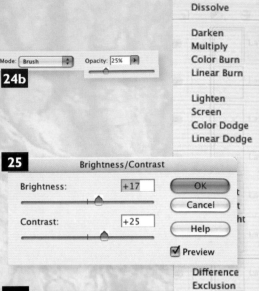

24b Size: 71 px Mode: Brush Opacity: 25%

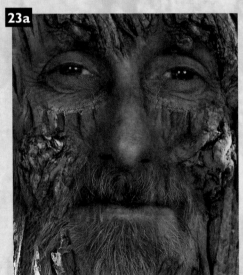

23a

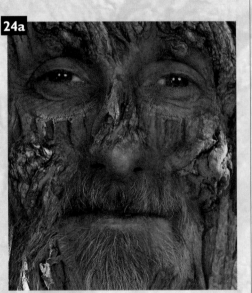

24a

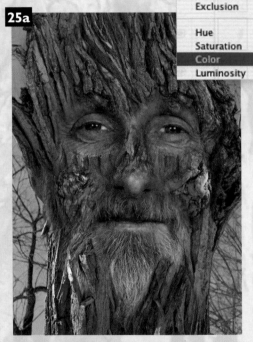

25a

25b
Normal
Dissolve

Darken
Multiply
Color Burn
Linear Burn

Lighten
Screen
Color Dodge
Linear Dodge

25 Brightness/Contrast

Brightness: +17 OK
Cancel

Contrast: +25 Help

☑ Preview

Difference
Exclusion

Hue
Saturation
Color
Luminosity

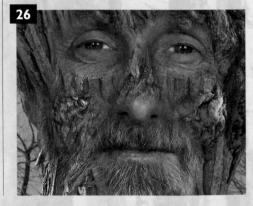

26

23 We'll use a similar knot of wood for the left cheek. Open up the image and, drag it into the working file with the Move tool. Position it over the left cheek and use the Eraser to soften the hard edges, a process you're certainly used to by now.

24 The figure is almost complete now. The only thing we're missing is a piece to cover the figure's nose. Open up a suitable bark image and drag it into the working file, using the Move tool to position it over the nose. Use the Eraser to soften the edges. You'll need to reduce the size of the brush tip and the opacity for certain areas. Remove the lower part so that it only covers the bridge of the nose.

25 Select the original face layer in the Layers palette and then choose *Enhance > Adjust Color > Brightness/Contrast* from the menu. Slightly increase the brightness and contrast as shown. Select the top-most layer in the Layers palette and create a new layer. Change the blending mode of the new layer to Color.

26 Use the Eyedropper tool to sample a brown color from one of the bark layers, then select the Brush tool. Use the Brush tool with soft, round, tips of varying sizes and opacity settings to paint on the color layer over all remaining areas of pink skin. Feel free to sample a variety of different brown colors.

27
Solid Color...
Gradient...
Pattern...

Levels...
Brightness/Contrast...

Hue/Saturation...
Gradient Map...
Photo Filter...

Invert
Threshold...
Posterize...

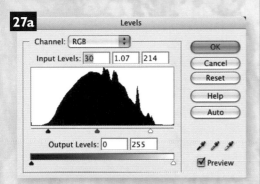

27a
Levels

Channel: RGB

Input Levels: 30 1.07 214

OK
Cancel
Reset
Help
Auto

Output Levels: 0 255

Preview

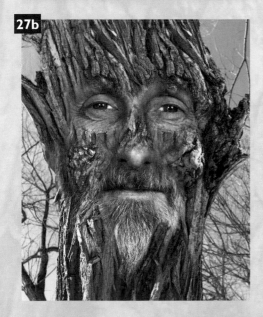

27b

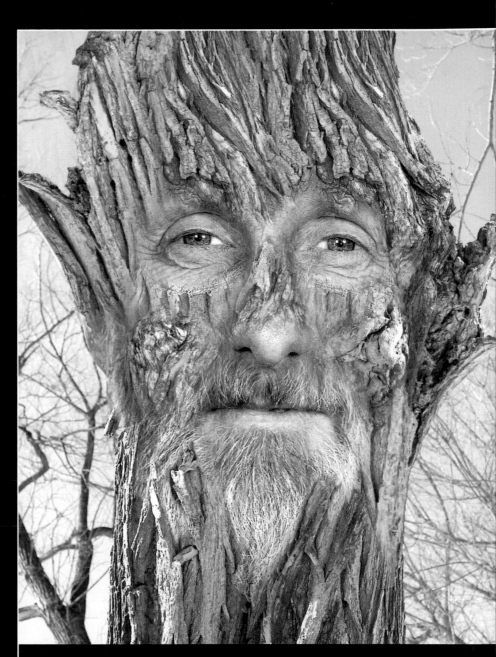

Now here's a fantasy figure if ever there was one.
Tree people are certainly nothing new in the world of
fantasy literature. However, what is new is that Photoshop
Elements affords each one of us the power to create this
effect using photos of our friends and family.

27 Finally, create a new Levels adjustment layer. Drag the left and right Input Levels sliders inward to increase the contrast dramatically. Move the center slider a little to the left to lighten the midtones.

THE PIXELATED MAN

Let's face it, the contemporary human is immersed in technology. We are fiercely dependent on cellular phones and our desktop PCs, and let's not forget what the Internet has to offer. This image represents the archetypal contemporary human, embracing technology to the point of becoming technology himself. His head becomes a monitor and even the environment around him starts to pixelate, painting a bleak and Kafka-esque picture of our future.

Okay, things aren't quite that bad. The technology available to us also allows us to do so much more, including producing fantastic scenes like this one. This time around we'll use some familiar methods and introduce some new tool functions, including the Selection Brush's Mask mode and the Mosaic filter.

1 Open a suitable sky image for the background of this composition. Once you have opened it, create a new Hue/Saturation adjustment layer from the pull-down menu in the Layers palette. Increase the Saturation by 93 to alter the color of the underlying layer.

2 This has brought out the grain in our scanned image. To remedy this, select the background layer in the Layers palette and choose *Filter > Blur > Gaussian Blur* from the menu. Set the pixel radius to 10 pixels to blur the image and remove the grainy texture.

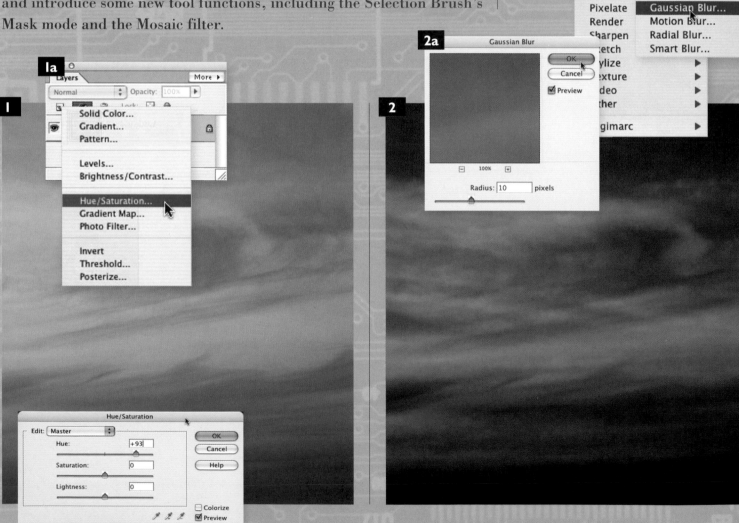

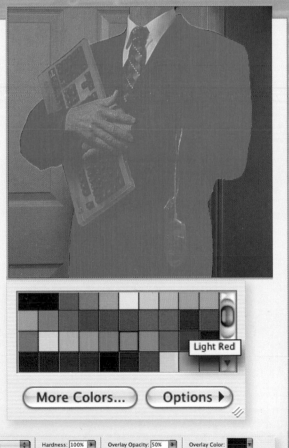

Overlay options

By default, the mask overlay is 50% red, allowing you to see your masked area as well as your background. However, in the Options Bar, there are a couple of features that allow you to adjust the appearance of the overlay. You can use the Overlay Opacity slider to make the overlay more or less opaque and the Overlay Color option allows you to change the mask color when the default red is less than ideal.

3 Open up an image of a man's body. Isolating the figure in our image would prove difficult with an automatic tool like the Magic Wand, so choose the Selection Brush tool, and set the Mode to Mask in the Options Bar.

4 Select a hard, round, brush tip preset, zoom in on the image, and start to paint along the inside edge of the figure with the Selection Brush to create a mask. Work your way around the figure until you get to a sharp area such as the keyboard in this image.

5 When you reach a straight area, click once at the starting point of the straight area and then, holding down the Shift key, click again at the endpoint of the straight area. The area between the two points will automatically be filled with a perfectly straight brush stroke.

6 Carefully continue to work your way around the image until you have created an outline mask on the inside of the figure's body. When you've created the outline, greatly increase the size of the brush.

THE PIXELATED MAN

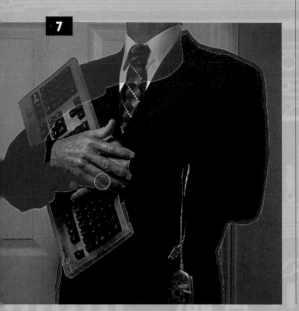

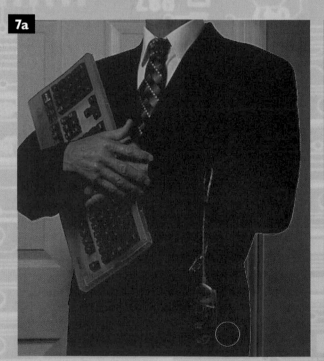

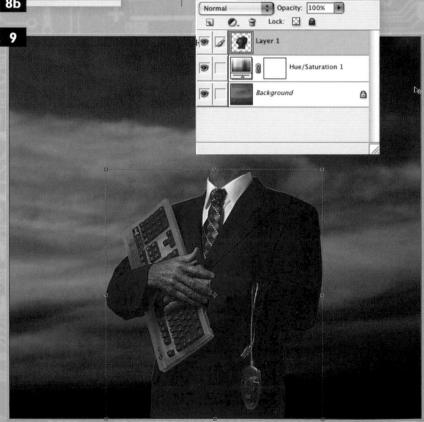

7 Use this larger brush to paint over the entire area inside of your outline. Increase the brush size to cover larger areas and decrease the size when you need to cover tricky areas like corners (don't forget the "[" and "]" keyboard shortcuts). Be careful not to go outside your outlined area.

8 When you have painted over the entire area, set the mode of the Selection Brush back to Selection. This converts the overlay to a selection. Because the colored overlay represents areas that lie outside the selection border, we'll need to invert it by choosing *Select > Inverse* from the menu.

9 When you have inverted the selection, copy it and paste it into the sky image as a new layer. Drag the layer to the top of the stack in the Layers palette. Use the Move tool to position the body at the bottom of the image.

Size: 150 px Mode:

✓ **Selection**
Mask

All	⌘A
Deselect	⌘D
Reselect	⇧⌘D
Inverse	⇧⌘I
Feather...	⌥⌘D
Modify	▶
Grow	
Similar	

Layers More ▶

Normal Opacity: 100%

Lock:

Layer 1

Hue/Saturation 1

Background

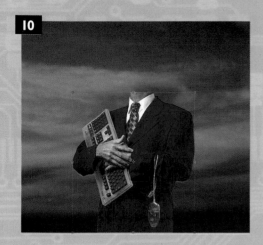

10

10a

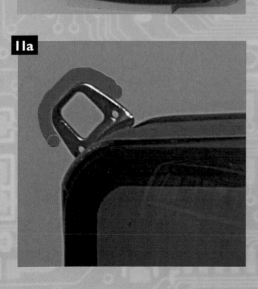

11

11a

12

12a

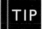

13

10 Ctrl/Cmd+click on the figure layer icon to generate a selection from the content. With the selection active, create a new Levels adjustment layer. Drag the right Input Levels slider to the right, brightening the highlights and drag the left slider slightly to the left, darkening the shadows. Also drag the middle slider to the left to lighten the midtones.

11 Open an image of a television or monitor screen. Again, using the Selection Brush, choose a hard, round tip and set the Mode to Mask. Reduce the brush size to about 20 and start to paint a border on the background, around the edge of the screen.

12 Paint all the way around the screen using a smaller brush to paint inside the corners. Remember to unmask any unwanted areas by holding down the Alt/Opt key. Switch to a larger brush to cover the background when you've finished your outline.

13 When you have covered everything except the screen with an overlay mask, switch the tool mode back to Selection. Copy the selected monitor and then paste it into the working file as a new layer. Use the Move tool to position it where the head should be.

TIP

Removing the mask

There will be areas with sharp corners that will be almost impossible to paint around accurately. To solve this problem, you can paint over unwanted masked areas while holding down the Alt/Opt key. This will remove the mask from those areas. This method of painting a masked area and then carefully removing rough edges is a very accurate way of selecting image components.

THE PIXELATED MAN

14a

New	▶
Duplicate Layer...	
Delete Layer	
	Lighten
Rename Layer...	Screen
Layer Style	Color Dodge
	Linear Dodge
New Fill Layer	
New Adjustment Layer	Overlay
Change Layer Content	**Soft Light**
Layer Content Options.	Hard Light
Type	Vivid Light
	Linear Light
Simplify Layer	Pin Light
	Hard Mix

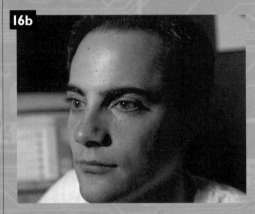

16b

Undo New Layer	⌘Z
Redo Paste Into	⌘Y
Revert to Saved	
Cut	⌘X
Copy	⌘C
Copy Merged	⇧⌘C
Paste	⌘V
Paste Into Selection	⇧⌘V
Delete	
Fill Selection...	
Stroke (Outline) Selection...	
Define Brush from Selection...	
Define Pattern from Selection...	
Clear	▶

17a

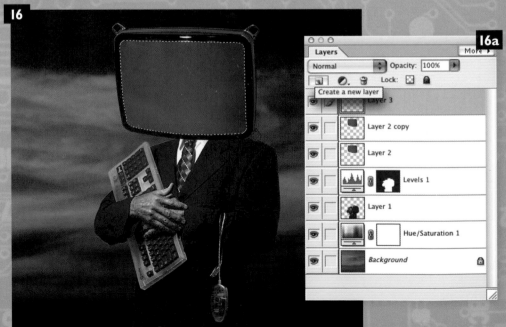

16a

Layers — More ▶

Normal — Opacity: 100%

Create a new layer
Layer 3
Layer 2 copy
Layer 2
Levels 1
Layer 1
Hue/Saturation 1
Background

14 Duplicate the monitor screen layer and change the blending mode of the duplicate layer to Soft Light. This will bump up the contrast and saturation. Choose the Selection Brush once again and zoom in on the screen.

15 Again, select a hard, round brush tip and change the Mode to Mask. Start to paint over the gray, display area of the screen. Take your time and use large or small brush tips as required to paint an overlay mask over the entire area. When finished, switch the Mode back to Selection.

16 Press Ctrl/Cmd+Shift+I on the keyboard to invert the selection and select the gray area. Create a new layer, and with the current selection active, open up an image of a face. Select all and copy.

17 Return to the working file and with the current selection active and the new layer selected, choose *Edit > Paste Into Selection* from the menu. When the image appears, select the Move tool and drag it to the center of the target area.

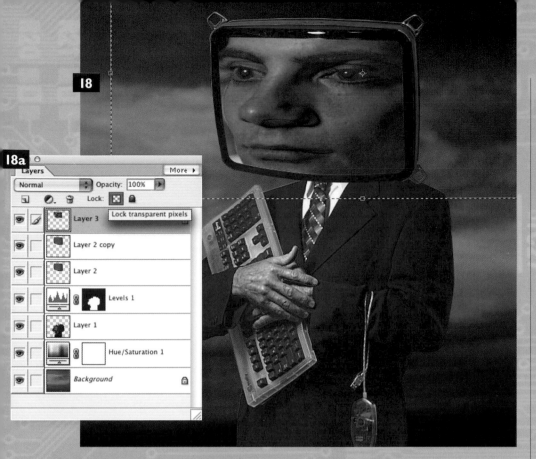

18 Hold down the Alt/Opt key and drag the handle in the middle of the left or right side of the bounding box outward, stretching the face. Reposition as necessary after you stretch it. Enable the layer transparency lock in the Layers palette, then choose *Filter > Pixelate > Mosaic* from the menu.

19 Set the Cell Size to 32 and click OK to pixelate the face. Change the blending mode of the layer to Luminosity, then duplicate the layer and change the blending mode of the duplicate layer to Overlay.

20 Open up an image of a circuit board. Select all and copy it, then paste it into the working file as a new layer. Select the Move tool and drag the corner points outward until the board covers the entire canvas area.

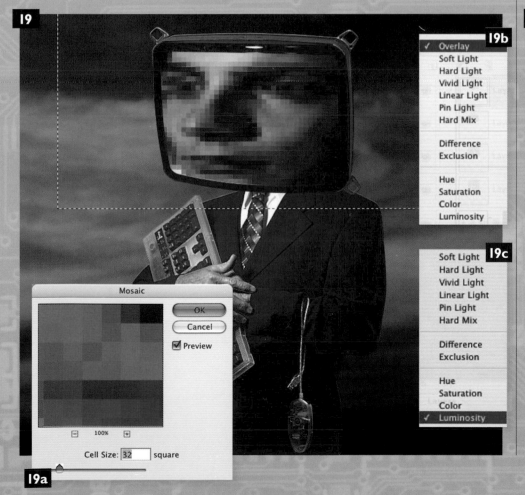

THE PIXELATED MAN

21a

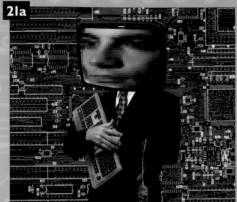

21c

22

22a

24

24a

23b

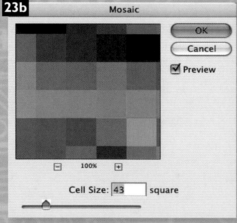

Mosaic

OK
Cancel
☑ Preview

⊟ 100% ⊞

Cell Size: 43 square

23a

Layers More ▶

Normal ⬥ Opacity: 100% ▶

▣ ⬤. 🗑 Lock: ☒ 🔒

👁 🖉 **Background copy**

👁 *Background* 🔒

Group with Previous ⌘G
Ungroup ⇧⌘G

Arrange ▶

Merge Down ⌘E
Merge Visible ⇧⌘E
Flatten Image

23

21

Layers
Normal ⬥ Opacity:
▣ ⬤. 🗑 Lock: ☒

👁 Layer 3 copy
👁 Layer 3
👁 Layer 2 copy
👁 Layer 2
👁 Levels 1
👁 Layer 1
👁 Layer 4
👁 Hue/Saturation 1
👁 *Background*

21b

✓ Normal
Dissolve

Darken
Multiply
Color Burn
Linear Burn

Lighten
Screen
Color Dodge
Linear Dodge

TIP **Quick zooming**
You can zoom in and out of your image on the fly while you work. Type Ctrl/Cmd+plus (+) on the keyboard to zoom in, or type Ctrl/Cmd+minus (-) to zoom out. This is quicker than always reaching for the Zoom tool.

21 Drag the circuit board layer thumbnail downward in the Layers palette until it sits just below the body and just above the Hue/Saturation layer. Change the blending mode of the layer to Color Dodge and reduce the opacity to 43%.

22 Duplicate the layer and drag it to the top of the Layers palette. Select the Eraser tool. Use a massive, soft, round brush tip and an opacity setting of 100% to erase some of the areas on this layer where it overlaps the figure.

23 Choose Layer > **Flatten Image** from the menu, then duplicate the background layer. Choose the duplicate layer and then select the Pixelate filter from the menu again. This time increase the Cell Size to 43.

24 Select the Eraser tool and, using it with the previous settings, remove pixelated areas that overlap the figure here and there. Increase the size of the brush tip and reduce the opacity. Use the Eraser to remove some of the pixelated areas from the background as well.

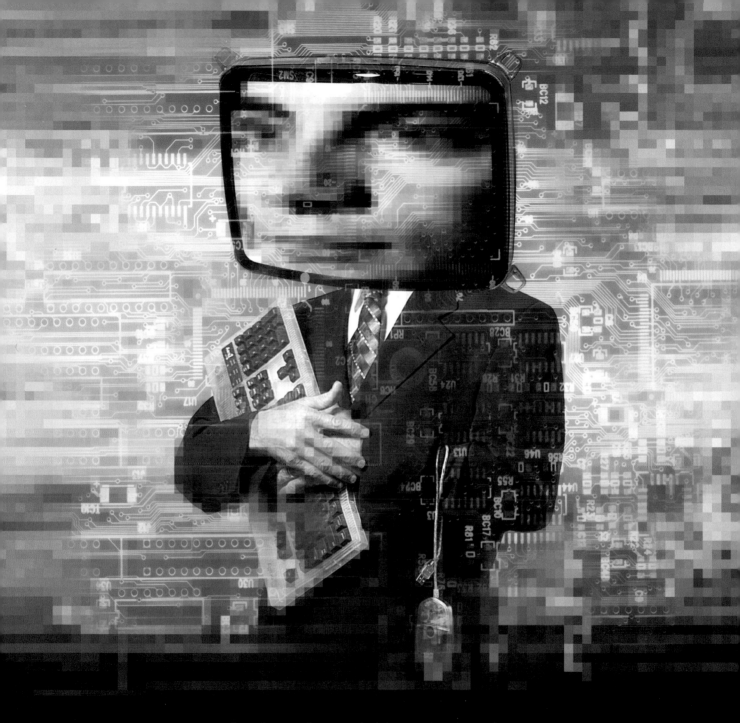

Every image tells a story. And the story here is one that
many of us can relate to. Technology is so much a part of
our lives that it impossible to imagine that we are not being
altered as a result. This figure represents the absolute limit
of our immersion in technology.

NIGHTMARE SCENARIO

Sometimes our dreams can be scary things. Most of the time all is well, but occasionally we awake from a slumber filled with horrifying images and beings. In this particular instance we'll start off with a regular portrait shot of a teenage boy. But because this is our own personal nightmare, we'll replace his eyes with two mouths, each in a different state of openness. As all three mouths scream, what was once a pair of ordinary ears morph into a second pair of hands extending outwards, grasping at the air.

Dreams of this sort often have a murky atmosphere about them. In this case, we'll use an image of a painted, rusted, metal box, spread over a series of layers to create an unhealthy ether in front of our mind's creation. All in all, we've got the makings of a terrifying dream image, one that makes us breathe a sigh of relief knowing that it is the product of Elements and not our own subconscious.

1 Open up the portrait shot. This will provide the background layer for our working file. Open up the first mouth image and use the Lasso tool to draw a rough selection around the mouth. It's a good idea to soften the edges of this selection before dragging it into the working file.

2 Choose *Select > Feather* from the menu and enter a value of 10 pixels. This should be sufficient for now. If we find we need a softer edge, we can always use the Eraser later on. Ctrl/Cmd+click inside the selection border to drag the mouth into your working file as a new layer.

3 Select the Move tool and ensure that the Show Bounding Box option is enabled in the Options Bar. Hold down the Shift key and drag one of the corner points in slightly to reduce the size a little. Click and drag in the center of the bounding box to position the mouth layer over his eye.

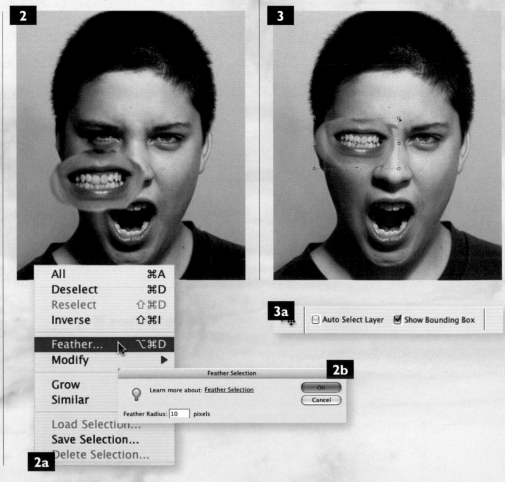

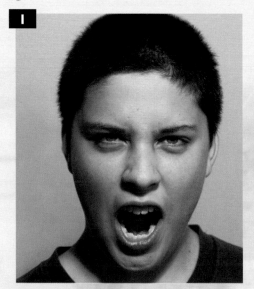

4 Select the Eraser tool with a soft, round brush tip preset. Adjust the size of the brush so that it is approximately 150 pixels wide. Reduce the opacity to 50%. Use the Eraser to remove areas from the layer that aren't required. The 50% opacity setting provides a nice blending effect, but to remove areas entirely you must brush over them twice.

5 Open up the second mouth image. Again, use the Lasso tool to draw a rough selection around the mouth area in the image. Feather the selection by 10 pixels, just like you did with the other mouth, and Ctrl/Cmd+drag the mouth into the working file as a new layer.

6 Holding the Ctrl/Cmd key again, drag the mouth over his other eye. Choose the Eraser tool once more. Leave the tool options set as they were and again, remove all areas of the layer that aren't needed. Create a new layer in the Layers palette.

TIP

Area zooming
In addition to continuously clicking on the canvas with the Zoom tool or using the keyboard shortcuts for zooming, there is another method that will allow you to zoom in closely on areas you define. Simply click and drag with the Zoom tool to create a rectangular marquee. When you release the mouse, Elements will automatically zoom into the area you've defined.

NIGHTMARE SCENARIO

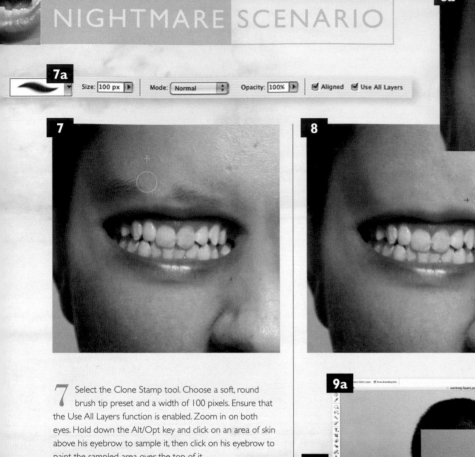

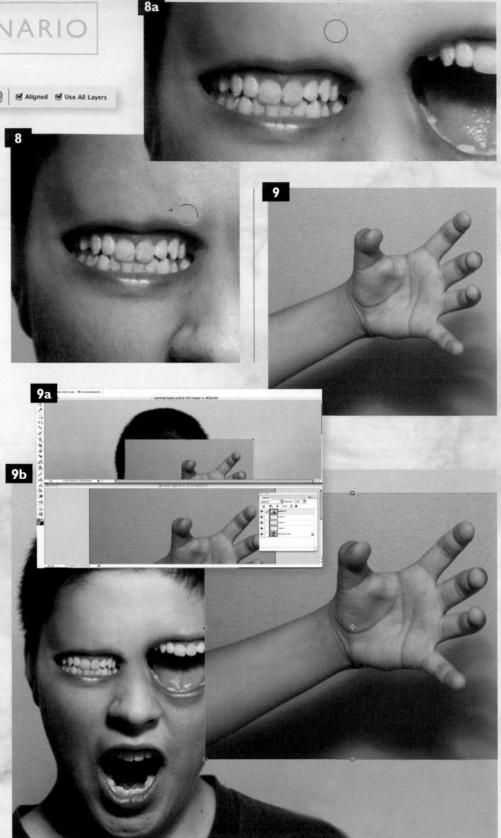

7 Select the Clone Stamp tool. Choose a soft, round brush tip preset and a width of 100 pixels. Ensure that the Use All Layers function is enabled. Zoom in on both eyes. Hold down the Alt/Opt key and click on an area of skin above his eyebrow to sample it, then click on his eyebrow to paint the sampled area over the top of it.

8 Use this method to cover his entire eyebrow, sampling from a variety of different places. Switch to a lower opacity setting and use the Clone Stamp to sample and paint over areas where the transitions appear too rough. Take your time and clone around the other eye too where required.

9 Open the first hand image and click on the Automatically Tile Windows button in the upper right of the screen so that you can see both open files at once. Select the Move tool and drag the hand into the working file as a new layer. Move the hand layer to the right so that part of the arm overlaps his face.

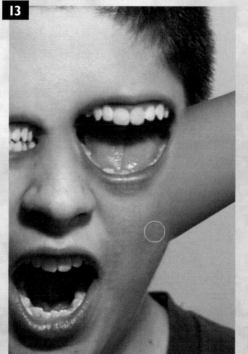

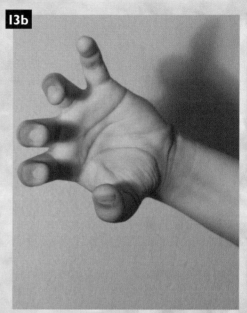

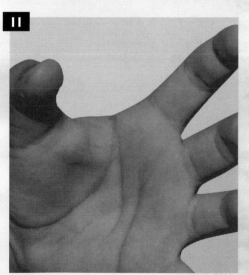

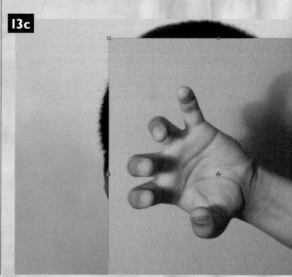

10 Choose the Selection Brush tool and set the Mode to Mask. Choose a hard, round brush tip preset, with a brush size of 100 pixels. Zoom in on the arm and use this brush to paint over it.

11 Take your time and carefully paint over the entire hand and arm. It will be almost impossible not to stray here and there. In this case, hold down Alt/Opt and paint over unwanted areas and bumps to remove them. Use this method to smooth out all of the edges of the mask. Increase and decrease brush tip size as required.

12 When you are satisfied that you have created an accurate and smooth mask, switch to Selection mode in the Options Bar to convert the mask to a selection. Type Ctrl/Cmd+shift+I on the keyboard to invert the selection. Press the Backspace key to remove all areas on this layer that aren't either hand or arm. Deactivate the selection.

13 Select the Eraser tool and leave the tool options as they were. Use the Eraser to remove the area of the arm where it overlaps his face, blending the two layers together. Open up the second hand image. As with the previous arm, drag it into the working file as a new layer using the Move tool.

NIGHTMARE SCENARIO

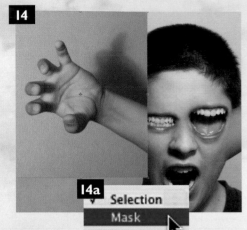

14

14a
Selection
Mask

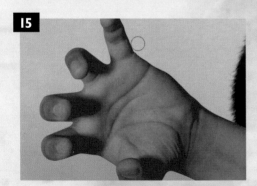

14b

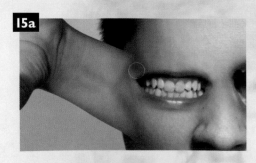

15

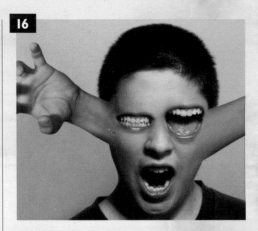

16

16a

Layers More ▶
Normal Opacity: 100%
Lock:
Layer 6
Layer 5
Layer 4
Layer 3
Layer 2
Layer 1
Background

17

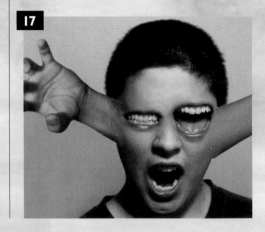

17a

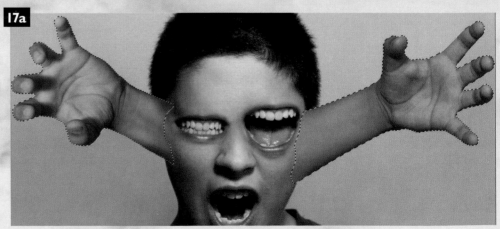

14 Use the Move tool to position this layer to the left so that the arm overlaps his head. Choose the Selection Brush tool and switch the Mode to Mask, leave the rest of the tool options as they were. Use the Selection Brush to begin painting over the arm.

15 Use the same method of carefully painting and Alt/Opt+click erasing, until you've created a smooth mask that covers the hand perfectly. Switch to Selection mode and then invert the selection just like you did with the other hand. Delete the contents of the inverted selection, then use the Eraser to remove areas that overlap his face.

16 Create a new layer in the Layers palette and select the Clone Stamp. Using the Clone Stamp, begin cloning on the new layer over the areas of the face where the arms meet the head. Sample from nearby areas often for a convincing effect.

17 Hold down the Ctrl/Cmd key and click on the current layer's thumbnail in the Layers palette to generate a selection from its content. Then holding down the Ctrl/Cmd and Shift keys, click the two hand layer thumbnails to add selections generated from the contents of these two layers to the current selection.

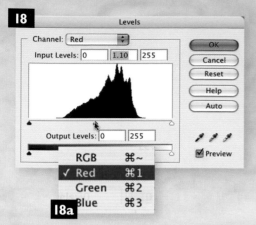

18

Levels

Channel: Red

Input Levels: 0 1.10 255

OK
Cancel
Reset
Help
Auto

Output Levels: 0 255

Preview

18a
RGB ⌘~
✓ Red ⌘1
Green ⌘2
Blue ⌘3

20 Radial Blur

Amount 25 OK
Cancel

Blur Method:
○ Spin
● Zoom

Blur Center

Quality:
○ Draft
● Good
○ Best

TIP

Blur quality
In most instances the Good setting is adequate when it comes to blur quality. However, if it's a pristine result you're after, choose the Best setting. Although it takes longer, the result is smoother. Draft mode is the quickest, but you can expect a noisy result. Draft mode is good for trying something quickly that you intend to undo later, but that's about it.

19
Layers More ▶
Normal Opacity: 100%
Lock:
👁 Background copy
👁 Background

19a ast Filter ⌘F
Filter Gallery...

Adjustments ▶
Artistic ▶ Average
Blur ▶ Blur
Brush Strokes ▶ Blur More
Distort ▶ Gaussian Blur...
Noise ▶ Motion Blur...
Radial Blur...
Smart Blur...

20a
Layers More ▶
Normal Opacity: 87%
Background copy
Background

20b

20c
Size: 600 px Mode: Brush Opacity: 50%

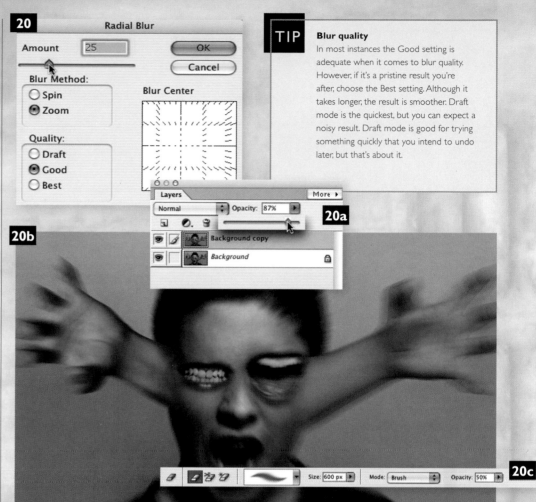

21

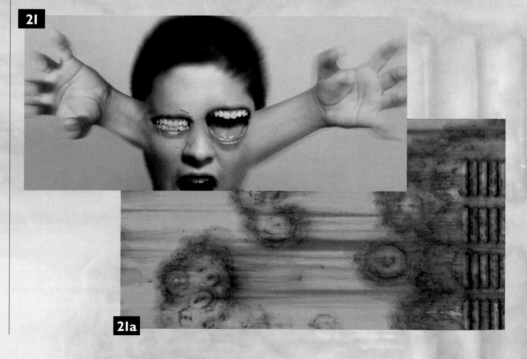

21a

18 With this selection active, create a new Levels adjustment layer in the Layers palette. For the composite channel, drag the two end sliders of the Input Levels toward the center, increasing the overall contrast in the selected area. Next, select the red channel from the channel pull-down menu. Drag the central Input Level slider to the left to make the midtones more red.

19 When you've adjusted the levels, flatten the image via the appropriate command in the Layers palette menu or using the Layer menu. Once the image is flattened, duplicate the background layer. With the duplicate layer selected, choose *Filter > Blur > Radial Blur* from the menu.

20 Select Zoom as the Blur Method and set the Quality to Good. Click and drag on the Blur Center and move it a little to the left. Set the Amount to 25 and click OK. Once the blur is applied, reduce the opacity of the layer to 87% and then select the Eraser tool. Leave the tool options as they were, except choose a massive brush size of 600 pixels.

21 Use the Eraser to remove areas of face and hand detail from the radial blur layer, revealing these sharp features and elements from the underlying layer. The last element we need is the rusted metal texture. Open the image and drag it into the working file. Drag the corner points of its bounding box outward until it covers the entire image.

NIGHTMARE SCENARIO

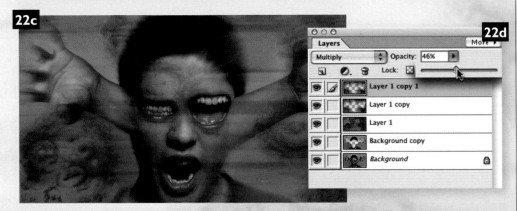

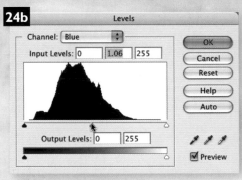

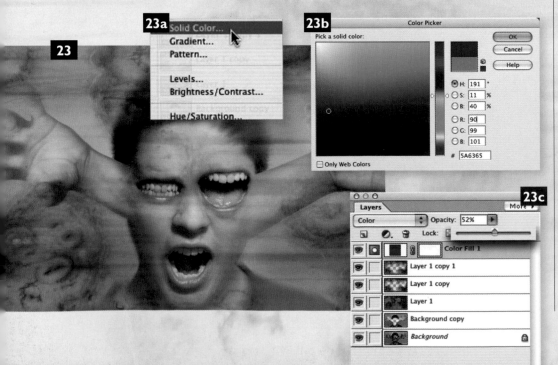

22 Change the blending mode of the layer to Soft Light. Duplicate this layer and then change the blending mode to Normal. Use the Eraser with the current settings, and remove areas from this layer where it overlaps the head and arms. Duplicate the layer and change the blending mode to Multiply, then reduce the opacity to 46%.

23 Create a new Solid Color adjustment layer in the Layers palette. Select a cool, dark gray color from the picker. Change the blending mode to Color and reduce the opacity of the layer to 52%. This gives the image a cooler color cast overall, but it still lacks contrast.

24 Create a new Levels adjustment layer, then increase the contrast in all channels and darken the midtones. Next, move to the red channel and drag the middle slider a little to the right. Finally, move to the blue channel and drag the middle slider a little to the left and press OK.

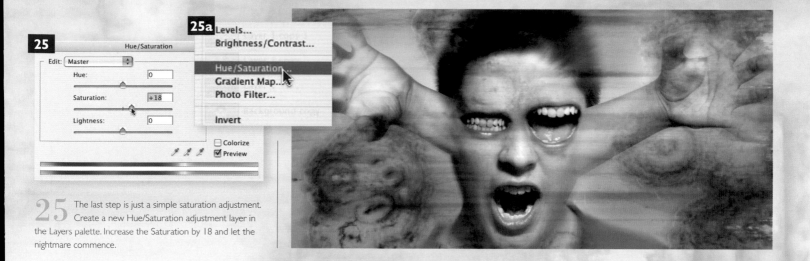

25 The last step is just a simple saturation adjustment. Create a new Hue/Saturation adjustment layer in the Layers palette. Increase the Saturation by 18 and let the nightmare commence.

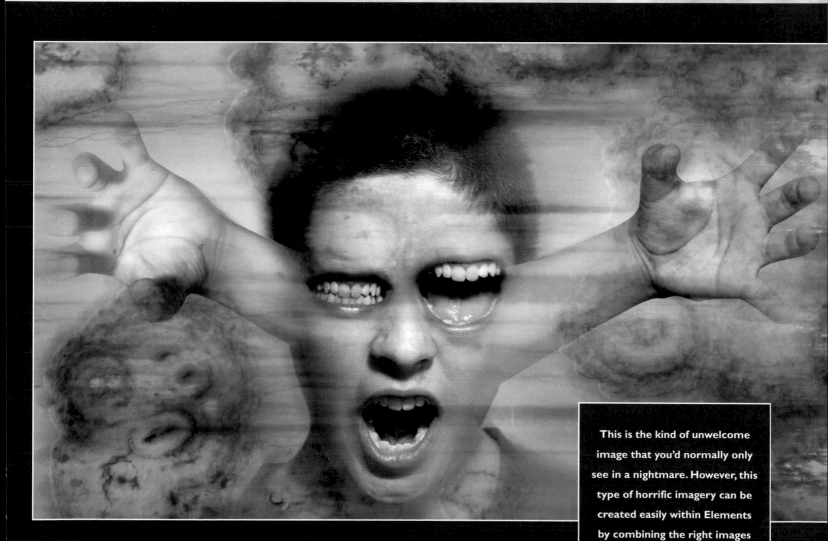

This is the kind of unwelcome image that you'd normally only see in a nightmare. However, this type of horrific imagery can be created easily within Elements by combining the right images

THE UNDEAD

Two steps behind famous monsters such as werewolves, Frankenstein, and Dracula, you'll find a slower, more lumbering beast. Quietly moaning to itself as it shuffles along, this is the zombie. He may not be swift, but his power lies in his relentless pursuit. No matter how far you run, he'll keep following. Oh, and did we mention that he wants to eat your brain?

Taking "brains" as the cue, our model moaned the word out loud while posing to get just the right facial expression. However, facial expressions aren't all that's required when creating zombies. You'll also need to reshape the head a little and blend some skull photos into the portrait shot. Add some blood, veins, and a creepy background and you're set. So if you think you'd like to try your hand at raising the dead, this project is for you. You have been warned.

1 Open up your portrait file. Our image is a little underexposed, but that's okay as we'll be drastically changing it anyway. The first thing we'll need to generate is a selection from the background. Select the Magic Wand tool, enable the Contiguous option, and set the Tolerance to 15.

2 Click on the upper left in the background area to generate a selection. Because this only partially selects the background, you'll need to hold down the Shift key while clicking on the remaining unselected areas to add them to your selection.

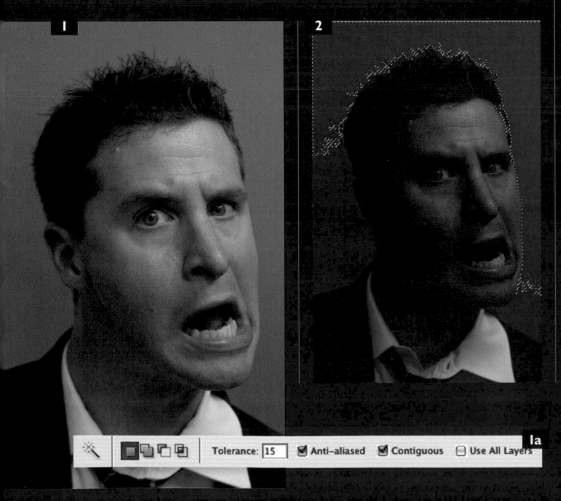

| 3 | | Size: 73 px ▶ | Mode: Selection ⬥ | Hardness: 100% ▶ |

3a

6

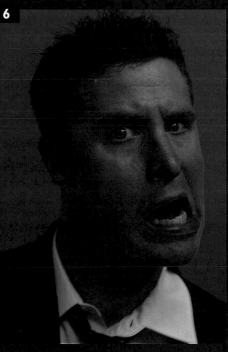

7

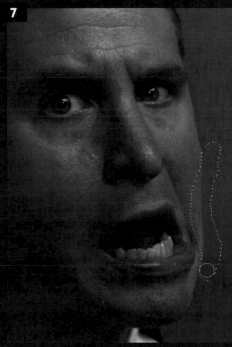

5 Save Selection

5a

Selection
Selection: New
Name: background

Operation
◉ New Selection
○ Add to Selection
○ Subtract from Selec
○ Intersect with Selec

Solid Color...
Gradient...
Pattern...

Levels...
Brightness/Contrast...

Hue/Saturation...
Gradient Map...
Photo Filter...

Invert
Threshold...
Posterize...

6a Photo Filter

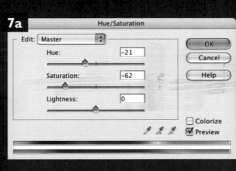

Learn more about: Photo Filter

Use
◉ Filter: Cooling Filter (82)
○ Color:

Density: 38

☑ Preserve Luminosity

Solid Color...
Gradient...
Pattern...

Levels...
Brightness/Contrast...

Hue/Saturation...
Gradient Map...
Photo Filter...

Invert
Threshold...
Posterize...

6b

7a Hue/Saturation

Edit: Master

Hue: -21
Saturation: -62
Lightness: 0

☐ Colorize
☑ Preview

TIP | **The Selection Brush and the Shift key**
When you use the Selection Brush to create a selection, each brush stroke automatically adds to the selection so you don't need to keep holding down the Shift key like with other selection tools. With the Selection Brush, the Shift key creates a straight-line stroke, or allows you join two points with a straight-line stroke.

3 Certain areas of the selection will not be perfect, so choose the Selection Brush tool. Use a hard, round brush tip preset and leave the Mode set to Selection. Hold down the Alt/Opt key and paint over any areas that stray from the background to remove them from the selection.

4 Any areas that remain unselected in the background can be added by painting over them with the Selection Brush, but be certain to release the Alt/Opt key first. When you are happy with your selection choose *Select* > *Save Selection* from the menu.

5 Name your selection and click OK. Once you've saved the selection, press Ctrl/Cmd+D to deactivate it. Worry not, we can reload it later because it is saved. Because he's dead, we'll need to give him a ghastly pallor. Create a new Photo Filter adjustment layer in the Layers palette.

6 Choose the Cooling Filter (82) option from the pull-down menu. Set the Density to 38% and be certain the Preserve Luminosity option is enabled. He's turning blue, but still needs a little work. Create a new Hue/Saturation adjustment layer in the Layers palette.

7 Adjust the Hue to -21 and reduce the Saturation by 62. Now that his complexion is suitably lifeless, we need to make him a little less meaty. Choosing the selection brush, leave the tool options set as they were previously and paint over the area of his cheek that needs removing.

8 — Save Selection dialog

Selection: background

Name:

Operation:
- ○ Replace Selection
- ● Add to Selection
- ○ Subtract from Select
- ○ Intersect with Select

OK / Cancel

Menu (8a):
- All — ⌘A
- Deselect — ⌘D
- Reselect — ⇧⌘D
- Inverse — ⇧⌘I
- Feather... — ⌥⌘D
- Modify — ▸
- Grow
- Similar
- Load Selection...
- Save Selection...
- Delete Selection...

9 — Load Selection dialog

Source
Selection: background
☐ Invert

Operation:
- ● New Selection
- ○ Add to Selection
- ○ Subtract from Selection
- ○ Intersect with Selection

OK / Cancel

8 Again, choose *Select* > **Save Selection** from the menu. In the Save Selection dialog box, choose your previously saved selection from the pull-down menu. In the Operation section, choose the Add to Selection option. Choose *Select* > **Load Selection** from the menu.

9 Choose your previously saved selection and the New Selection Operation and then click OK. This will load your saved selection. With this selection active, open up a suitable background image. We're using a creepy crypt. Select all and copy the image.

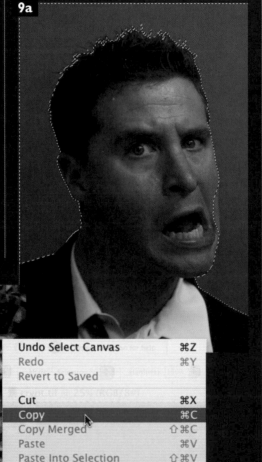

9a

9b

Menu (9c):
- Undo Select Canvas — ⌘Z
- Redo — ⌘Y
- Revert to Saved
- Cut — ⌘X
- Copy — ⌘C
- Copy Merged — ⇧⌘C
- Paste — ⌘V
- Paste Into Selection — ⇧⌘V
- Delete

10

Menu (10a):
- Undo New Layer — ⌘Z
- Redo Paste Into — ⌘Y
- Revert to Saved
- Cut — ⌘X
- Copy — ⌘C
- Copy Merged — ⇧⌘C
- Paste — ⌘V
- Paste Into Selection — ⇧⌘V
- Delete
- Fill Selection...
- Stroke (Outline) Selection...

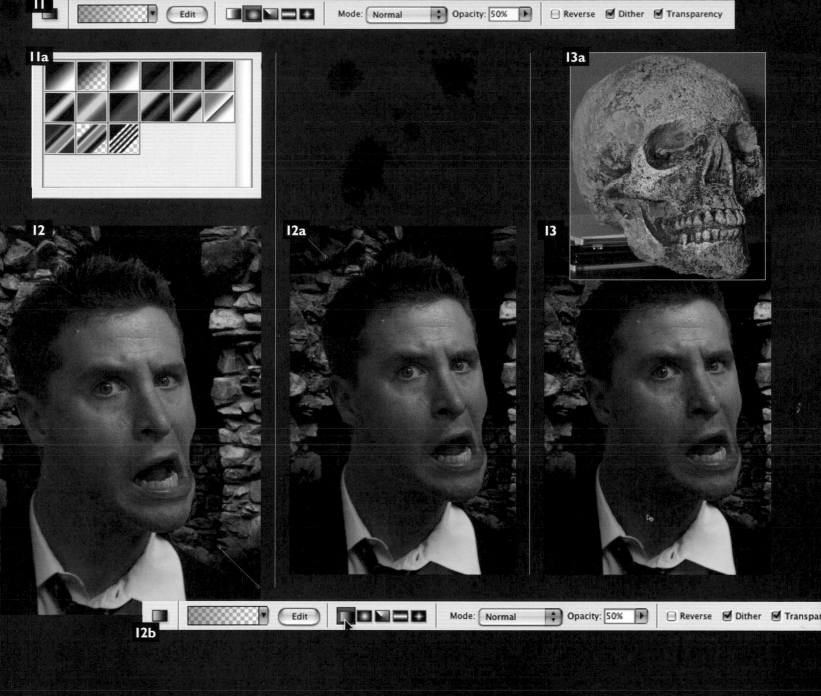

11

11a

13a

12 **12a** **13**

12b

Mode: Normal Opacity: 50% Reverse ☑ Dither ☑ Transparency

Mode: Normal Opacity: 50% Reverse ☑ Dither ☑ Transpar

10 Return to your working file and create a new layer. With this layer selected and the current selection active, choose *Edit > Paste Into Selection* from the menu. Press Ctrl/Cmd+D to deactivate the selection border after pasting.

11 Press "D" on the keyboard to reset the foreground and background colors to their default settings of black and white. Select the Gradient tool and in the Options Bar, choose the Radial Gradient method. From the gradient picker, choose the Foreground to Transparent preset.

12 With the opacity set to 50%, click and drag on the new layer, creating gradients in the areas where his shoulders meet the background. Create some more, extending from the top corners inward, darkening the corners. Now choose the Linear option in the Options Bar.

13 Click and drag from the top of the image down to his hairline, creating a dark gradient that helps blend the hair into the image. Next, we'll use an image of a skull to add some bone-like texture to his face and teeth..

TIP

Why Foreground to Transparent?

The Foreground to Transparent option is ideal when you wish to introduce a series of gradients into a single layer. If you used a different option, such as Foreground to Background, the entire layer would be filled completely each time.

16

Size: 300 px Mode: Brush Opacity: 50%

14

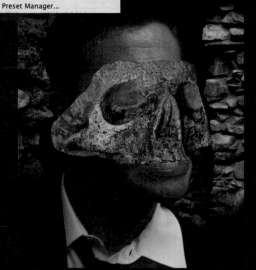

14a

~~do Delete Layer~~
~~Redo~~
Revert to Saved

Cut
Copy
~~Copy Merged~~
~~Paste~~
~~Paste Into Selection~~
Delete

Fill Selection...
Stroke (Outline) Selection...

Define Brush from Selection...
~~Define Pattern from Selection...~~

Clear ▶

Preset Manager...

15a

Layers More ▶

Normal Opacity: 62%

👁 🖊 Layer 3

👁 Layer 2

👁 Layer 1

👁 Hue/Saturation 1

👁 Photo Filter 1

👁 *Background* 🔒

14b **15**

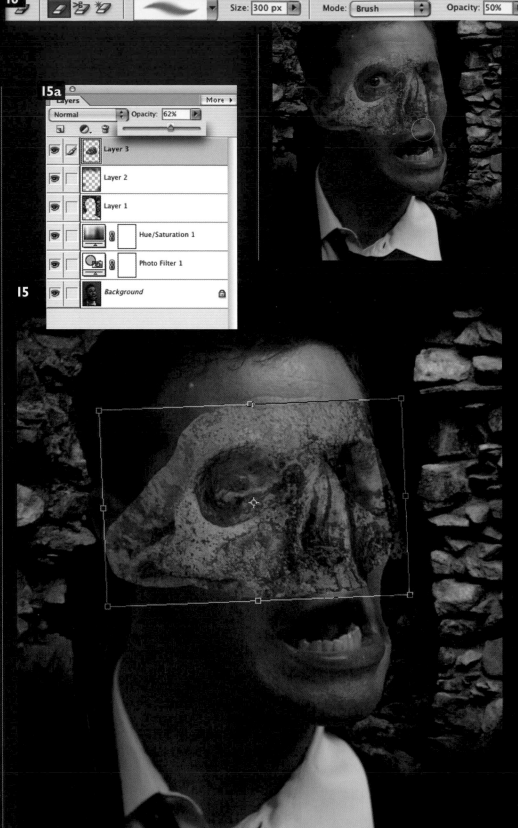

14 Select the Lasso tool and use it to draw a rough, closed selection around the eyes and nose area of the skull. With the selection active, copy the content via the Edit menu and then return to the working file. Paste it into the working file as a new layer.

15 Reduce the opacity of the skull layer so that you can see the face underneath. Select the Move tool. Shift+drag a corner inward to reduce the size proportionately and rotate it a little. Position the skull's right eye over the face's right eye.

16 Select the Eraser tool and with a large, soft round brush tip set the opacity to 50%. Use the Eraser to begin removing the hard edges and expose the hidden eye.

17

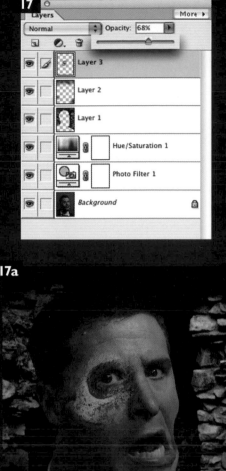

18

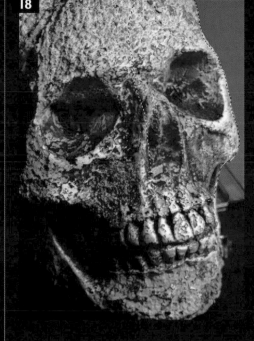

17a

17b

17 Increase the layer opacity a little, then use the Eraser to remove the nose and other eye socket while blending it into the underlying layers. Duplicate the layer, change the blending mode to Soft Light, and reduce the opacity to 33%.

18 We'll use another image of the same skull to cover the other eye. Open the file and Lasso a rough selection around the eye socket. Copy it and paste it into the working file as a new layer. Again, reduce the opacity of the layer, then move it into position over the eye. Blend it in with the Eraser and return the layer to full opacity.

19 Use this method a couple more times to bring sections of teeth in from the skull images as a series of layers. It is the exact same process, the only difference being that you'll need to use a smaller brush tip for the eraser when erasing around the teeth.

20 Create a new layer and select the Clone Stamp tool. Choose a small, soft round brush tip of around 30 pixels. Enable the use all layers function. Use the Clone Stamp to repair unconvincing areas around the teeth and lips, vary the brush size as needed.

18a

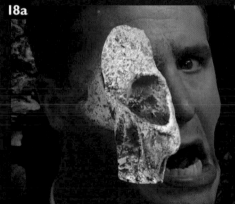

18b

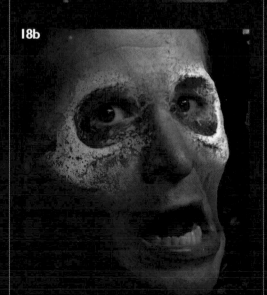

19

20

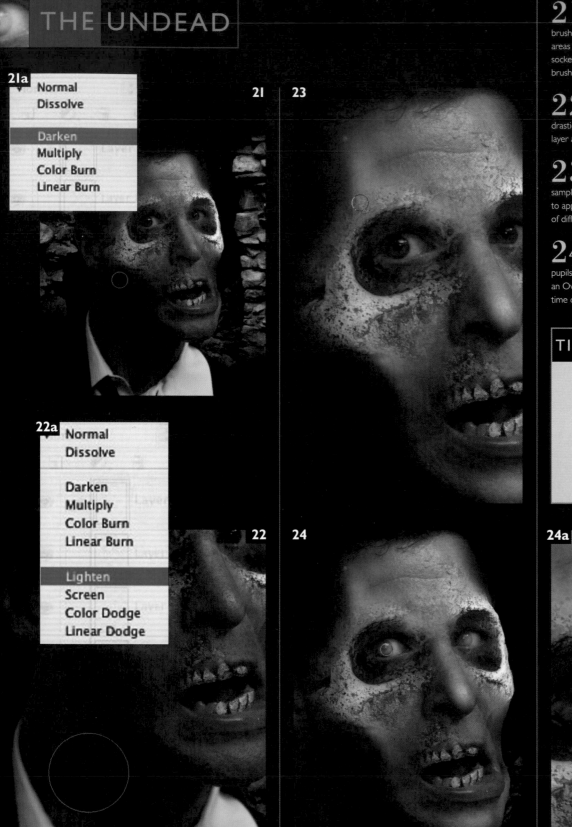

21a

Normal
Dissolve

Darken
Multiply
Color Burn
Linear Burn

21

23

22a

Normal
Dissolve

Darken
Multiply
Color Burn
Linear Burn

Lighten
Screen
Color Dodge
Linear Dodge

22

24

24a

21 Create a new layer and change the blending mode to Darken. Select the Brush tool. Choose a soft brush tip and a very low opacity setting to paint over any areas that should appear sunken, such as the cheeks and eye sockets. Sample colors from within the face and vary the brush size as needed.

22 Use the Eraser with a low opacity setting and a soft brush tip to remove any areas that appear too drastic, blending them into the other layers. Create a new layer and this time change the blending mode to Lighten.

23 Select the Brush tool again. Use the same low opacity setting and variable tip sizes to gently sample areas of light color and paint over areas that you want to appear raised. Take your time and sample from a number of different areas.

24 Now zoom in on his eyes. Paint over his eyes with a very light color. Paint over the irises and the pupils, to achieve a cataract-like look. Create a new layer with an Overlay blending mode and paint over his eyes one more time on the new layer.

TIP

Lighten and Darken modes
These two blending modes allow you to paint with a somewhat carefree attitude. When you are painting on a layer with a Lighten blending mode, only colors lighter than the base color will be visible, so if you accidentally paint over a highlight with a dark color, it won't appear. Darken is the exact opposite, preventing you from accidentally lightening any shadows.

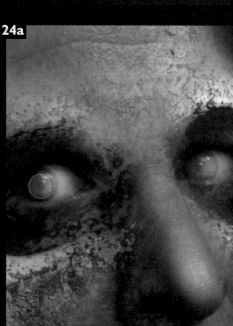

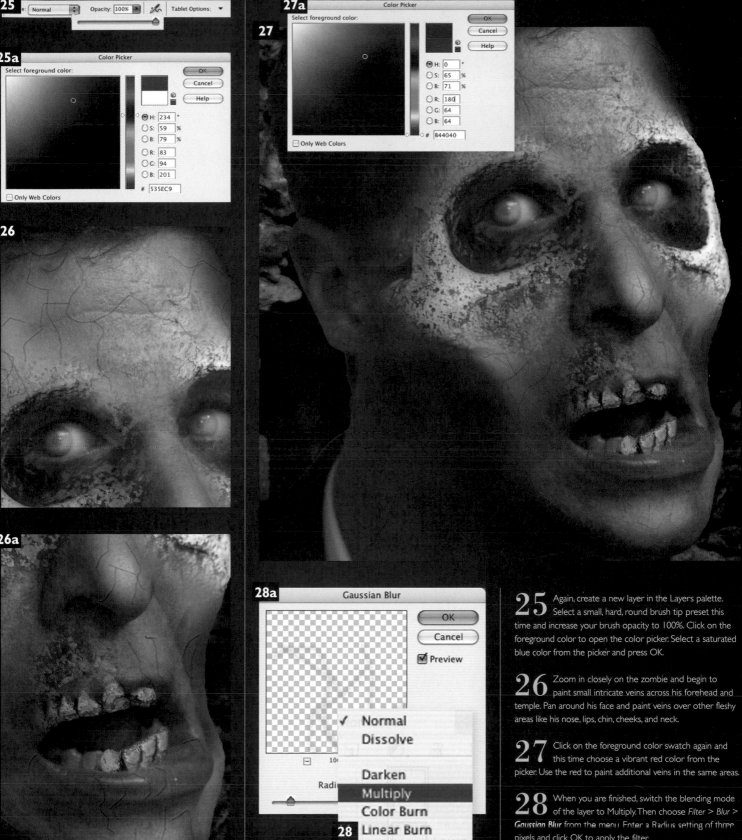

25 Again, create a new layer in the Layers palette. Select a small, hard, round brush tip preset this time and increase your brush opacity to 100%. Click on the foreground color to open the color picker. Select a saturated blue color from the picker and press OK.

26 Zoom in closely on the zombie and begin to paint small intricate veins across his forehead and temple. Pan around his face and paint veins over other fleshy areas like his nose, lips, chin, cheeks, and neck.

27 Click on the foreground color swatch again and this time choose a vibrant red color from the picker. Use the red to paint additional veins in the same areas.

28 When you are finished, switch the blending mode of the layer to Multiply. Then choose *Filter* > *Blur* > *Gaussian Blur* from the menu. Enter a Radius setting of three pixels and click OK to apply the filter.

THE UNDEAD

29a

Size: 100 px Mode: Brush Opacity: 25%

29

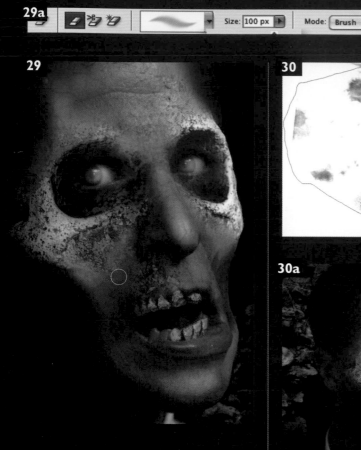

30

31a

30a

31

30b

32

29 The veins will be a little overwhelming, so first reduce the opacity of the layer to around 70%. Select the Eraser tool, and reduce its opacity to 25% and select a soft, round brush tip preset. Remove any areas in which the veins appear too strong.

30 We're using two images of spattered paint to represent blood. Open up the first blood image and use the Lasso tool to select some of the droplets. Copy them and then paste them into the working file as a new layer. Change the blending mode of the layer to Multiply and then use the Move tool to position the blood over his collar.

31 Use the Eraser to soften or remove any areas that are too sharp or out of place. Open up the second blood image and again, use the Lasso to select some spattered red paint and copy it over.

32 Paste the spattered paint into the file as a new layer and change the blending mode to Multiply. Use the Move tool to rotate and position it over his mouth. Use the Eraser to remove any unwanted areas. You can always add more spatters if you think he needs to be any bloodier and repeat the same process.

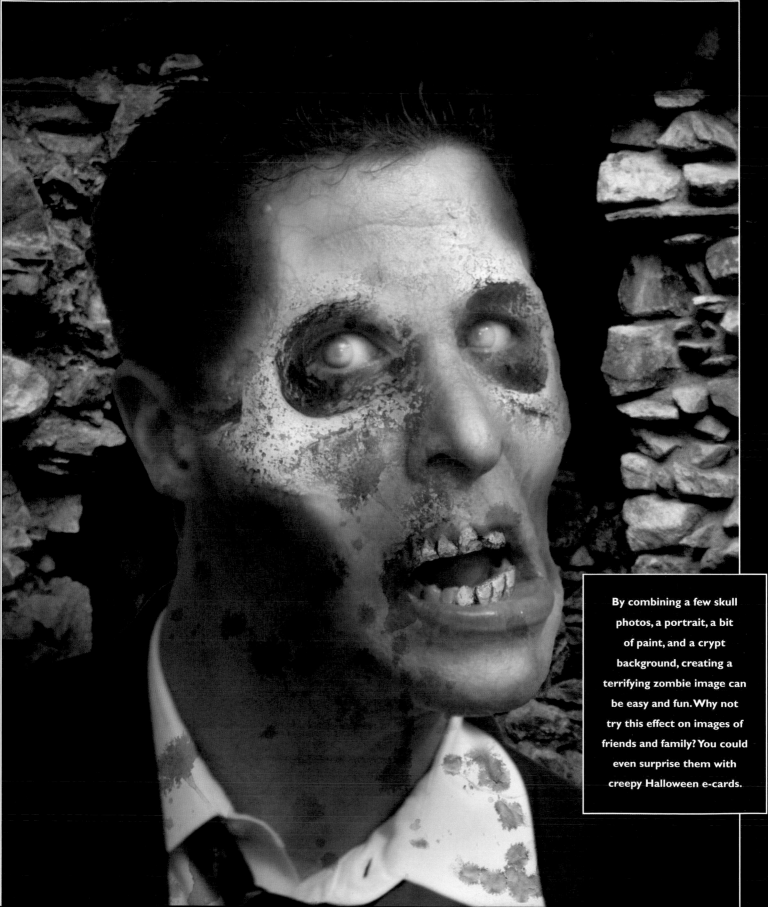

By combining a few skull
photos, a portrait, a bit
of paint, and a crypt
background, creating a
terrifying zombie image can
be easy and fun. Why not
try this effect on images of
friends and family? You could
even surprise them with
creepy Halloween e-cards.

ROBOT REVEALED!

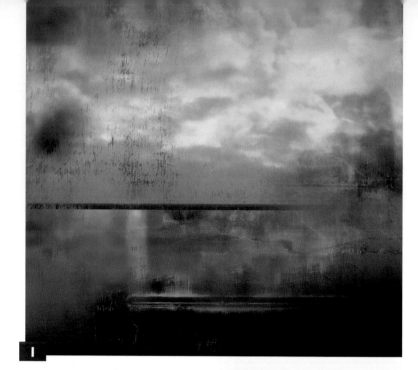

As science-fiction movies tell us over and over again, things really aren't what they seem, and we're certainly not alone. What strange creatures walk among us in the guise of humans? Well, in this case we aren't talking about aliens, that was a previous chapter. This time around, we've been infiltrated by robots, so similar to us that we only know their true form when they're unmasked, revealing the circuitry that makes them tick.

In this project, we'll showcase some illustrative techniques that demonstrate how to draw things that indicate three-dimensional objects, like face masks, and the holes they leave behind when they're removed. We will be skipping a few of the initial rudimentary set-up steps here, because we want to focus completely on the new techniques.

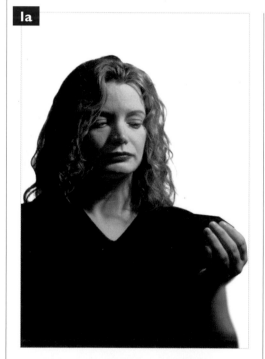

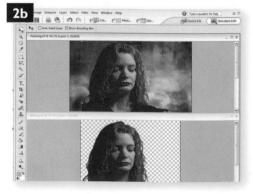

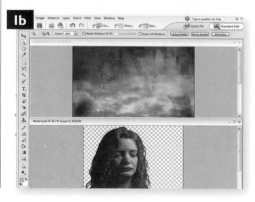

1 In preparation for this example, we've already created two files. The first is a murky montage that we'll use for the background, and the second is a shot of a woman holding her hand up in readiness that we have already cut out from its background. With both files open, click on the Automatically Tile Windows button so that you can see them both at the same time.

2 Select the Move tool and then drag the model into the background image. It will be added as a new layer. When you're finished, click on the Maximize Mode button to view only the selected file. Use the Move tool to position the layer in the lower left corner of the image.

3 Open up the file that you will use for the face mask, and use the same image tiling method and the Move tool to drag the face image into your working file as a new layer. Reduce the opacity of the layer so that you can see through it. Hold down the Shift key and drag a corner point of the bounding box inward to reduce the size of the face layer.

4 Position the face over the model's hand and then select the Eraser tool. Select a hard, round brush tip preset and an opacity setting of 100%. Zoom in on the face and carefully erase the area where her fingers overlap the image.

5 When you have erased this area, return the layer to full opacity. Use the Eraser to erase all the way around the face, under the jaw line, and then define the shape of the face mask. When you've done that, increase the brush size and erase the remaining areas outside the face.

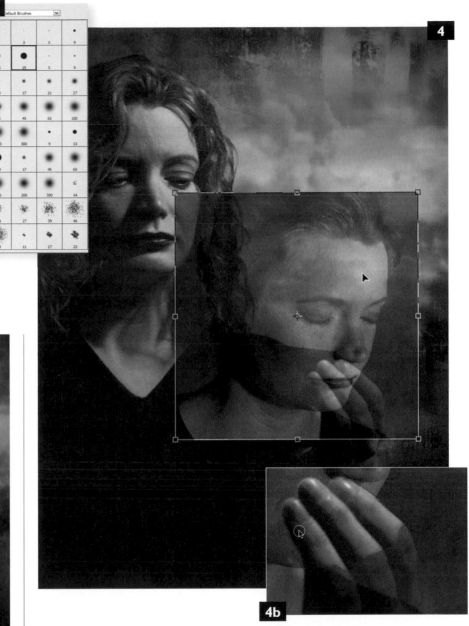

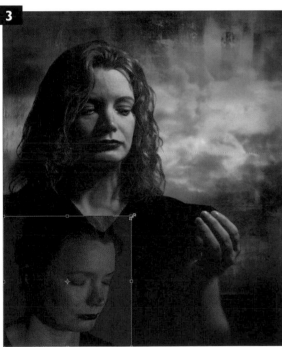

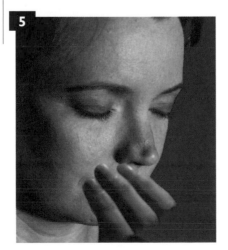

ROBOT REVEALED!

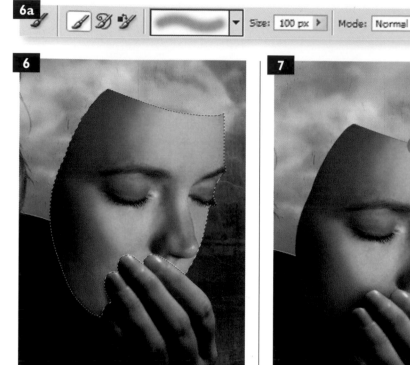

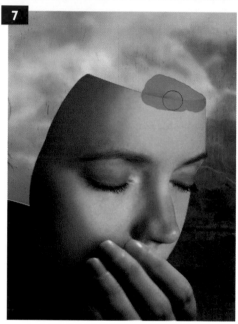

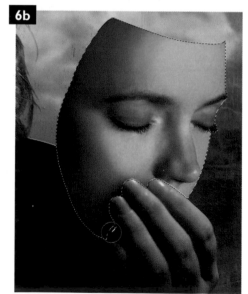

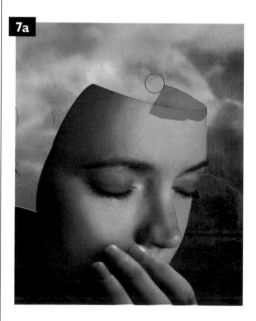

6 Ctrl/Cmd+click on the face mask layer thumbnail to generate a selection from it. Choose the Brush tool with a large, soft brush tip. Create a new layer set to the Multiply blending mode and then paint within the active selection to add subtle shadows under the fingers.

7 Deactivate the selection and then choose the Selection Brush tool. Set it to Mask mode in the Options Bar. Paint with a hard, round brush tip over the area where the back of the face mask would appear. Hold down the Alt/Opt key to erase the selection, creating a sharp corner.

8 Create a new layer and drag it beneath the face mask layer in the Layers palette. Select the Paint Bucket tool. This will change your existing mask into a selection. Invert the selection, *Select > **Inverse*** from the menu, then Alt/Opt+click on a dark area of skin on the face mask to sample the color.

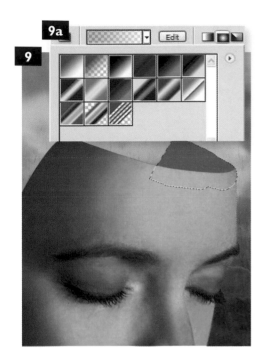

9 Click inside the selection on the new layer with the Paint Bucket to fill it with the skin color. Select the Gradient tool, choose the Radial option and the Foreground to Transparent preset. Set the opacity to 50%.

10 Alt/Opt+click on an area to sample a darker color, then click and drag within the selection to add a gradient that simulates dark shading. Deactivate the selection (Ctrl/Cmd+D) and then choose the Selection Brush tool again. Leave the tool options as they were, but reduce the size of the brush considerably.

11 Zoom in even closer to the top of the head and paint a stroke where the top edge of the mask should appear. Don't try to get it perfect yet, because it is nearly impossible. Next, hold down the Alt/Opt key and start to remove unwanted areas from the stroke by painting over them. Use this method of subtraction to produce a sharp stroke indicative of the top edge of the face mask.

12 When you are finished, select the Paint Bucket tool and then select the face mask layer in the Layers palette. Sample a light skin color and then fill the active selection with the Paint Bucket on the face mask layer. Deactivate the selection when finished.

13 Create a new layer in the Layers palette and drag it down so that it sits just above the layer containing the model. Select the Clone Stamp tool. Enable the Use All Layers option and select a small, soft round brush tip. With the opacity set to 100%, begin to sample skin from the model's forehead and cover any stray hairs and shadows in this area.

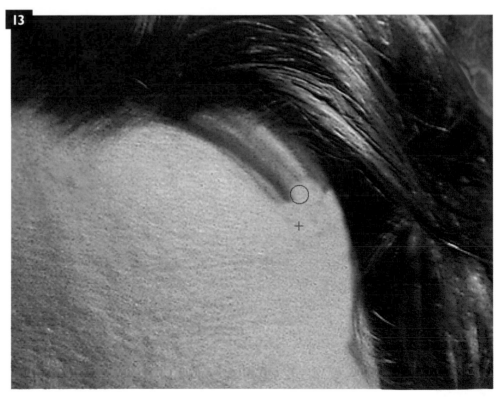

ROBOT REVEALED!

14

15

15a

16

16b

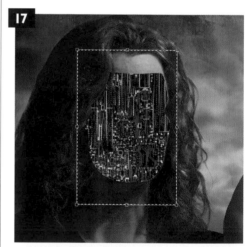

17

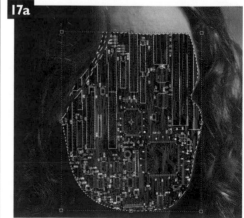

17a

14 Choose the Selection Brush tool again. Use the same tool options including Mask mode, but this time increase the size of the brush tip considerably. Paint a shape with the Selection Brush over the model's face, similar to that which would represent the hole created by the removal of the face mask.

15 As before, hold down the Alt/Opt key and paint over areas to remove them, refining curves and sharpening corners. When you get to the area where the model's hair overlaps her face, reduce the brush tip size and paint while holding down the Alt/Opt key. You may need to vary brush sizes as you go.

16 Choose the Move tool. This changes the mask to a selection. Invert it via the Select menu. Open up an image of computer circuitry. Select all and copy the image, then return to the working file and create a new layer. Choose *Edit > **Paste Into Selection*** from the menu.

17 Hold down Alt/Opt+Shift and drag a corner point inward to reduce the size of the pasted circuit board to fit the face. Press Enter to apply the transformation. Ctrl/Cmd+click on the circuit board layer's thumbnail to generate a selection from it, and then create another new layer on top of it in the Layers palette.

18 Set the layer blending mode to Multiply and then choose the Gradient tool. Leave it set to Radial and Foreground to Transparent. Create a series of gradients inside the selection with a 50% opacity setting to mimic shadows. Choose the Selection Brush when finished.

19 Because of the previous settings for this tool, the mask for your active selection instantly appears. Increase the brush size and then paint over all of the unmasked circuitry except for a strip on the right side

20 Select the Paint Bucket tool. This will convert the mask to a selection. Create a new layer in the Layers palette. Hold down Alt/Opt to sample a color from the model's skin and then fill the selection by clicking inside it with the Paint Bucket tool.

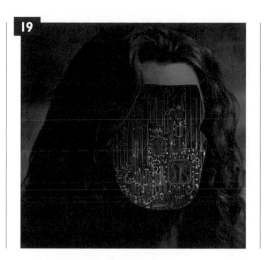

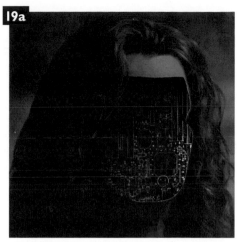

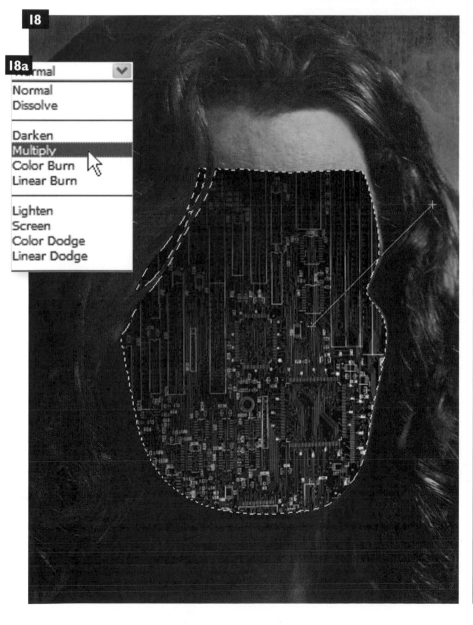

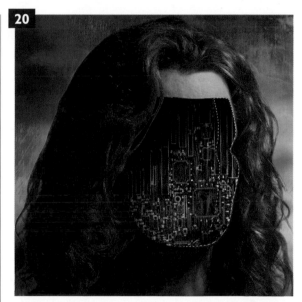

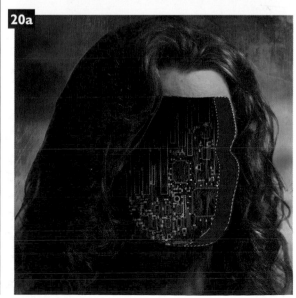

ROBOT REVEALED!

21 Press "D" to reset the foreground color to black and choose the Brush tool. Slowly paint within the selection to add shading to the shape, making it look like the inside wall of a recessed area. Brush over the frontal areas more than once for a darker shadow effect.

22 Press Ctrl/Cmd+D to deactivate the selection. We need to add a bit of thickness to the edge of the skin, just like we did at the top of the face mask, so choose the Selection Brush tool again and reduce the size of the brush tip.

23 Paint a stroke around the edge of the hole we created in her face. Again, refine it by subtracting areas via painting while holding down the Alt/Opt key. Select the Paint Bucket tool to convert the mask to a selection, then invert the selection.

24 Hold down the Alt/Opt key and sample a very light skin tone from the image. Create a new layer and use the Paint Bucket to fill the selection. Select the Gradient tool, leaving the tool options set as they were. Sample darker colors from the image and create gradients within the selection to add shading to the new edge area.

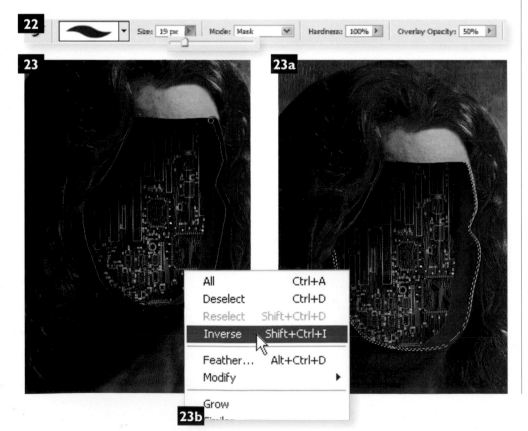

Yes, that's correct, she's a robot. A woman sits before you, places her hand under her chin, and pulls. And what happens? Her face comes off, revealing the circuitry beneath. But how did she get this way? Photoshop Elements played a part in this cybernetic conspiracy!

A FACE IN THE LEAVES

The image of the Green Man is both ancient and familiar. Carved in stone, it stares down at us from archways and cathedral pillars. Some speculate that this ancient symbol represents the spirit of the wilderness. Though, truth be told, its literal meaning remains unknown, probably forever.

Our plan is to serve up the Green Man with an androgynous twist that captures the viewer's attention. We'll blend a hand-made Green Man face mask with a portrait shot of a woman's face, going on to incorporate some scans of real fall leaves in an innovative manner. All this, set against a backdrop of an historic carving, combined with a tree-littered winter scene, creating a compelling mix of stone and wood.

1 We're using an image of a stone block wall as the basis of our background, however, we only need to use a section of this image. Select the Crop tool. In the Options Bar, enable a Width setting of 235mm, a Height setting of 267mm, and a Resolution of 300 pixels per inch.

2 Click and drag with the Crop tool to isolate a section of the image. When you're satisfied, click on the Commit current crop operation button in the Options Bar. This will crop the highlighted section.

3 Now we'll start to build a layered background texture. Open up an image of a stone carving. Select all (Ctrl/Cmd+A), and copy (Ctrl/Cmd+C). Return to the background file and paste it into the file as a new layer (Ctrl/Cmd+V). Press Ctrl/Cmd+T to add a free-transform bounding box around the layer content.

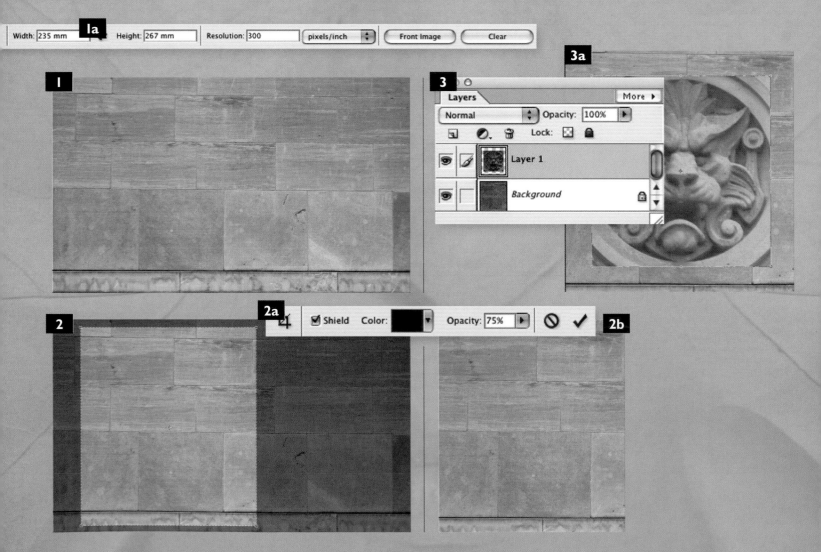

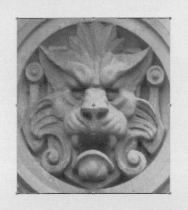

Hold down the Alt/Opt key and drag one of the corner points to a corner of the canvas area, increasing the size outward equally from the center. Press the Commit transform button in the Options Bar to apply the transformation. (Or press Enter on the keyboard.)

Change the layer blending mode to Luminosity and open up a woodland image for the background. Copy the entire image and paste it into the working file as a new layer. Press Ctrl/Cmd+T again and then drag one of the vertical center points out toward the edge of the canvas, scaling the image horizontally out from the center.

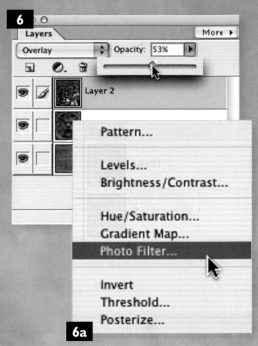

5
Normal
Dissolve

Darken
Multiply
Color Burn
Linear Burn

Lighten
Screen
Color Dodge
Linear Dodge

Overlay
Soft Light
Hard Light
Vivid Light
Linear Light
Pin Light
Hard Mix

Difference
Exclusion

Hue
Saturation
Color
Luminosity

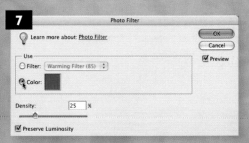

Change the layer blending mode to Overlay and then reduce the layer opacity to 53%. As soon as you change the blending mode of the layer, the transformation will be applied and the bounding box will disappear. Create a new Photo Filter adjustment layer via the pull-down menu in the Layers palette.

Select a color instead of the filter option. Click on the color swatch to launch the picker. Select a saturated green color and click OK. Reduce the Density to 13% and disable the Preserve Luminosity function. Now that we've built the background, its time to start thinking about creating the green man mask.

A FACE IN THE LEAVES

TIP

Brush preset quick access
When you are using a tool that uses brush tip presets, like the Eraser or Selection Brush, it is possible to change brush tip presets quickly on the fly. Simply Right/Ctrl+click on the canvas area while using the tool and the brush presets will appear in a temporary pop-up menu.

8
Tolerance: 40

8a
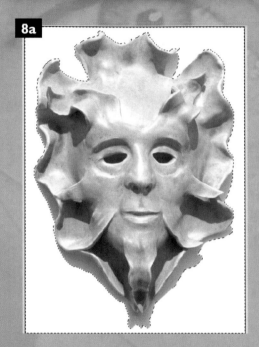

9
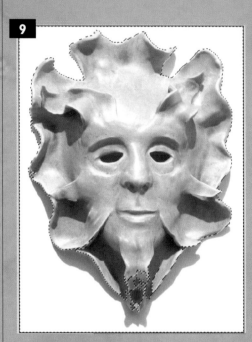

10a

8b
Tolerance: 25

9a

All	⌘A
Deselect	⌘D
Reselect	⇧⌘D
Inverse	⇧⌘I
Feather...	⌥⌘D
Modify	▶
Grow	
Similar	
Load Selection...	
Save Selection...	
Delete Selection...	

10

✓ Selection
✓ Mask

10b

10c

8 Open up the green mask image. Select the Magic Wand tool and set the Tolerance to 40. Ensure that the Contiguous option is enabled. Click on the white background to generate a selection with the Magic Wand. Once you've done this, reduce the Tolerance setting to 25.

9 Holding down the Shift key, begin clicking on any gray shadow areas cast on the image background by the green mask to add them to the active selection area. When you're finished, choose *Select > Inverse* from the menu. Don't be overly concerned with creating a flawless selection with the Magic Wand.

10 Choose the Selection Brush tool and set the Mode to Mask. The area outside your active selection will automatically be masked. Choose a hard round brush tip and then paint over areas that still need to be removed from the selection area. Hold down the Alt/Opt key and then paint over areas that need to be added to the selection.

11

11a

Selection
✓ Mask

12

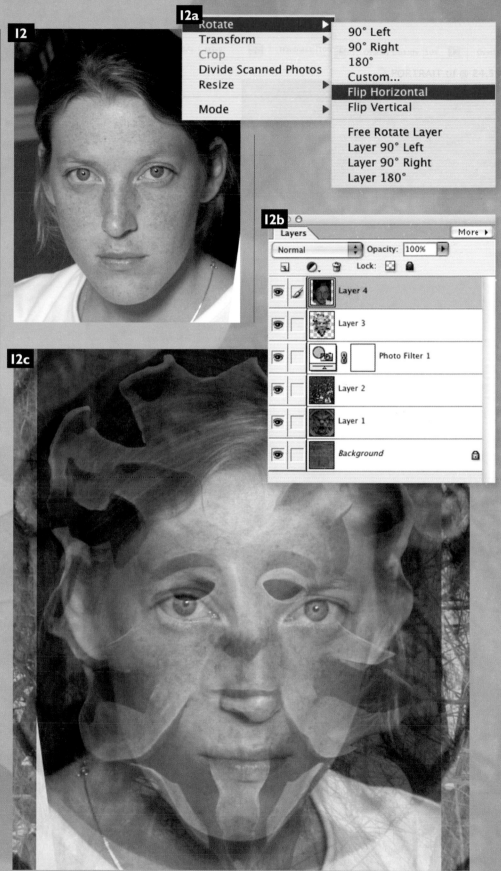

12a

Rotate	▶
Transform	▶
Crop	
Divide Scanned Photos	
Resize	▶
Mode	▶

90° Left
90° Right
180°
Custom...
Flip Horizontal
Flip Vertical
Free Rotate Layer
Layer 90° Left
Layer 90° Right
Layer 180°

12b

Layers — More ▶
Normal — Opacity: 100%
Lock:

- 👁 🖌 Layer 4
- 👁 Layer 3
- 👁 Photo Filter 1
- 👁 Layer 2
- 👁 Layer 1
- 👁 Background

11b

Layers — More ▶
Normal — Opacity: 100%
Lock:

- 👁 🖌 Layer 3
- 👁 Photo Filter 1
- 👁 Layer 2
- 👁 Layer 1

TIP

Selection pop-up menu
When you are using a selection tool like the Rectangular Marquee tool or the Lasso, Right/Ctrl+click on the canvas and a pop-up menu will appear. In addition to accessing a couple of layer functions, this allows you to select all or reselect a deactivated selection.

11 When you are finished, switch the Mode back to Selection to convert the masked area back to a selection. Copy the selected area and then paste it into the working file as a new layer. Use the Move tool to center it as best you can within the canvas area.

12 Open the face image that you are going to blend with the green mask. Flip the image if necessary so that it matches up with the mask a little better. Choose *Image > Rotate > Flip Horizontal* from the menu. When you're done, select all then copy, and paste the face into the working file as a new layer. Reduce the opacity of the layer so that you can see through it.

12c

A FACE IN THE LEAVES

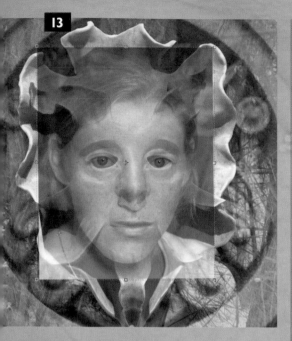

13 Select the Move tool, hold down the Shift key, and drag one of the corner points inward to reduce the size of the face proportionally. By clicking and dragging within the bounding box, position the face with the eyes perfectly overlapping the eyes of the green mask. Return the opacity of the layer to 100%.

14 Zoom in close on her face. If the image is a little soft, you can remedy this by choosing *Filter > Sharpen > Unsharp Mask* from the menu. We're going to go a little further than perhaps you would when sharpening a regular photo, mainly because we want her eyes to be quite sharp and we'll be erasing most of the rest of her face so any drastic over-sharpening will be removed.

15 Set the Amount to 104%, the Radius to 2.8 pixels, and the Threshold to 0 levels. Click OK to apply the filter and then choose the Eraser tool. Select a massive, soft, round, brush tip preset and set the opacity to 100%. Begin to erase the hard image edge and outside of her face.

st Filter	⌘F
Filter Gallery...	
Adjustments	▶
Artistic	▶
Blur	▶
Brush Strokes	▶
Distort	▶
Noise	▶
Pixelate	▶
Render	▶
Sharpen	▶
Sketch	
Stylize	
Texture	
Video	
Other	▶
Digimarc	▶

Sharpen
Sharpen Edges
Sharpen More
Unsharp Mask...

Layers More ▶
Normal Opacity: 100%
Lock:
Layer 4
Layer 3
Photo Filter 1
Layer 2
Layer 1
Background

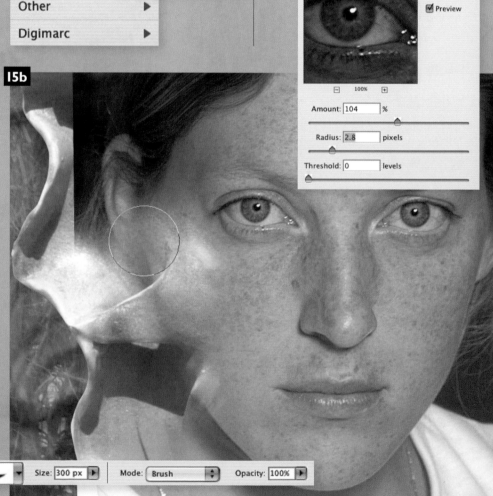

Unsharp Mask

OK
Cancel
☑ Preview

100%

Amount: 104 %
Radius: 2.8 pixels
Threshold: 0 levels

Size: 300 px Mode: Brush Opacity: 100%

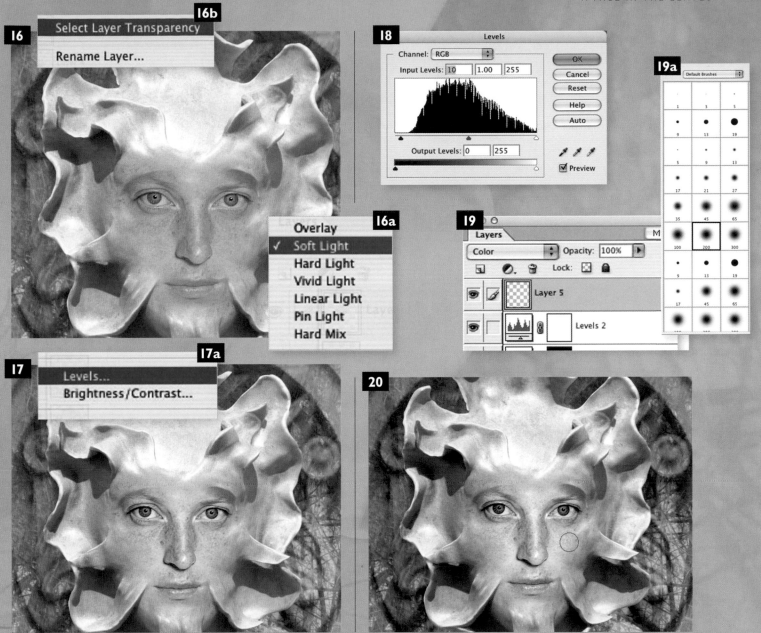

16 Continue to erase until all that remains is her facial features surrounded by a soft edge. Duplicate the layer and change the blending mode to Soft Light. Right/Ctrl+click on the layer thumbnail and then choose Select Layer Transparency from the resulting pop-up menu.

17 With the new selection active, create a new Levels adjustment layer in the Layers palette. Drag the left Input slider to the right and the right input slider even further to the left, darkening the shadows and lightening the highlights.

18 When the adjustment layer is created, the selection becomes deactivated after it is used to generate the adjustment layer's mask. With no selection active, and because we want to affect the entire image, create another new Levels adjustment layer. Simply darken the overall shadows a little.

19 Now the biggest problem is that the model's skin is a completely different color from that of the green mask. Create a new layer and change the layer blending mode to Color. Press "B" on the keyboard to access the Brush tool. Select a 200 pixel wide, soft, round brush tip preset and set the opacity to 50%.

20 Hold down Alt/Opt to temporarily access the Eyedropper and click on a green area within the mask to sample it as the current foreground color. Begin to paint over areas of the model's skin on the color layer, turning them green to match the mask. Feel free to sample different greens as you paint so the result doesn't appear too flat.

A FACE IN THE LEAVES

21

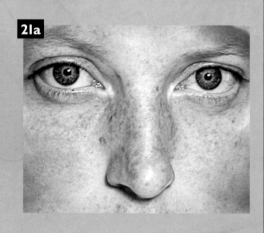

21a

22 Mode: Selection Hardness: 100%

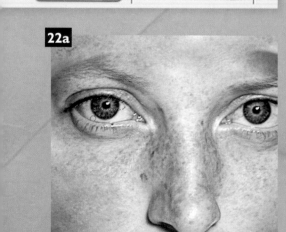

22a

21 Reduce the opacity of the brush to 25% when you paint over the model's lips so that they're slightly different from the rest of her skin. Return the brush opacity to 50% and reduce the size considerably. With the smaller brush tip, carefully paint around her eyes.

22 Choose the Selection Brush. Select a small, hard, round brush tip preset. Use Selection mode and a hardness setting of 100. Paint over her eye areas, including the irises. Feel free to use a smaller brush tip to paint hard to reach areas like her tear ducts.

23 Choose *Select > Feather* from the menu and feather the edge of the selection by one pixel, just so it isn't unnaturally sharp. With the selection active, create a new Brightness/Contrast adjustment layer. Increase the Brightness by 18 and the Contrast by 9.

24 Increase the size of the Selection Brush tip preset. Use it to paint over the iris and pupil areas of each eye. When you are finished, feather the selection by a single pixel, just like you did previously for the eye selection.

23
Feather Selection

💡 Learn more about: **Feather Selection**

Feather Radius: 1 pixels

OK
Cancel

23a
Brightness/Contrast

Brightness: +18 OK
 Cancel
Contrast: +9 Help

☑ Preview

24

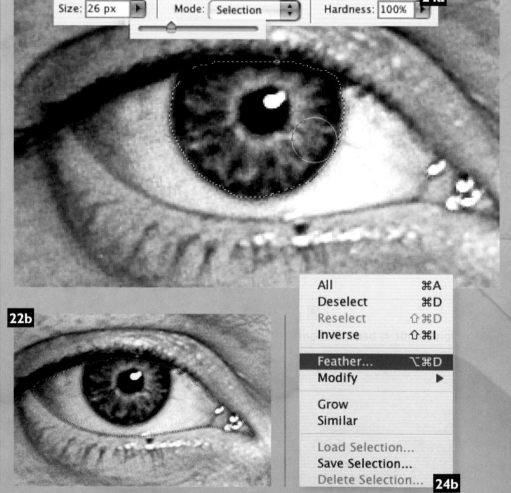

Size: 26 px Mode: Selection Hardness: 100% **24a**

22b

All	⌘A
Deselect	⌘D
Reselect	⇧⌘D
Inverse	⇧⌘I
Feather...	⌥⌘D
Modify	▶
Grow	
Similar	
Load Selection...	
Save Selection...	
Delete Selection...	**24b**

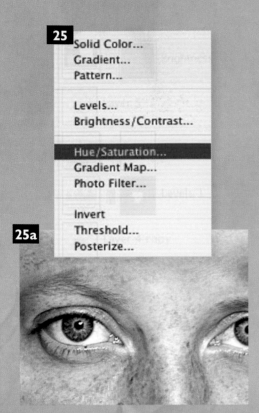

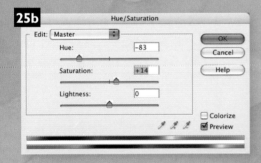

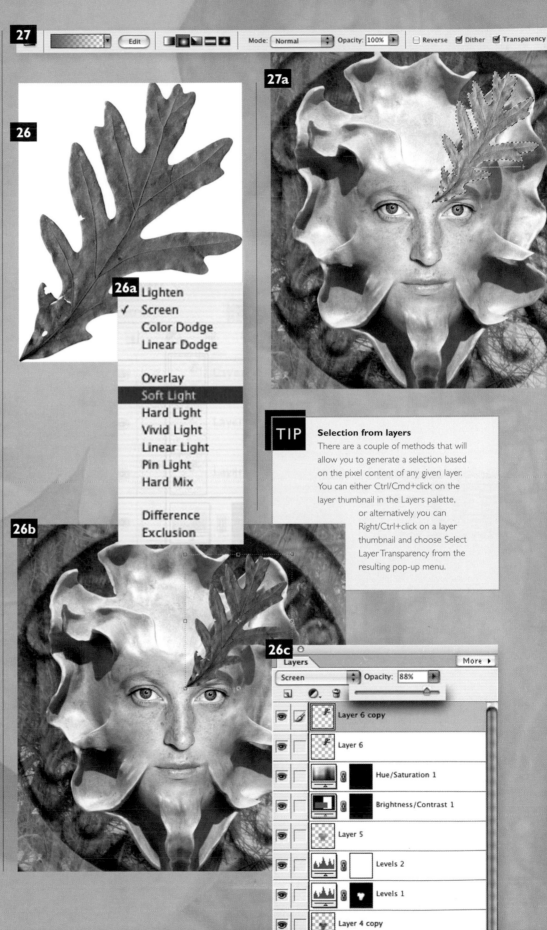

25 With the new selection active, create a new Hue/Saturation adjustment layer. Adjust the Hue to -83 and then increase the Saturation to +14. Do not adjust the Lightness. This will turn the model's eyes to a bright green instead of blue.

26 We'll now use a couple of images of leaves to lay over the top of the composition. Open up the first leaf file and drag the leaf into your working file using the Move tool. Position it above the model's left eye. Duplicate the layer and change the blending mode to Screen. Reduce the opacity to 88%. Duplicate the new layer and reduce the opacity to 82%. Change the blending mode to Soft Light. Ctrl/Cmd+click the layer thumbnail to generate a selection from the content of the layer.

27 With the selection active, create a new layer with a Color blending mode and select the Gradient tool. Choose the Foreground to Transparent option and the Radial method. Sample colors from the green mask and click and drag to create gradients within the selection on the current layer.

TIP

Selection from layers
There are a couple of methods that will allow you to generate a selection based on the pixel content of any given layer. You can either Ctrl/Cmd+click on the layer thumbnail in the Layers palette, or alternatively you can Right/Ctrl+click on a layer thumbnail and choose Select Layer Transparency from the resulting pop-up menu.

A FACE IN THE LEAVES

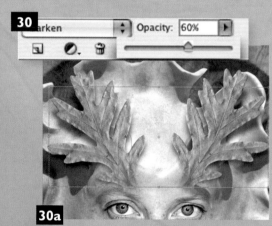

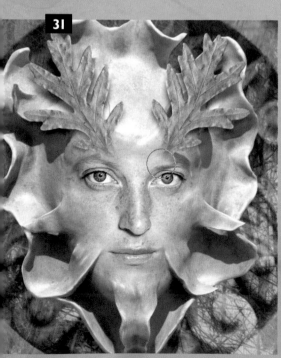

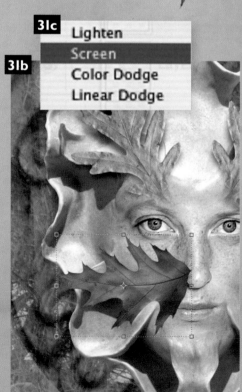

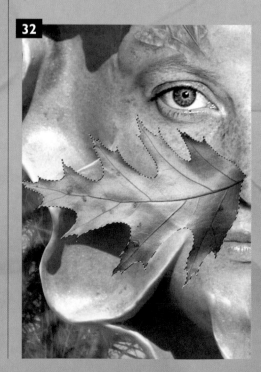

28 Link all of the leaf layers and choose the Merge Linked option from the Layers palette menu. Deactivate the selection and then choose the Eraser tool. Use a large, soft, round brush tip preset and erase the bottom of the leaf. Duplicate the layer and then choose *Image > Rotate > Flip Layer Horizontal* from the menu.

29 Use the Move tool to drag it over to the other side of her face. Link both leaf layers and then merge them into one. Generate a selection from the contents of the layer and create a new layer. Drag it beneath the leaf layer in the Layers palette. Choose *Select > Feather* from the menu and feather the current selection on the new layer by 20 pixels.

30 Press "D" to set the foreground color to black. Type Alt/Opt+Backspace to fill the selection with black. Change the layer blending mode to Darken and reduce the opacity to 60%. Type Ctrl/Cmd+D to deactivate the selection. Drag the midpoint of the top edge of the bounding box down to adjust the size of the shadows. Select the Eraser tool again with the same tool options.

31 Use the Eraser, with various opacity settings, to remove unwanted areas of shadow from the layer. Open up the second leaf image. Use the Move tool to drag it into your working file as a new layer and position it on the left side, just above the model's mouth. Duplicate the layer and change the blending mode to Screen.

32 Create another duplicate layer and change the blending mode to Soft Light. Generate a selection from the layer content and then create a new layer above it with the blending mode set to Color. Use the Gradient tool, like you did previously, to introduce a series of colored gradients into the selection.

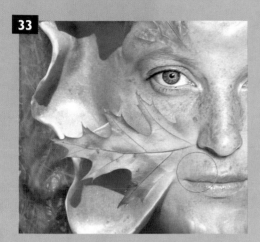

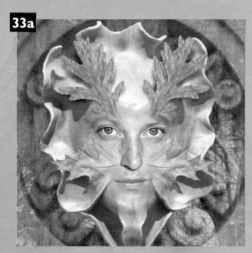

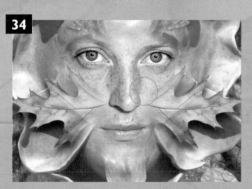

33 Deactivate the selection, link all of the layers containing the second leaf, and then merge them into one. Use the Eraser tool to remove the hard edges near the model's nose and mouth. Duplicate this layer, flip it horizontally, and move it to the other side of the face. Link the two layers and merge them.

34 Now, use the same method you used for the first leaves to create soft shadows of the second leaves using feathered selections on an underlying layer. Use the Eraser to remove unwanted shadow areas and finally create adjustment layers above the other layers to increase global saturation and contrast.

The inspiration for this image came from looking down at fallen oak leaves on the ground during a stroll in fall. The oak leaves, when combined with a portrait photo, immediately brought to mind the ancient Green Man motif. Taking this as a cue, this stunning image was later devised and created within Photoshop Elements.

THE LIVING STATUE

What started off as a quick digital snapshot of a brass statue has evolved into something far beyond that. Combining this photo with a selection of shots featuring human arms, we can create a living, multiple-armed goddess. Removing the brass from the statue and the skin from our human model with stacked adjustment layers and masks, we eventually developed a brand-new complexion for them both.

A desktop scan of imported fabric is the basis for our background. Combined with the Elements shape layer tools, it allows us to create an exotic and interesting motif on which to position our living statue. And as if things weren't strange enough, we can mix it up with a few additional eyes, one for the palm of her hand and another in the center of her forehead.

1 Open the fabric image file and select the Rectangle tool. Press "D" to set the foreground and background colors to their default settings, then press "X" to invert the colors. Click and drag to draw a rectangular shape layer across the entire image area.

2 Select the Ellipse tool from the Options Bar and press the Subtract from shape area button. Hold down the Shift key and then click and drag to draw a perfect circle. Because you enabled the Subtract button, the circular shape is knocked out of the rectangle on the shape layer.

3 Select the Shape Selection tool from the Options Bar. Click inside the circular shape and drag it to the visual center of the canvas. Next, select the Ellipse tool from the Options Bar and click on the Create new shape layer button.

1

1a

	Rectangle Tool	U
	Rounded Rectangle Tool	U
	Ellipse Tool	U
	Polygon Tool	U
	Line Tool	U
	Custom Shape Tool	U
	Shape Selection Tool	U

2

2a

3

3a

4

5

6

4a

5a

6a

4 Hold down the Shift key and click and drag with the Ellipse shape tool to create a perfect circle shape on a new shape layer. Choose the Shape Selection tool again and move the shape so that it is visually centered.

5 Using the Shape Selection tool, Alt/Opt+click and drag the shape to copy it within the same shape layer. Click the Subtract from shape area button to knock it out of the circle on the same layer.

6 Holding down the Shift key, drag a corner point of this shape's bounding box inward to reduce its size proportionally. Click and drag, like you've been doing already, to visually center this shape within the others and the canvas area. In the Layers palette reduce the opacity of this shape to 50%.

7 With the background ready, it's time to open up your statue image file. Ensure that the windows are tiled automatically so that you can easily drag from file to file and then use the Move tool to drag the statue layer into the working file. Use the Move tool to position the statue slightly left of center.

7

TIP	**Shape tool shortcut**

Type "U" on the keyboard to select the Shape tool without returning to the toolbox. With the Shape tool selected, typing "U" will toggle to the next shape option. Repeatedly pressing "U" will cycle you through the entire list of shape tools.

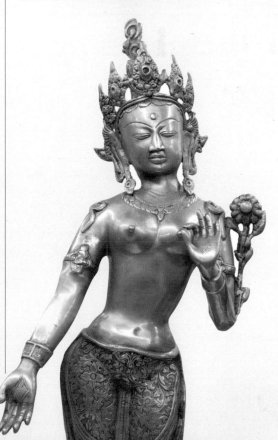

THE LIVING STATUE

8

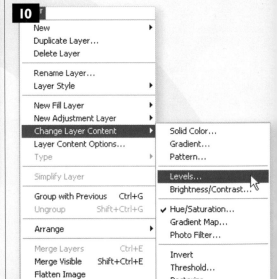

9

8 Ctrl/Cmd+click on the statue layer thumbnail in the Layers palette to generate a selection from the statue. With the selection active, create a new Hue/Saturation adjustment layer. Change the Hue to +133 to turn the statue blue.

9 Duplicate the adjustment layer as you would a normal layer and then double-click the adjustment layer icon in the Layers palette to edit it. Change the Hue to 20, the Saturation to 36, and the Lightness to 6. Duplicate the layer one more time.

10 Choose *Layer > Change Layer Content > Levels* from the menu. Drag the left Input slider slightly to the right and drag the right Input slider slightly to the left to increase the contrast within the statue.

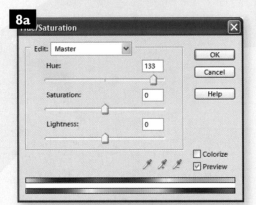

8a

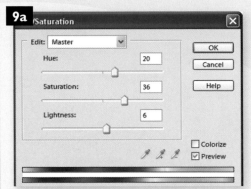

9a

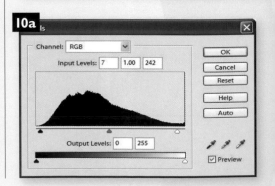

10

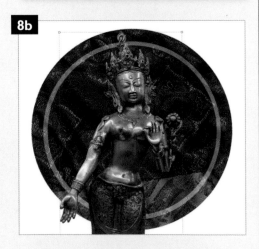

8b

9b

10a

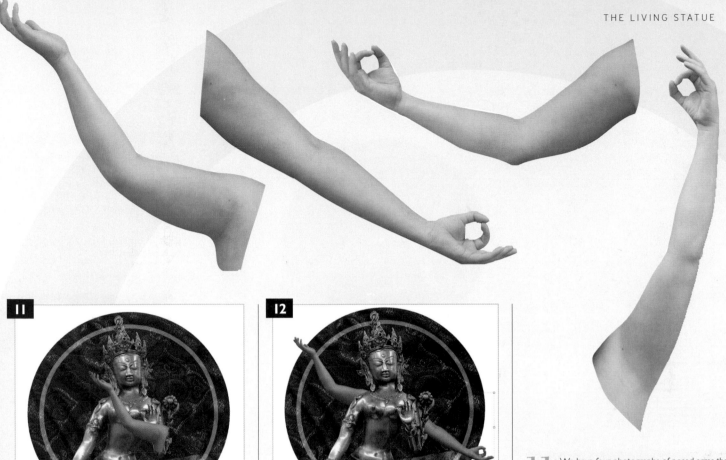

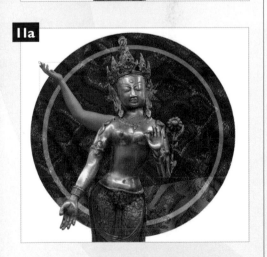

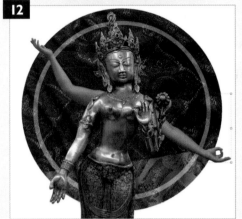

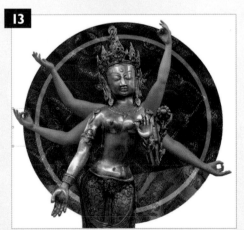

11 We have four photographs of posed arms that we have already cut out. Open the first arm. Again, tile the windows so that you can see both open files. Use the Move tool to drag the arm layer into the working file. Use the Move tool to position the arm, then drag the layer down in the Layers palette so that it sits directly beneath the statue layer. Keep this layer selected.

12 Open the second arm and use the same method to drag the content into your working file and position it with the Move tool. The layer will be placed directly above your currently selected layer so there is no need to move it beneath the statue.

13 Use this method to bring in the remaining two arms as separate layers and position them with the Move tool. Link the arm layers in the Layers palette and merge them into a single layer. With the merged layer selected, choose *Filter > Sharpen > **Unsharp Mask*** from the menu.

THE LIVING STATUE

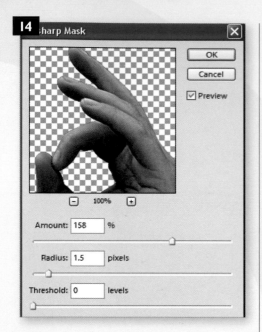

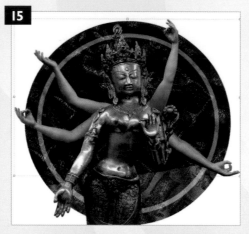

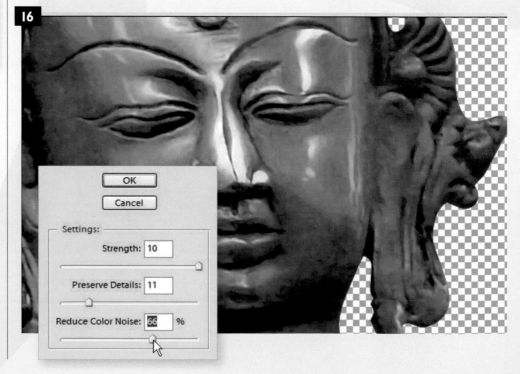

14 Set the Amount to 158% and the Radius to 1.5 pixels to sharpen the arms and hands. Ctrl/Cmd+click on the arm layer thumbnail to generate a selection from the layer's content. With the selection active, create a new Levels adjustment layer. Darken the shadows considerably and lighten the highlights via the Input sliders.

15 Duplicate the Levels layer and then, with the duplicate layer selected, choose *Layer > Change Layer Content > Hue/Saturation* from the menu. Adjust the Hue by 175, set the Saturation to 41, and reduce the Lightness by 2. Link the statue layer and its adjustment layers.

16 Merge the linked layers and then choose *Filter > Noise > Reduce Noise* from the menu. Set the Strength slider to 10, set the Preserve Details slider to 11, and set the Reduce Color Noise slider to 66%. Link the arms layer and its adjustment layers and then use the Layers palette menu to merge them into a single layer.

17

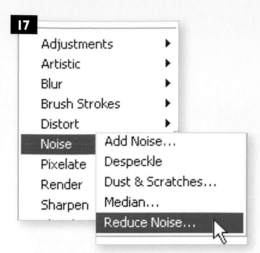

Adjustments　　　▶
Artistic　　　　　▶
Blur　　　　　　　▶
Brush Strokes　　▶
Distort　　　　　　▶
Noise　　　　Add Noise...
Pixelate　　　Despeckle
Render　　　Dust & Scratches...
Sharpen　　Median...
　　　　　　Reduce Noise...

18

19

Pin Light
Hard Mix

Difference
Exclusion

Hue
Saturation
Color
inosity

19a

17a

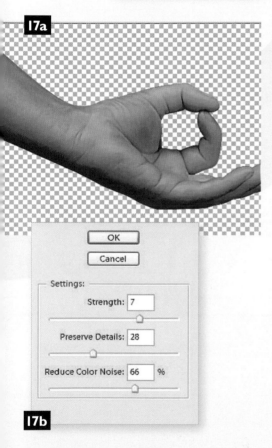

OK

Cancel

Settings:

Strength: 7

Preserve Details: 28

Reduce Color Noise: 66 %

17b

18a

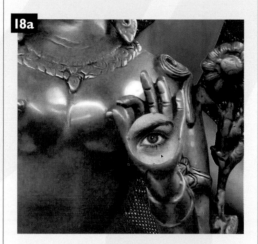

20

18b

18c

20a

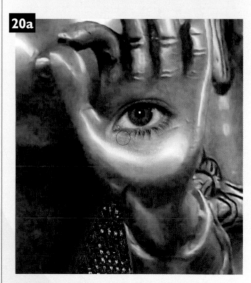

17 With the merged arms layer highlighted, select the Reduce Noise filter from the menu. The effect doesn't need to be as drastic as the one we did earlier; set the Strength to 7, Preserve Details to 28, and leave Reduce Color Noise set to 66%.

18 We're using a cut-out eye image to add a surreal aspect to our composition. Open the image and drag it into the working file. Move it to the top of the Layers palette and position it over the palm of the statue's hand. Select the Eraser tool and, using a soft, round brush tip preset, erase the hard edges, blending the eye into the hand.

19 Ctrl/Cmd+Alt/Opt+click on the eye and drag a copy of the layer over to the center of the statue's forehead. Create a new layer with a Color blending mode. Select the Brush tool.

20 Choose a soft, round brush tip shape and an opacity setting of 100%. Sample nearby colors by Alt/Opt+clicking in nearby areas and then paint these colors over the pink skin areas surrounding both eyes.

THE LIVING STATUE

21

22

22a

21a

23

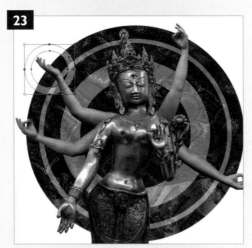

24

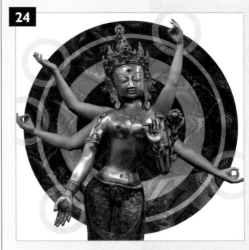

23a

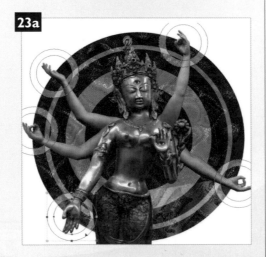

24a

21 Create a new Levels adjustment layer and increase the contrast as done previously to affect all of the visible underlying layers. Duplicate the top-most shape layer in the Layers palette. Use the Shape Selection tool to select the inner-most shape. Hold down Alt/Opt+Shift to drag a corner point inward, making the shape smaller.

22 Press the Enter key to apply the transformation and then click on the Combine button in the Options Bar to combine the two shapes on that layer. Proportionally reduce the shape size again by dragging a corner point toward the center. Press the Enter key to apply the transformation.

23 Duplicate the layer and reduce its size using the same method, move it underneath one of the statue's hands. Press Enter and then hold down the Alt/Opt key. Click and drag on the shape to create duplicate shapes within the same layer. Place one underneath each hand.

24 Double-click on the shape layer thumbnail in the layers palette to open the color picker. Choose a light, yellow color from the picker. Clicking OK will change the color of each shape on the current layer.

25 Next, click on the foreground color swatch to launch the picker. Choose a light green color and click OK to exit the picker. Select the Ellipse shape tool. Choose the Create new shape layer option in the Options Bar.

26 Click and drag, while holding down the Shift key to create a perfect circle on the new layer, inside one of the previous shapes. Choose the Shape Selection tool. Select the new shape and Alt/Opt+click and drag to duplicate the shape within the layer. Use this method to add a green circle inside each gold hoop.

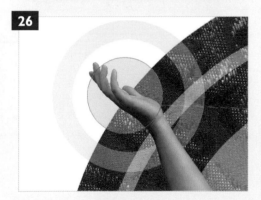

In this section we've added movement to inanimate objects. This bronze statue is turned into a living goddess figure by combining it with photos of real arms. The background is another story, and represents our first foray into the technology of the Shape tool.

A MASK OF BUTTERFLIES

Taking our lead from Mother Nature, we'll use a handful of neat Elements tricks to metamorphose this woman into a strange and fantastic creature. The mask of butterflies seamlessly blends into her skin, reshaping her face, creating an ethereal goddess of Spring.

The secret to this composition is basic repetition, layers scaled and rotated to achieve the desired coverage. The butterflies are isolated using a combination of selection tools and brought into the file as layers. Layers with differing blending modes are stacked on top of one another to create brilliant color effects. Gentle Eraser work then reveals essential facial features so the woman still remains somewhat humanoid. Finally, we'll introduce you to a new merge function that allows you to affect all visible layers.

2

2a

1

1a

1b | Feather: 0 px ☑ Anti-aliased | Width: 10 px Edge Contrast: 11% Frequency: 57 | ☐ Pen Pressure

TIP

Magnetic Lasso
When using the Magnetic Lasso tool, instead of double-clicking, you can simply press Enter on the keyboard to generate a closed selection.

1 Open the face image, this will be our working layered file. Next, open up an image of a butterfly. Select the Magnetic Lasso tool. Set the Width to 10 pixels, the Edge Contrast to 11%, and the Frequency to 57. These are just rough guidelines, as we aren't striving for precision at this point.

2 Click and drag in an area just outside the butterfly's edge. Trace around the butterfly, not worrying too much if all the points don't fall where you want them. We'll fix that soon enough. When you return to your original point, double-click to generate a selection.

3 Choose the Selection Brush, and with the current selection active, switch it to Mask mode in the Options Bar. This causes the exterior of the selection border to become masked. Select a small, round, hard brush tip. Zoom into an area that needs masking.

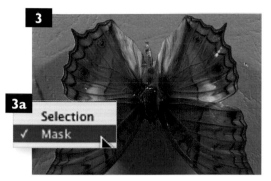

4 Use the brush to paint over all the areas you want to remove from the selection border. Then, holding down the Alt/Opt key, paint over any masked areas that you wish to unmask, including those in your selection. When you're finished, switch to Selection mode to create a selection from the mask.

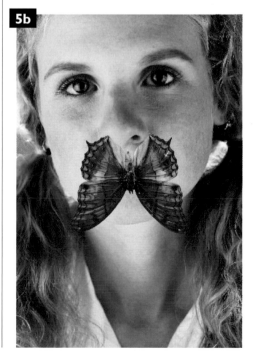

5 With the selection active, copy the content and then paste the butterfly into the face file as a new layer. Duplicate the layer and change the blending mode of the duplicate layer to Color Dodge. Reduce the opacity of the layer to 47% and then link the two layers in the Layers palette.

6 Type Ctrl/Cmd+E on the keyboard to merge the linked layers together. This is the master butterfly layer that we'll use to create duplicate layers. Only the duplicates will be visible in the Layers palette, not this layer. Duplicate the layer, hide the master layer and select the Move tool.

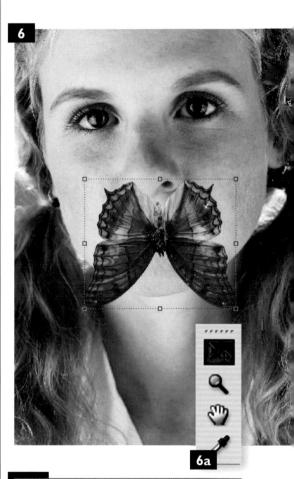

TIP

Why a master layer?
Every time you scale, rotate, or transform an image, it deteriorates image quality slightly. This is why we will always use the master butterfly layer to create our duplicate layers from. That way, when we alter them, they only have a single transformation performed. This will give a sharper result than transforming a layer that is a duplicate of a transformed layer that is also a duplicate of a transformed layer, etc.

A MASK OF BUTTERFLIES

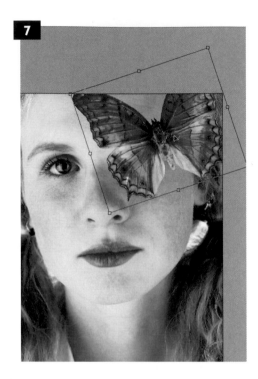

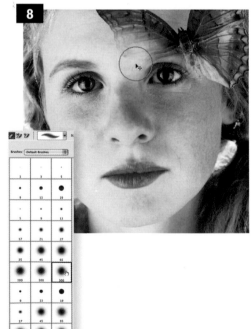

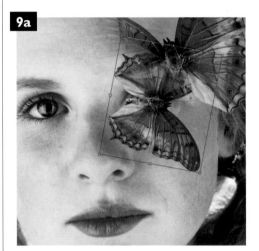

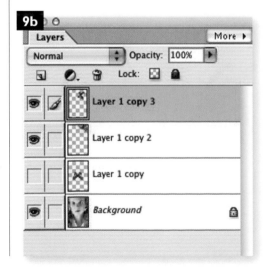

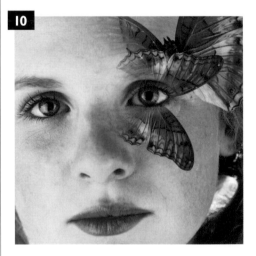

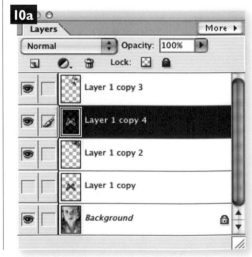

7 Drag the mouse pointer outside of the bounding box and then click and drag to rotate the butterfly, hold down the Shift key and drag a corner handle to proportionally increase the size. Position it over the model's eye so that it overlaps the top and side of the canvas.

8 Select the Eraser tool and choose a large, soft, round brush tip preset. Set the opacity to 50% and erase the lower-left area of the butterfly so that the model's eye shows through, blending the edges.

9 Increase and decrease brush size and opacity as needed to create a nice, seamless blend. Create another duplicate of the master butterfly layer. Once more, select the Move tool and rotate almost 90° Drag it to the top of the Layers palette and select the Eraser tool.

10 Use the Eraser with soft brush tips that vary in size and opacity to gently erase areas of this layer and reveal the model's eye. Duplicate the master layer again and drag it up in the Layers palette so that it sits between the previous two duplicate layers.

11 Select the Move tool and rotate and resize the butterfly, positioning it over the model's eye. Select the Eraser and then use it again to blend the butterfly into the face and reveal the eye. Continue adding overlapping butterflies in this fashion until they cover one side of the face.

12 Open up the second butterfly image. Select the Magnetic Lasso and trace the outline in the same way as the first butterfly, then switch to the Selection Brush. Again, use Mask mode to refine the selection. When you're finished, revert to Selection mode, copy the butterfly, and paste it into the working file.

13 Duplicate the new layer, change the blending mode to Overlay, and reduce the opacity to 70%. Link the two new layers and use the Ctrl/Cmd+E shortcut to merge them into one. Drag the layer beneath all of your butterfly duplicate layers in the Layers palette.

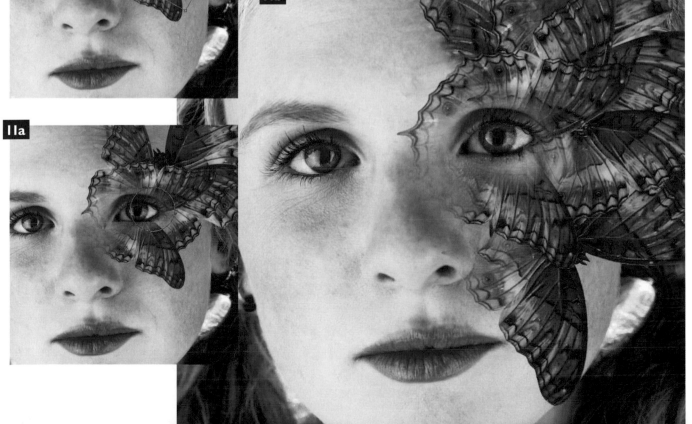

A MASK OF BUTTERFLIES

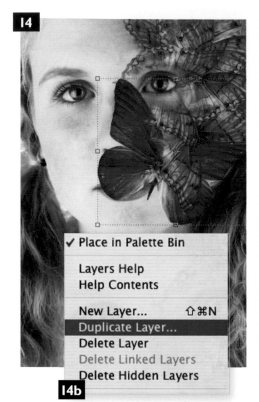

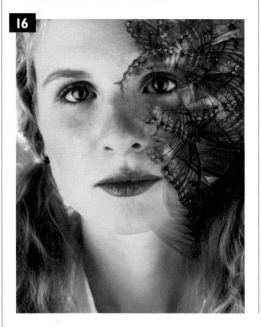

14 Select the Move tool. Rotate the butterfly and increase the size proportionally, moving it down alongside the model's cheek and jaw line. Select the Eraser tool and remove all the layer content except the areas to the right. Duplicate this layer and select the Move tool. Move the butterfly down onto the side of the model's chin.

15 Choose *Image > Rotate > **Flip Layer Vertical***. Rotate the bounding box and position the flipped butterfly so it is parallel with the side of the model's chin. Select the Eraser tool and lightly erase anything that overlaps her mouth. Enable the transparency lock for this layer and select the Brush tool.

16 Choose a massive, soft brush tip preset and a low opacity setting. Hold down the Alt/Opt key and click on a nearby area of her chin to sample that color as the foreground color. Use this color to gently paint over the butterfly where it meets her skin on this layer.

17 Make the background layer invisible. Choose *Layer > **Merge Visible*** from the menu. Once you have merged the layers into one, duplicate the merged layer and then make the background layer visible once again.

18 With the duplicate layer selected, choose *Image >
Rotate > **Flip Layer Horizontal*** from the menu. Use
the Move tool to carefully rotate and position the flipped
duplicate layer on the other side of the model's face.

19 Use the Crop tool to draw a box that omits the
areas lacking butterflies at the left. You can rotate the
Crop tool's bounding box like any other. Press the Enter key
to crop the image.

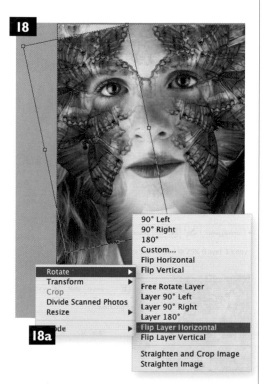

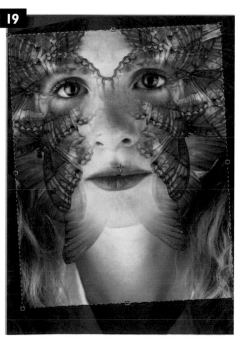

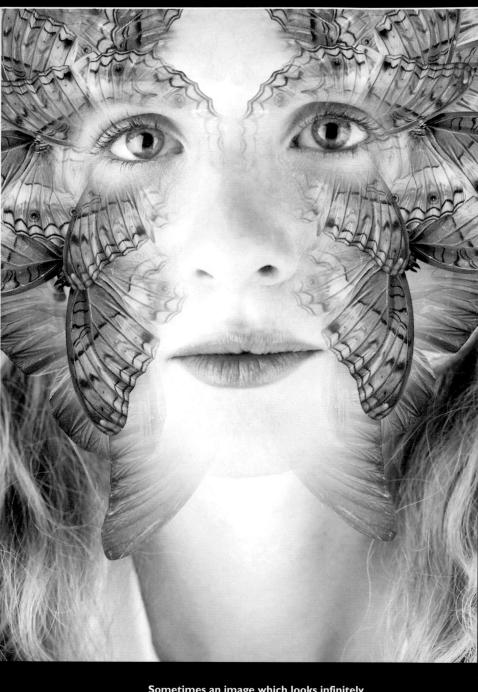

**Sometimes an image which looks infinitely
complicated is the result of something very
simple. This picture appears complex, but in
reality it's nothing more than one photograph
of a woman and two photographs of a butterfly.**

fantastic scenes

FLYING SAUCER ATTACK

We have always wondered if we are alone in the Universe, and if not, whether our neighbors would be friendly or hostile. Taking our cues from the likes of H.G. Wells' "War of the Worlds" and Tim Burton's "Mars Attacks!" this project mixes photos of dinnerware, the Toronto skyline, a toy skeleton, and some more tricks courtesy of Photoshop Elements into a B-movie scene that would make Ed Wood proud.

1 Launch Elements and choose *File > New > Blank File* from the menu. Create a custom-sized file 386mm wide and 204mm tall with a resolution of 300 pixels per inch. Set the color mode to RGB and set the background to white.

2 Open up your background sky image. Copy the contents of the file and paste it into the working file as a new layer. Use the Move tool to drag it to the upper-left hand corner of the image. Choose *Filter > Blur > Gaussian Blur* from the menu.

3 Set the pixel radius to 8 and click OK to blur the sky, softening the image and removing any grain. Duplicate the layer and change the blending mode of the layer to Overlay. Reduce the opacity of the layer to 54%. Create a new Levels adjustment layer.

4 Drag the left and right Input Levels sliders toward the center to increase the contrast. Open up the skyline image. Copy and paste, or simply drag, the image into your working file as a new layer. Select the Move tool and Shift+drag a corner point of the bounding box inward to reduce its size.

5 Position the buildings to the lower left. Select the Magic Wand tool, leaving the Tolerance set at the default setting of 32 and ensuring the Contiguous option is disabled. Click on the sky and then Shift+click on any unselected sky areas to add them to the selection. Choose *Select > Modify > Expand* from the menu.

6 Expand the selection by one pixel and then press the Backspace key to remove the sky. Deactivate the selection. Use the Lasso to draw a rough selection around the left building and then delete it. Choose *Enhance > Adjust Lighting > Levels* from the menu. Drag the right Output Levels slider to the left to darken the highlights.

7 Duplicate the layer. Change the blending mode to Soft Light and reduce the opacity to 67%. Link the two building layers in the Layers palette and then merge them into one. Use the Lasso tool to draw rough selections around the tops of the buildings to look like laser blasts, and then delete the selected content. Deactivate the selection.

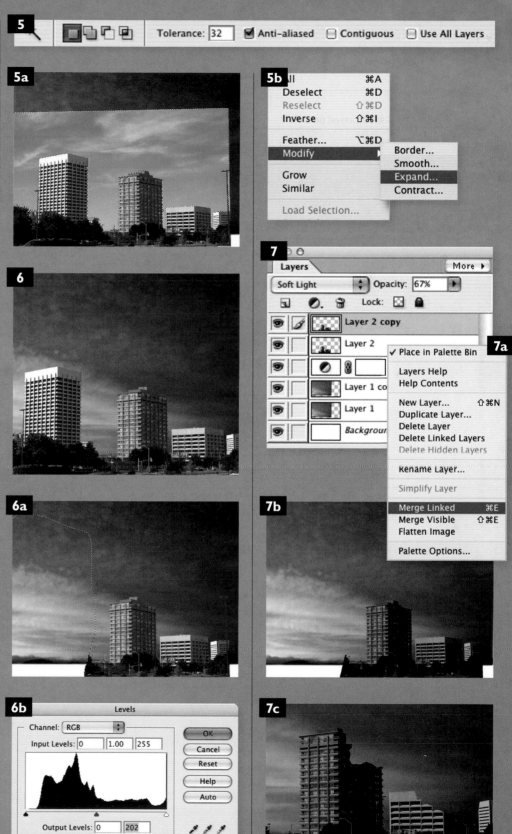

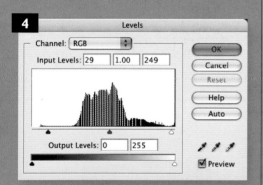

FLYING SAUCER ATTACK

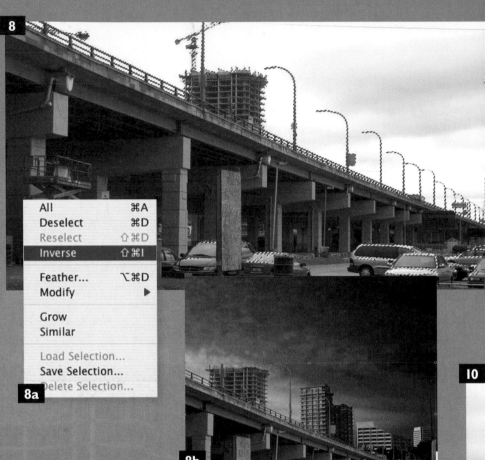

8

9

10

8 We're adding a second image, this time of an overpass, to help fill out the skyline. Use the Magic Wand with the same settings to select the sky like before. Expand the selection by one pixel again and then invert the selection by choosing *Select > Inverse* from the menu. Copy the selected area and paste it into the working file as a new layer. Use the Move tool to drag it to the lower left of the image.

9 Duplicate the overpass layer and change the blending mode to Overlay. Link the two overpass layers and merge them. Use the Lasso tool to draw a rough selection around a portion of the building on this layer and delete the content to look like alien damage. Deactivate the selection.

10 Open an image of a building for the foreground. Use the Polygonal Lasso to draw a rough selection around the building. Using the Move tool, drag it into the working file as a new layer and position it on the right of the image. Select the Magic Wand tool and leave the Tolerance set at 32 and the Contiguous option enabled.

10a

10b

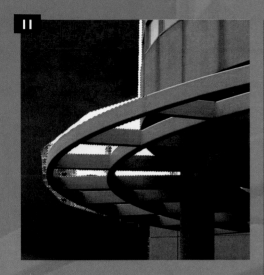

Click on a section of sky to select it, then hold down the Shift key and click on the rest of the sky areas to select them. Hold down the Shift key and use the Magic Wand to select as many unwanted areas you can without accidentally selecting the building. Choose *Select > Modify > Expand* from the menu.

Expand the selection by one pixel and press the Backspace key. Deactivate the selection and choose the Eraser tool. Select a small, hard, round brush tip preset and an opacity setting of 100%. Use the Eraser to remove any extra background that you couldn't select with the Magic Wand, increasing and decreasing the brush tip size as needed.

When you've finished erasing, duplicate the layer and change the blending mode to Soft Light. Overall, the colors are still a little dull. To remedy this, create a new Hue/ Saturation adjustment layer and increase the Saturation by 36. This will liven up the colors in the image content added so far.

All	⌘A	
Deselect	⌘D	
Reselect	⇧⌘D	
Inverse	⇧⌘I	
Feather...	⌥⌘D	
Modify	▶	
	Border...	
Grow	Smooth...	
Similar	Expand...	
	Contract...	
Load Selection...		
Save Selection...		
Delete Selection...		

 Size: 13 px Mode: Brush Opacity: 100%

Layers — More ▶

Soft Light Opacity: 100%

Lock:

- Layer 4 copy
- Layer 4
- Layer 3
- Layer 2
- Le...
- Layer 1 copy
- Layer 1
- Background

Solid Color...
Gradient...
Pattern...

Levels...
Brightness/Contrast...

Hue/Saturation...
Gradient Map...
Photo Filter...

Invert
Threshold...
Posterize...

Hue/Saturation

Edit: Master

Hue: 0
Saturation: +36
Lightness: 0

OK
Cancel
Help

☐ Colorize
☑ Preview

TIP

Wand removal
You now know that holding down the Shift key while clicking on an area with the Magic Wand will select this area and add it to the currently active selection. However it is also possible to remove areas of a selection with the Magic Wand. Alt/Opt+clicking with the wand removes areas from the active selection.

FLYING SAUCER ATTACK

14 Open an image of a skeleton, and use the Polygonal Lasso to draw a rough closed selection around it. Use the Move tool to drag the selected skeleton into the working file as a new layer. Hold down the Shift key and drag a bounding box corner point inward to reduce the size. positioning it in the lower right of the image.

15 Choose *Enhance > Adjust Lighting > Levels* from the menu. Drag the left and right Input Levels sliders toward the center of the histogram to greatly increase the contrast. Drag the middle Input Levels slider a little to the left to slightly lighten the midtones.

16 Hit Ctrl/Cmd+I on the keyboard to invert the colors of the skeleton layer. Change the blending mode to Multiply to remove the white areas completely. Select the Magic Wand tool.

17 Leaving the Tolerance set to 32 but disabling the Contiguous option, click on the white area surrounding the skeleton to select it. Even though you can't see it in Multiply mode, it's still there. Hold down the Shift key and click on the layer transparency to add it to the selection. Press Ctrl/Cmd+Shift+I to invert the selection.

14

16

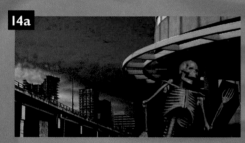
14a

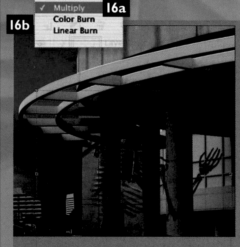
16b

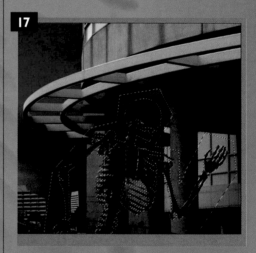
17

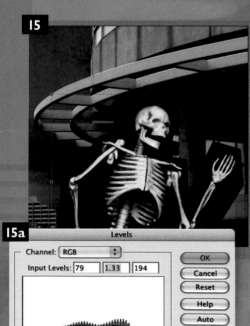
15

15a

Normal
Dissolve

Darken
✓ Multiply **16a**
Color Burn
Linear Burn

Levels	
Channel: RGB	
Input Levels: 79 1.33 194	OK / Cancel / Reset / Help / Auto
Output Levels: 0 255	
	☑ Preview

TIP

Planning ahead
We knew that we were going to invert the skeleton shot and change the layer blending mode to Multiply in the working file because we wanted to achieve an X-ray effect. We purposely photographed the skeleton against a black background, because when black is inverted it turns to white, and white doesn't appear at all when using Multiply mode. This little bit of planning saved us the trouble of removing the background from the skeleton shot when compositing.

17a

Tolerance: 32 ☑ Anti-aliased ☐ Contiguous ☐ Use All Layers

17b

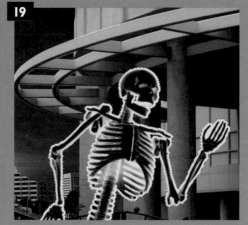

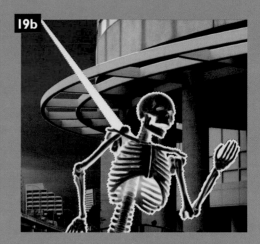

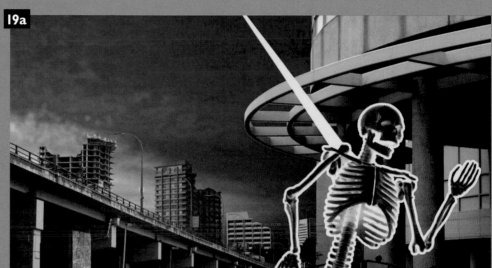

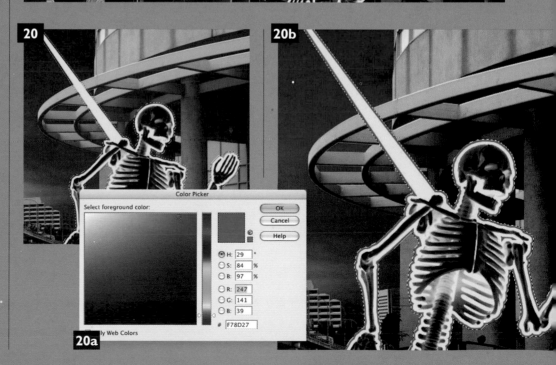

18 Create a new layer in the Layers palette and drag it beneath the skeleton layer. Keep this new layer selected in the Layers palette as the active layer. Choose *Select > Modify > **Expand*** from the menu and expand the selection by 20 pixels. Click on the foreground color swatch to access the picker and specify a light yellow-green color.

19 Type Alt/Opt+Backspace on the keyboard to fill the active selection with the current color on the new layer. Use the Polygonal Lasso to draw a laser beam shape that touches the current shape. Fill it with the same color and then deactivate the selection. Ctrl/Cmd+click on the layer thumbnail to generate a selection from it.

20 With the selection still active, create a new layer in the Layers palette and drag it below the current layer. Expand the selection by 15 pixels via the *Select > **Modify*** menu. Select an orange foreground color from the picker and type Alt/Opt+Backspace on the keyboard to fill the selection with the current foreground color on the new layer.

FLYING SAUCER ATTACK

21
Gaussian Blur

OK
Cancel
☑ Preview

100%

Radius: 40.0 pixels

22
Gaussian Blur

OK
Cancel
☑ Preview

100%

Radius: 20 pixels

21 Deactivate the selection (Ctrl/Cmd+D) and then choose *Filter > Blur > **Gaussian Blur*** from the menu. Blur the content of the layer using a Radius setting of 40. After applying the filter, duplicate the layer so that the orange is nice and bright in the image. Select the layer with the yellow-green shape on it.

22 Launch the Gaussian Blur filter again. This time, enter a Radius value of 20 so the yellow is not as blurred as the orange, resulting in an orange edge being added to the yellow area.

23 Now it's time for the UFO. The image we're using is actually an upside down bowl sitting on a plate! Open the image, and select the Magic Wand tool. Leave the Tolerance set to 32, making sure that the Contiguous option is enabled. Click on the plate to generate a selection.

24 Hold down the Shift key and click on all of the areas of the bowl and plate that remain unselected. Feel free to reduce the Tolerance if you find that your selection is straying onto the background. Copy the selection and paste it into the working file as a new layer.

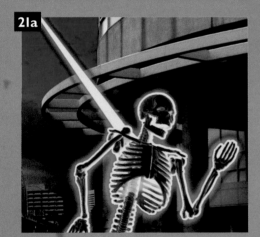

21a

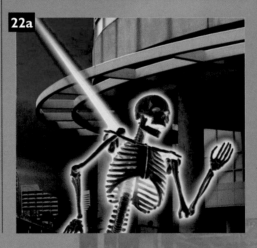

22a

24

23

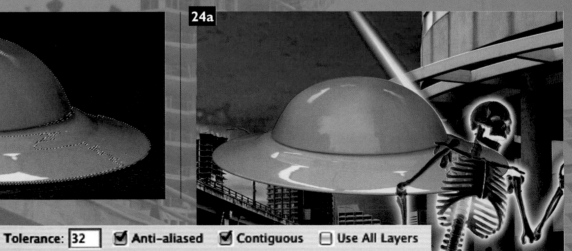

24a

23a Tolerance: 32 ☑ Anti-aliased ☑ Contiguous ☐ Use All Layers

25

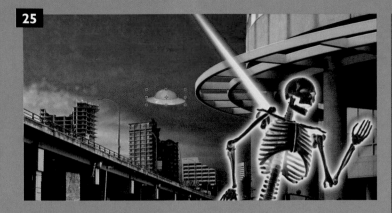

25a

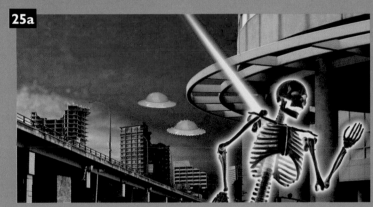

26

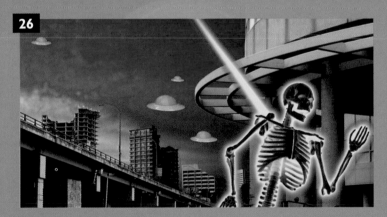

26a

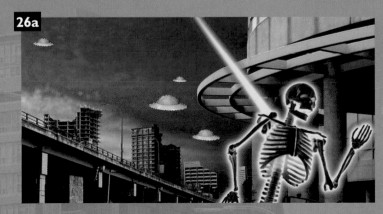

27

| Difference |
| Exclusion |
| |
| Hue |
| Saturation |
| ✓ Color |
| **27a** Luminosity |

28

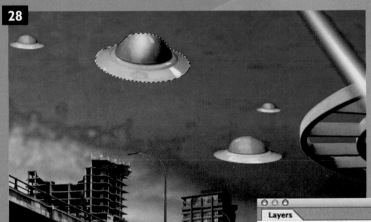

25 Use the Move tool to reduce the size of the UFO and reposition it. Use the Rectangular Marquee tool to draw a selection around the UFO. Hold down the Ctrl/Cmd+Alt/Opt keys, then click on the selected UFO and drag it to another area to make a duplicate of it on the same layer.

26 Use the Move tool to resize and reposition the duplicate then use this same duplication method to create a few smaller UFOs in the background on the same layer. Duplicate the layer and change the blending mode of the duplicate to Overlay. Ctrl/Cmd+click the layer thumbnail to generate a selection from the layer content.

27 Create a new layer with a Color blending mode. Use the Eyedropper tool to click on a gray area from the building at the right, specifying the gray as the current foreground color. Type Alt/Opt+Backspace to fill the selection with the current foreground color, giving the UFOs a uniform gray appearance. Deactivate the selection.

28 We'll now use another UFO image, taken from a different angle, to add some variety. Open the image and use the Magic Wand tool to select it like you did with the previous dinnerware shot. Paste it into the working file. Reduce the size and position it to the left-hand side of the image. Duplicate the layer and then alter the color of this UFO in exactly the same manner as the previous UFOs.

28a

👁			Layer 5
👁	🖊		Layer 11
👁			Layer 10 copy
👁			Layer 10
👁			Layer 9
👁			Layer 8 copy
👁			Layer 8
👁			Layer 6
👁			Layer 7 copy
👁			Layer 7
👁		⬤ 🔲	Hue/Saturation
👁			Layer 4 copy
👁			Layer 4
👁			Layer 3
👁			Layer 2
👁		⬤ 🔲	Levels 1
👁			Layer 1 copy
👁			Layer 1
👁			Background

Layers
Color — Opacity: 100%
Lock:

FLYING SAUCER ATTACK

29

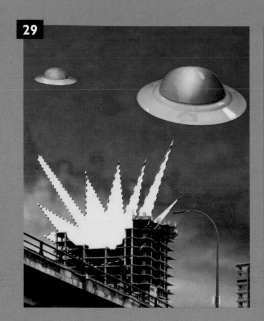

31

30a Gaussian Blur

OK
Cancel
☑ Preview

Radius: 15 pixels

31a

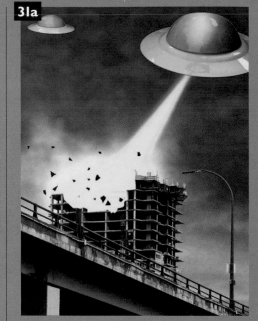

30 Gaussian Blur

OK
Cancel
☑ Preview

Radius: 50 pixels

30b

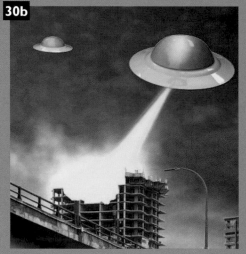

32 Gaussian Blur

OK
Cancel
☑ Preview

Radius: 2 pixels

29 Create a new layer and drag it beneath the overpass layer in the Layers palette. Use the Polygonal Lasso to create a rough starburst shape under the top area of the left building. Use the Eyedropper to sample the yellow-green color from your skeleton glow and then fill the selection with it on the new layer.

30 Deselect and use the Gaussian Blur filter to blur the starburst using a 50 pixel Radius. Create another new layer and use the same method to draw a laser beam shape connecting the explosion to the UFO. Fill it using the same color. Use the Gaussian Blur filter with a lower setting of 15 to blur the contents of this layer as well. Deactivate the selection.

31 Create another new layer and with the Lasso tool, making sure the Add to selection option is enabled, to draw a series of shapes in front of the explosion. Sample a black color from the building at the right and fill the selection with it on the new layer. Deactivate the selection.

32 Use the Gaussian Blur filter to slightly blur the black bits, using a Radius setting of only 2 pixels. Create a new layer in the Layers palette and drag it down beneath the very first buildings layer. Specify an orange foreground color from the picker and then select the Gradient tool.

32a Color Picker
Select foreground color:

OK
Cancel
Help

○ H: 33 °
○ S: 84 %
○ B: 100 %
○ R: 255
○ G: 157
○ B: 41

FF9D29

☐ Only Web Colors

FLYING SAUCER ATTACK **135**

33 Select the Foreground to Transparent gradient preset and the Radial option in the Options Bar. Draw a series of radial gradients on the new layer. Create one underneath each destroyed section of building. One under the explosion, and one where the UFO laser is coming from.

34 Use the Eyedropper tool to sample a light yellow-green color from somewhere in the image, specifying it as the foreground color. Use the Gradient tool to draw two smaller gradients over the orange gradients beneath the buildings at the right. This will give the effect of a yellow center to the light source, suggesting fires.

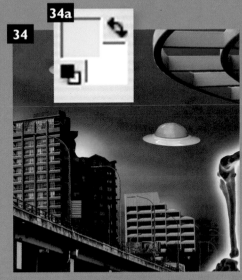

Never underestimate your dinnerware. In this case, when photographed upside down and manipulated in Photoshop Elements, it quickly becomes a deadly alien invasion force.

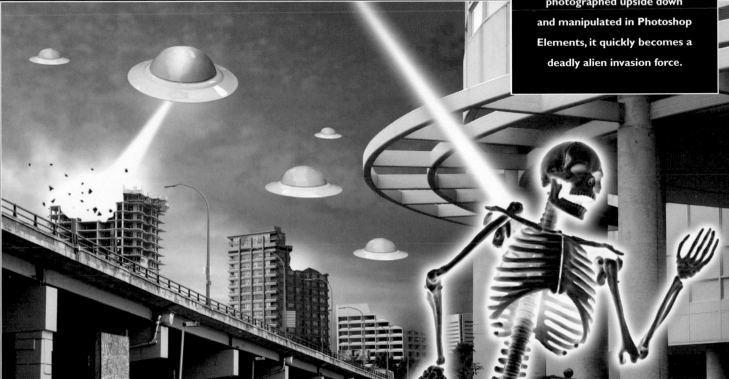

In this fantastic scene, a quick snapshot of the Giant's Causeway in Ireland and a couple of clay statue photos come together to create a composition that far exceeds, the sum of its parts. Blending mirror images of the causeway together to form the basis of the alien landscape, will also create a surreal and strange-colored sky. Actual clay sculptures were photographed and we gave life to them by blending them together with photos of human models.

Playing a prominent role in the final look of this image is the Replace Color tool. This is an excellent tool for isolating certain ranges of color within an image and changing them to any other color you desire. This tool was essential for creating the strange and alien color palette used in the overall image. The result gives the effect of creatures being born directly out of this rocky, alien world, illuminated by a bright blue sun.

1 Create a new file, 355mm wide and 178mm high with a resolution of 300 pixels per inch. Leave the color mode set to default RGB and the background color set to default white. Open the image of the Giant's Causeway.

2 Click on the Automatically Tile Windows button to view both of your files at the same time. Use the Move tool to drag the causeway image into your working file as a new layer. Shift+click on the bounding box's corner handle and increase the size. Click and drag outside of the box to rotate it then position it to the left of the image.

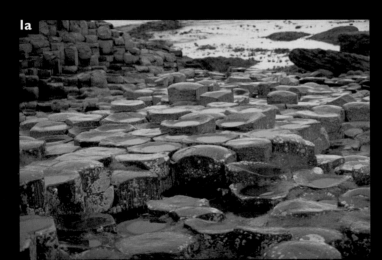

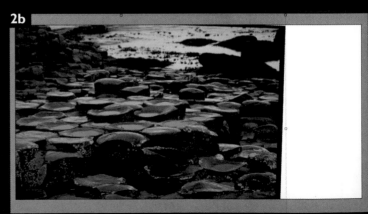

90° Left
90° Right
180°
Custom...
Flip Horizontal
Flip Vertical

Free Rotate Layer
Layer 90° Left
Layer 90° Right
Layer 180°
Flip Layer Horizontal
Flip Layer Vertical

Straighten and Crop Image
Straighten Image

Transform ▶
Crop
Divide Scanned Photos
Resize ▶

Mode ▶

Size: 30 px ▶ Mode: **Selection** Hardness: 100% ▶ Overlay Opacity: 50% ▶ Overlay Color:
 ✓ **Mask**

5a

6

6a

3a

3b

Size: 250 px ▶ Mode: Brush ▶ Opacity: 100% ▶

4

4a

3 Duplicate the layer and then choose *Image > Rotate > Flip Layer Horizontal* from the menu. Use the Move tool to drag it to the right and upward a little. Select the Eraser tool, and choose a large round, brush tip preset and set the opacity to 100%.

4 Use the Eraser tool to remove the areas to the left of this layer, removing the hard edge and blending the two layers together. Don't worry about getting the water at the top looking perfect, we'll get to that next. For now, just concentrate on getting the left area erased. Here we've temporarily switched off the underlying layer to show you what we've erased.

5 Choose the Selection Brush tool. Set it to Mask mode, and choose a hard, round brush tip preset. Use the Selection Brush to carefully paint a mask border just above the top of the causeway rocks you wish to keep, painting over the water area.

6 Continue to paint the mask border, remembering that you can remove any areas that you've painted over by using the Selection Brush with the Alt/Opt key held down. Work your way across the entire water area until you've painted a border, defining the area between water and rock.

7 Size: 150 px Mode: Mask Hardness: 100% Overlay Opacity: 50% Overlay Color:

7a

9 Open a sky image for the background. Use the Rectangular Marquee tool to draw a selection around the lower half of the image. Copy the selected area and then return to your working file. Create a new layer in the working file Choose Edit > *Paste Into Selection* from the menu to paste the sky into your currently active selection.

10 Click and drag inside the selection border to move it up within the defined area. Then press Ctrl/Cmd+T to activate the Free Transform function. Drag the midpoints on either side outward to increase the horizontal size, filling the target area with sky.

9a do Select Canvas ⌘Z
Redo ⌘Y
Revert to Saved

Cut ⌘X
Copy ⌘C
Copy Merged ⇧⌘C
Paste ⌘V
Paste Into Selection ⇧⌘V
Delete

Fill Selection...
Stroke (Outline) Selection...

Define Brush from Selection...
Define Pattern from Selection...

9 Clear ▶

Preset Manager...

8
8a
Selection
✓ Mask

All ⌘A
Deselect ⌘D
Reselect ⇧⌘D
Inverse ⇧⌘I

Feather... ⌥⌘D
Modify ▶

Grow
Similar

Load Selection...
Save Selection...
8b elete Selection...

7 Increase the size of the brush tip and use it to paint over the area above the mask line border. Take your time and carefully mask over the entire area. Take extra care not to paint any areas below the thin, masked border line.

8 Change the mode of the Selection Brush from Mask to Selection to convert the masked area to a selection. The masked area will automatically lie outside of the selection, so to switch this, choose Select > *Inverse* from the menu.

10

11

11a

12

	Solid Color...
	Gradient...
	Pattern...
	Levels...
	Brightness/Contrast...
	Hue/Saturation...
	Gradient Map...
	Photo Filter...

12a Color Picker

12b

13

Levels...
Brightness/Contrast...

13a

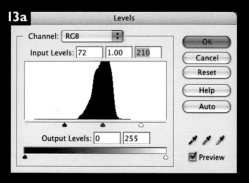

Levels

Channel: RGB
Input Levels: 72 1.00 210

OK
Cancel
Reset
Help
Auto

Output Levels: 0 255

☑ Preview

14

Hue/Saturation

Edit: Master

Hue: +180
Saturation: 0
Lightness: 0

OK
Cancel
Help

☐ Colorize
☑ Preview

14a

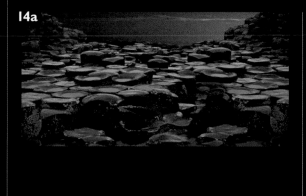

15

Layers More ▶
Overlay Opacity: 100%
Lock:

Layer 2 copy
Hue/Saturation 1
Levels 1
Color Fill 1
Layer 2
Layer 1 copy
Layer 1
Background

15a

Size: 454 px Mode: Brush Opacity: 100%

15b

11 Click and drag outside the bounding box to rotate the content a little. Press the Enter key on the keyboard to apply the transformation. Hold down the Ctrl/Cmd key and click on the sky layer thumbnail in the Layers palette to generate a selection from the layer content.

12 With this selection active, create a new solid color layer in the Layers palette. Choose a dark gray color from the picker and click on the OK button. In the Layers palette, change the blending mode of the layer to Color and reduce the opacity to 59%.

13 Ctrl/Cmd+click on the solid color layer mask thumbnail in the Layers palette to generate a selection from the mask. With the selection active, create a new Levels adjustment layer in the Layers palette. Drag the left and right Input Levels sliders toward the center of the histogram to increase the contrast.

14 Generate a selection from this adjustment layer's mask. With the selection active, create a new Hue/Saturation adjustment layer. Drag the Hue slider to the far right to shift the color of the sky from blue to orange.

15 Duplicate the sky layer and drag it to the top of the Layers palette. Change the blending mode of the duplicate layer to Overlay. Select the Eraser tool and, using the same tip preset but a little larger, erase just the top portion of this layer.

THE CREATURES COME TO LIFE

16 Open the stone steps image that we'll use as a base for the creatures. Copy and paste or drag it into the working file as a new layer. Drag it down in the Layers palette so that it resides directly above the causeway layers. Use the Move tool to drag it down and to the right within the image.

17 Select the Eraser tool. Choose a hard, round brush tip preset and an opacity setting of 100%. Use the Eraser to remove everything from this layer except the largest stone slab and a couple of smaller ones to the left.

18 Link the two Giant's Causeway layers in the Layers palette and then merge them into a single layer. With the merged layer selected, choose *Enhance > Adjust Color > Replace Color*. When the Replace Color dialog box opens, use the Eyedropper to click on a blue/gray area of your image.

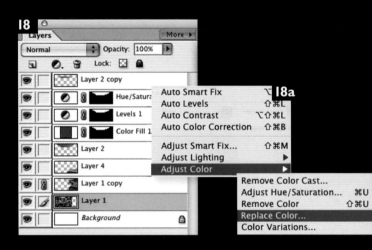

TIP Adjustment layer masks

1 The Eyedropper allows you to sample a color from your image. You can use the two extra eyedroppers to add or remove ranges of color from the desired color range.

2 The color you sampled from your image is displayed here for reference.

3 Enabling the Preview allows you to witness the results in the image window in real time as you work.

4 The Fuzziness slider allows you to expand or reduce the range of color by specifying an amount that determines which neighboring color ranges will be included.

5 There are two options for the thumbnail preview. You can either view the selected areas as white against black, or preview the image itself.

6 Color adjustments are achieved via a set of sliders identical to the Hue/Saturation adjustment tools.

7 The final result of your color adjustment is displayed here for reference.

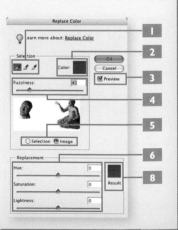

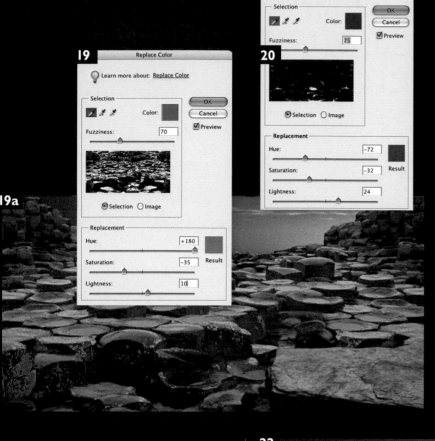

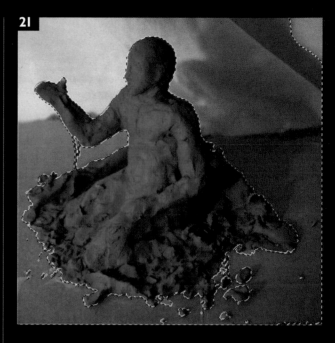

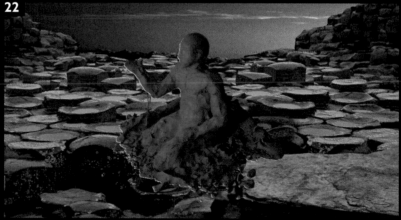

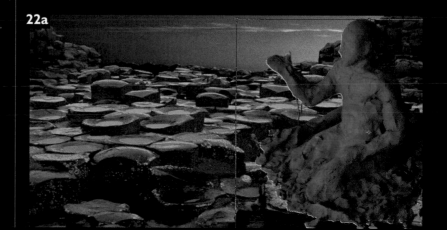

19 Increase the fuzziness to about 70 to select a larger range of color. Adjust the Hue setting to +180, reduce the Saturation to -35 and increase the Lightness by 10. This miraculously transforms the selected color range and creates a surreal alien environment that matches nicely with the stone slab layer.

20 After pressing OK, launch the Replace Color feature again. This time, use the Eyedropper to click on one of the green plants in the image to sample the green range of color. Increase the Fuzziness to 75 to ensure all green areas are selected. Set the Hue to -72, the Saturation to -32, and the Lightness to 24.

21 Open the first sculpture file. Select the Magic Wand tool. Leave the Tolerance set at the default setting of 32. Ensure that the Contiguous option is enabled. Click on an area of the background to select it, then hold down the Shift key and click on other areas to add them to the selection.

22 When you have selected as much of the background as you can, type Ctrl/Cmd+Shift+I to invert the selection. Copy the selected area and paste it into your working file as a new layer. Use the Move tool to drag the sculpture to the lower right corner. Shift+drag a corner point of the bounding box outward to proportionally increase the size.

25

23

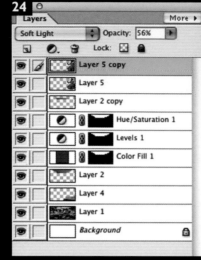

24

23a

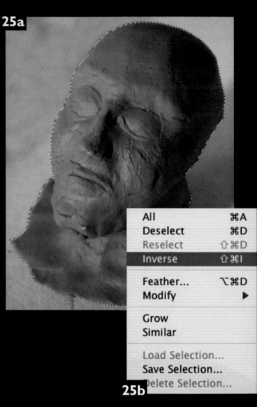

25a

23b

24a

24b

All		⌘A
Deselect		⌘D
Reselect		⇧⌘D
Inverse		⇧⌘I
Feather...		⌥⌘D
Modify	▶	
Grow		
Similar		
Load Selection...		
Save Selection...		
Delete Selection...		

25b

23 Use the Eraser with a hard, round brush tip preset to remove unwanted bits including the sculpture's hand and a great deal of the background clay above his knee. Now choose a soft brush tip preset and use it to erase areas along the bottom that you want to blend into the stone slab.

24 Duplicate the layer and change the blending mode to Soft Light. Reduce the opacity to 56%. We'll use an image of pieces of clay to help blend the sculpture with the causeway. Open up the image, and use the Magic Wand like you did previously with the sculpture image to select the background. Invert the selection, then copy and paste it into the working file as a new layer.

25 Use the Move tool to resize, rotate, and position the pieces at the left of the statue's base. Select the Eraser tool again. Use a soft tip to erase the hard edges where you want the pieces to blend into the stone slab and statue. Open up the second sculpture image. Again, use the Magic Wand to select the background and then invert the selection.

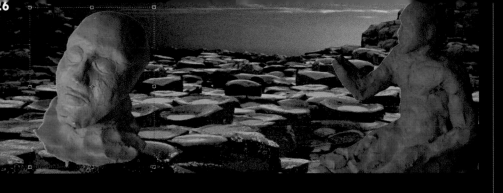

26 Copy the sculpture head selection and paste it into the working file. Use the Move tool to position it toward the left of the image. Select the Eraser tool and using a hard, round, brush tip preset, remove unwanted side areas and make the bottom look as if it's sitting on the rock formations. Switch to a soft brush tip and using a lower opacity setting, erase the left side of his neck.

27 We'll now blend a human model with the sculpture. Open the model image, and use the Lasso tool to draw, with the Add to selection button enabled, three rough selections around his face, arm, and chest. Copy the active selection areas and paste them into the working file as a new layer. Enable the New selection button, then select each different piece and position them within the layer so that they line up with the sculpture underneath.

28 Use the Eraser tool, first with a small, round, hard brush tip preset and opacity setting of 100%, to erase carefully around the model's hand as well as remove other areas that require precision. Then switch to a soft, round brush tip and use a variety of brush sizes and opacity settings to soften the edges of his body parts as well as do things like remove the eyes from this layer.

29 We'll use the same technique to blend an image of an eye with the second sculpture head. Open the image, and draw a rough Lasso selection around one eye. Bring it into the working file, and use the Move tool to position it over the head. Rotate and scale it as needed. Use the Eraser tool to soften the edges of the eye. Finally, change the layer blending mode to Overlay.

6a

26b

27

Feather: 0 px ☑ Anti-aliased

7a

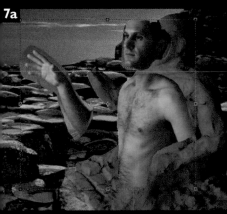

28

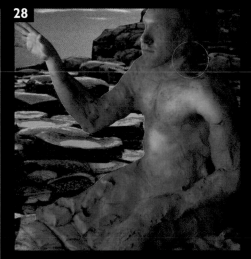

29a

7b

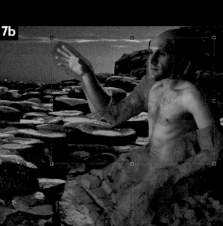

29

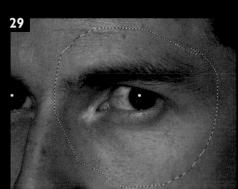

29b

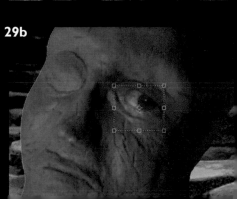

30 Link all of the clay sculpture and body parts layers in the Layers palette and merge them into a single layer. Choose *Enhance > Adjust Color > **Adjust Hue/Saturation*** from the menu. Change the Hue to +22 and reduce the Saturation to -73.

31 Choose *Enhance > Adjust Lighting > **Brightness/Contrast***. Increase the Contrast by +15. Choose *Enhance > Adjust Color > **Replace Color***. Sample a light area from the creature's face. Increase the Fuzziness to get a broad range and alter the settings to give the layer a desaturated pink clay appearance. Press OK.

32 Launch the Replace Color tool again. This time, sample one of the lightest areas you can find and use a lower Fuzziness setting. Adjust the settings to turn the highlights to a light blue color similar to that of the highlights on the background rocks. Press OK to apply the effect.

33 Launch the Replace Color tool one final time. Click on a shadow area and then Shift+click on similar shadow areas to add them to the range. Use an even lower Fuzziness setting this time so that the range doesn't stray too far. Adjust the settings so that the shadows are a desaturated purple-blue color.

30

30a

30b

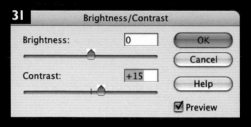

31

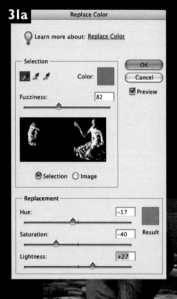

31a

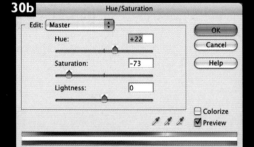

31b

31c

TIP **Resetting Replace Color**
If you find that things haven't quite gone the way you expected when using the Replace Color tool, you don't have to cancel and relaunch. All you need to do is hold down the Alt/Opt key and the Cancel button will turn into a Reset button. Click on the Reset button to revert to the state before any adjustments were made.

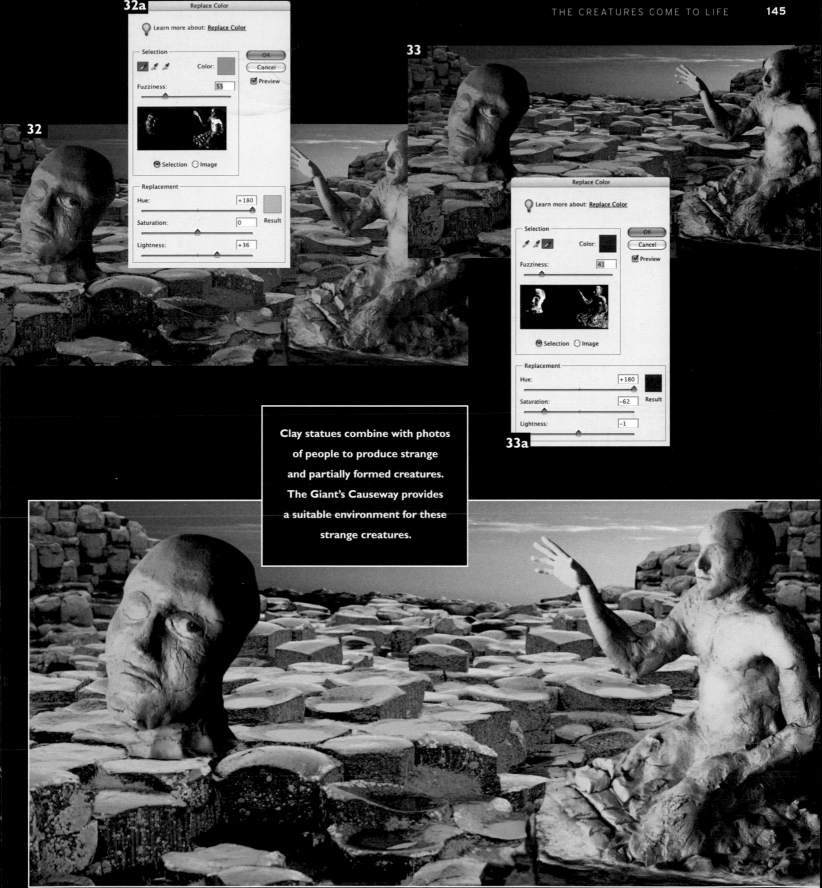

32a

Replace Color

Learn more about: **Replace Color**

Selection

Color:

Fuzziness: 53

● Selection ○ Image

Replacement

Hue: +180

Saturation: 0 Result

Lightness: +36

32

33

Replace Color

Learn more about: **Replace Color**

Selection

Color:

Fuzziness: 41

● Selection ○ Image

Replacement

Hue: +180

Saturation: -62 Result

Lightness: -1

33a

Clay statues combine with photos
of people to produce strange
and partially formed creatures.
The Giant's Causeway provides
a suitable environment for these
strange creatures.

A CITY IN THE CLOUDS

Science-fiction films often feature cities floating high above the Earth's surface. Whatever the reason, environmental destruction or simply a lack of space on the ground, floating cities are cool and we're going to show you how you can design your own with nothing more than some digital photos and a copy of Photoshop Elements.

You will find that the real trick to this scene is getting the clouds to work. Worry not, as we explain which blending mode and method to use and how to alter image luminance. We might even let you in on how we got those skyscrapers to stay up there.

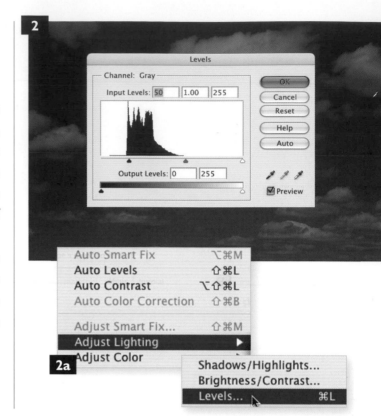

1 Open an image of a sunrise to act as the backdrop for our working layered file. Next, open up a sky image with individual clouds. Although this is a nice photo of a blue sky and fluffy clouds, we'll need to convert it to grayscale. Choose *Image > Mode > Grayscale* from the menu.

2 Now we really need to increase the contrast and reduce the tonal range of this flat image. Choose *Enhance > Adjust Lighting > Levels* from the menu. Drag the left Input Levels slider to the right, darkening the shadows, until the numeric field reads 50.

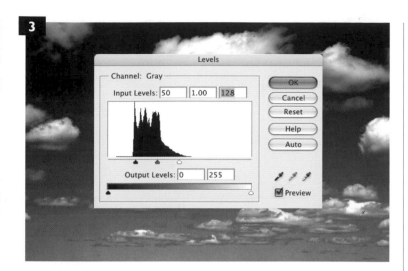

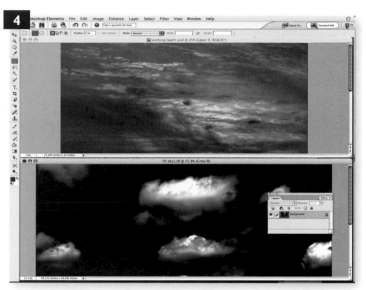

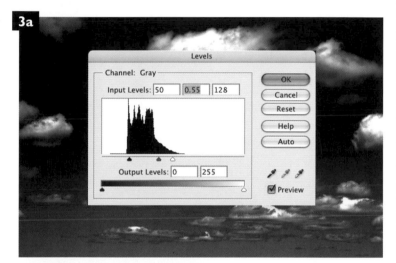

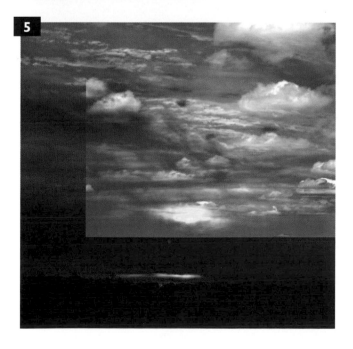

3 Drag the right Input Levels slider to the left, lightening the highlights until its numeric field reads 128. Now drag the middle Input Level slider to the right, darkening the midtones until its numeric field reads 55. This is a quite drastic adjustment, but entirely necessary as you'll soon discover.

4 Apply the Levels adjustment, and click on the Automatically Tile Windows button at the upper right to view both images simultaneously. In the Layers palette, click on your background layer containing the grayscale clouds and drag the layer thumbnail across to the other image. This will add the clouds image to the sunrise image as a new layer.

5 Close the adjusted clouds image. In the working file, change the blending mode of the grayscale clouds layer to Screen in the Layers palette. You'll notice all of the dark areas disappear, leaving only the light areas visible.

A CITY IN THE CLOUDS

6

6a

7

8a

Rotate ▶
Transform ▶
Crop
Divide Scanned Photos
Resize ▶

Mode ▶

Flip Horizontal
Flip Vertical

Free Rotate Layer
Layer 90° Left
Layer 90° Right
Layer 180°
Flip Layer Horizontal
Flip Layer Vertical

Straighten and Crop Image
Straighten Image

8b

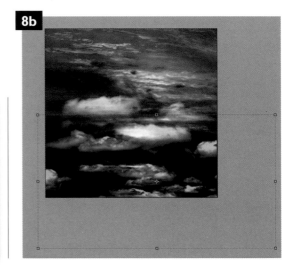

7a

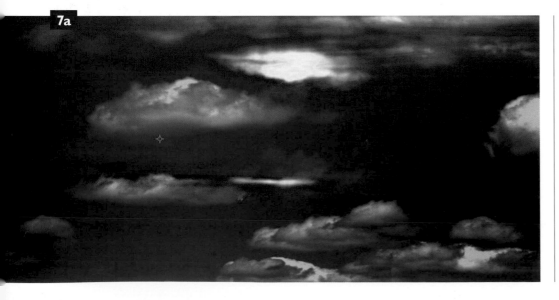

6 Select the Move tool and move the cloud layer down within the image. Then grab the center handle of the left side and drag it outwards, increasing the size of the layer horizontally. Reduce the opacity of the clouds layer to 81%.

7 Choose *Enhance > Adjust Lighting > **Levels*** from the menu. Drag the left Input slider a little to the right to darken the shadow areas, removing some of the darker gray mist from the bottom, which was caused by haze in our original clouds photo.

8 Duplicate the layer, then choose *Image > Rotate > **Flip Layer Horizontal*** from the menu. Use the Move tool to drag the layer content down and a little toward the right of the canvas. Select the Eraser tool.

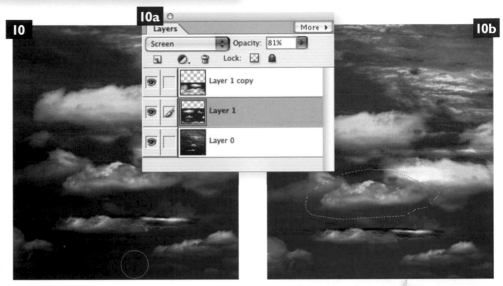

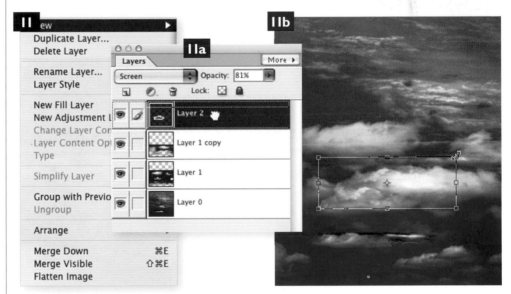

9 Set the opacity of the Eraser to 50% and choose a large, soft, round brush tip preset in the Options Bar. Erase areas of cloud on this layer that aren't necessary, for example the clouds along the bottom. Increase the brush size where necessary and paint over areas more than once to completely remove them.

10 Select the original clouds layer in the Layers palette. Use the Eraser on this layer to remove some of the clouds from along the bottom of the layer. Choose the Lasso tool and draw a rough selection around the cloud just left of center on this layer.

11 Choose *Layer > New > **Layer Via Copy*** from the menu. Drag your new layer to the top of the Layers palette, then use the Move tool to drag the layer upwards and a little to the left. Hold down the Shift key and drag one of the corner points outwards to slightly increase the size of the cloud.

12 Duplicate the layer. Use the Move tool to drag the layer up and to the left. Hold down the Shift key and drag a corner point outward to substantially increase the size.

TIP

Play it safe
Before erasing something from your original clouds layer, it's a good idea to create a duplicate of the layer first. Disable the visibility of the duplicate layer and keep it as an insurance policy. By doing this, you ensure that you can start over if things don't work out as planned.

A CITY IN THE CLOUDS

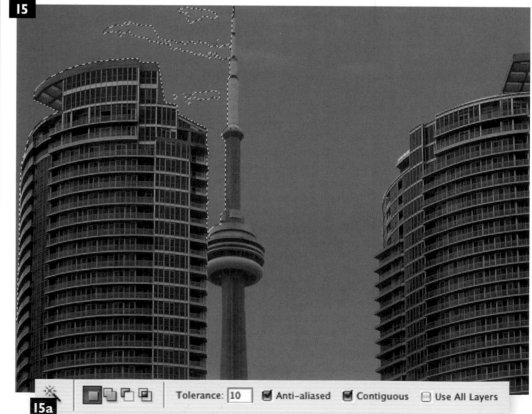

13 Return to the original clouds layer in the Layers palette and this time, use the Lasso tool to draw a closed selection. Press Ctrl/Cmd+J to create a new layer with the copied selection content. Drag the new layer to the top of the Layers palette.

14 Choose *Image > Rotate > **Flip Layer Horizontal*** from the menu, then select the Move tool and drag the layer content up and to the right of the canvas. Hold down the Shift key and drag a corner point of the box outward to increase the selection size and move it further to the right.

15 Now it's time to add the buildings. Open the image and select the Magic Wand tool. Set the Tolerance to 10 and ensure that the Contiguous option is enabled. If disabled, it will be difficult to isolate the buildings, certain areas being very similar in color and value to the sky. Click on the upper left area of the sky.

16 ☐ ☑ ☐ ☐ Tolerance: 10 ☑ Anti-aliased ☑ Contiguous ☐ Use All Layers

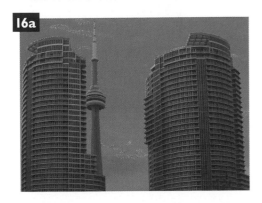

16a

17

All ⌘A
Deselect ⌘D
Reselect ⇧⌘D
Inverse ⇧⌘I

Feather... ⌥⌘D
Modify ▶

Grow
Similar

Load Selection...
Save Selection...
Delete Selection...

17a

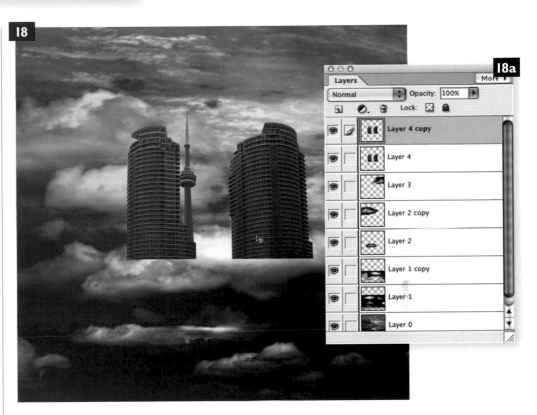

18

18a

16 Click on the Add to selection button in the Options Bar (or hold down the Shift key when you use the Magic Wand tool). Click on another area of the sky to add it to the selection.

17 Continue clicking on all unselected areas of the sky until the entire sky area is within the selection border. Choose Select > *Inverse* from the menu (or press Ctrl/Cmd+Shift+I) to select the buildings. Choose Edit > *Copy* (or use Ctrl/Cmd+C) to copy the selected buildings and then return to the working file.

18 Paste the buildings into the working file as a new layer. Hold down the Ctrl/Cmd key to temporarily switch to the Move tool from the Magic Wand tool and move the buildings to where they sit nicely on top of the main cloud bank. Duplicate the buildings layer.

TIP

Choosing the right blending mode
When you first paste the clouds into the file, altering the blending mode is the factor that will make the result believable. In this case, we knew we wanted only the light areas to appear, so the first impulse was to try any mode with a similar name. Here are some other modes that we tried before settling on the Screen mode. In some cases, it's obvious why we didn't use certain modes, while others show a more subtle difference. Don't be afraid to try different things and experiment. You can always switch your blending mode back.

Original image

Lighten
Subtle edges are lost.

Color Dodge
Looks like an overexposed photograph in places.

Hard Light
This obviously won't do.

Soft light
Not as bad, but still not good enough.

Vivid light
A different effect altogether, but now you see why we settled on Screen.

A CITY IN THE CLOUDS

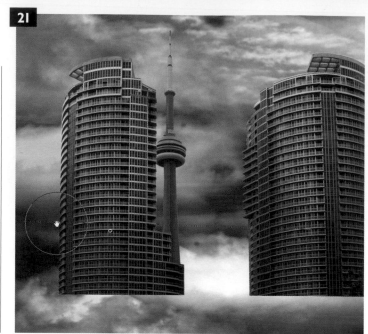

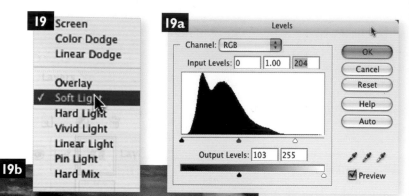

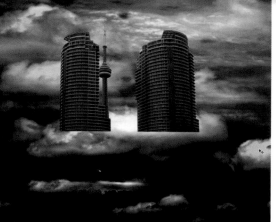

19 Change the blending mode of the duplicate layer to Soft Light. Choose *Enhance > Adjust Lighting > **Levels*** from the menu. Drag the right Input Levels slider to the left to lighten the highlights. Drag the left Output Levels slider to the right to lighten the shadows.

20 Duplicate the original building layer again and drag it to the top of the Layers palette. Change the blending mode of the layer to Screen. Press Ctrl/Cmd+L to quickly access the Levels dialog box. Drag the left Input Levels slider to the right to darken the shadows on this layer.

21 Select the Eraser tool. Leave the tool options set to their previous setting and use the Eraser to remove the sides and bottom areas of the buildings so that the layer provides a highlight enhancement only in the remaining areas.

22 Link all three building layers in the Layers palette and then type Ctrl/Cmd+E to merge them into a single layer. Keep the soft brush tip preset but set the size of it to 150 and set the opacity to 50%. Erase the bottom of the buildings so that it looks like they're buried in fog.

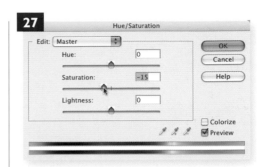

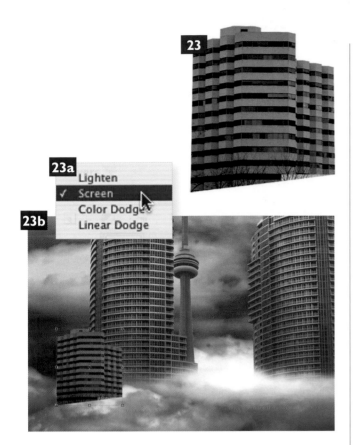

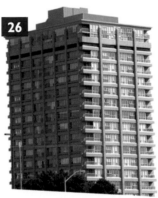

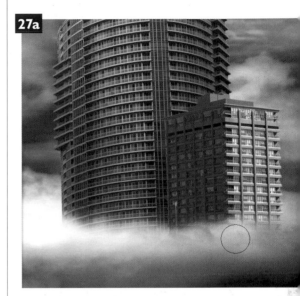

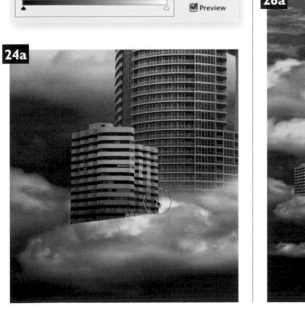

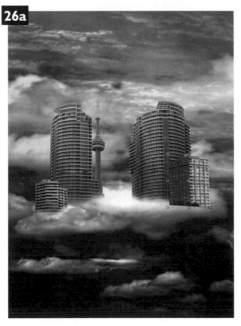

23 Open up the second building image. Use the Move tool to drag the building into the working file as a new layer. Position it to the lower left of the other buildings in the scene. Duplicate the layer and change the blending mode of the duplicate layer to Screen.

24 As before, use Levels to darken the shadows via the Input Levels left slider. Select the Eraser and use it to remove areas of the building that you do not wish to use as highlights. Reduce the opacity of the layer to 90%.

25 Link the two single building layers in the Layers palette and then merge them into one. Use the Eraser to remove the bottom of the building, making it look like it's buried in fog. Use lighter opacity settings, like 25, for a gentler blend effect.

26 Open the a third image of a building. By now we're certain you're getting the hang of this. Use the Move tool to drag the layer into the working file and position it in front and to the right of the other buildings. This building already has a natural highlight so there is no need to create a Screen duplicate layer.

27 The color of this building is a little saturated in comparison to the others, so choose *Enhance > Adjust Color > **Adjust Hue/Saturation*** to reduce the Saturation a little and then click OK. Select the Eraser tool and soften the bottom of this building, too.

A CITY IN THE CLOUDS

28 Hold down the Ctrl/Cmd key and click on the main building layer thumbnail to generate a selection around the group of buildings. Create a new layer in the Layers palette and drag it down to where it rests just above the main buildings layer. Change the blending mode to Multiply.

29 Select the Brush tool. Use a large, soft, round brush tip and a low opacity setting to paint black inside of the selection area on the new layer. Paint behind the two foreground buildings to create shadows.

30 Deactivate the current selection and then choose your original clouds layer in the Layers palette. Use the Lasso to draw a rough selection around a group of the lower clouds and then type Ctrl/Cmd+I to create a new layer via copy. Drag this new layer to the top of the Layers palette.

31 Use the Move tool to drag the layer up and to the left so that the clouds overlay the left-most buildings. Alt/Opt+click on the cloud layer and drag to another part of the image, creating a duplicate layer.

32 Use this method to add a number of different cloud layers throughout the image. Feel free to vary the size of the clouds as well as the opacity from layer to layer. Also, move the cloud layer up and down within the Layers palette so that some buildings have clouds between them.

TIP **Dragging copies**
When you hold down Alt/Opt while using the Move tool, and click and drag on a layer, it will duplicate the entire layer in the Layers palette. However, if you have a selection active, and Alt/Opt click and drag within the selection border, you will duplicate the contents of your selection on the current layer.

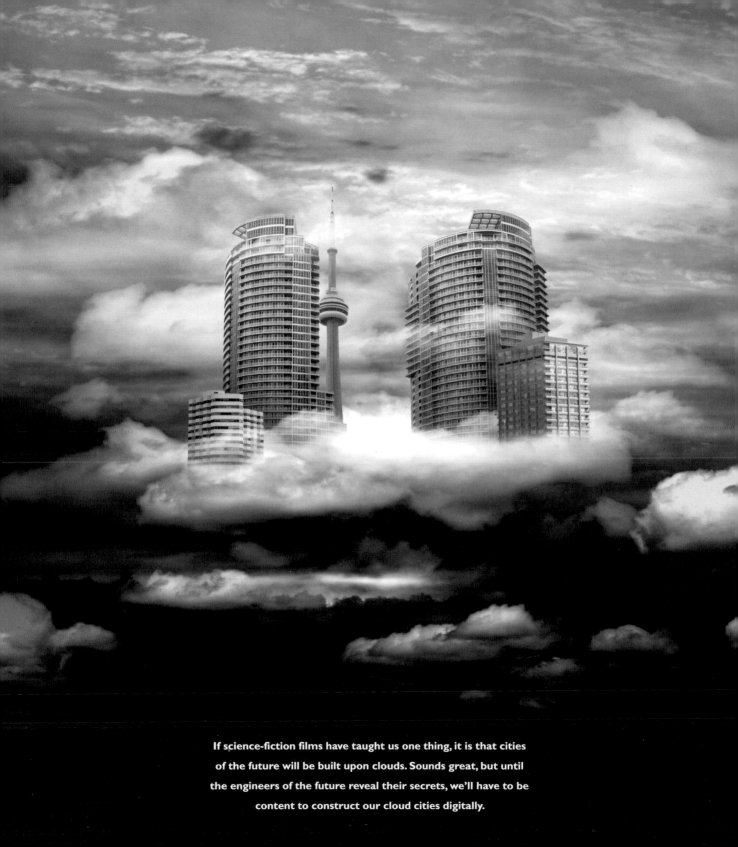

If science-fiction films have taught us one thing, it is that cities of the future will be built upon clouds. Sounds great, but until the engineers of the future reveal their secrets, we'll have to be content to construct our cloud cities digitally.

MEDUSA UNDER THE SEA

Deep, deep, beneath the sea live creatures we can only dream of. Alongside this particular coral reef resides a beautiful and exotic creature of our own creation. She has a Medusa-style mane made up of octopus tentacles and she's been living under the water for so long that her complexion is a beautiful shade of aquatic blue. She wasn't always this way though. Our model is a mere mortal who had her picture snapped one sunny day in the pool. Not only that, but our deep, dark reef is actually a photo of a shallow reef, visited often by recreational divers.

The tentacles are another story. Her hair (if you can call it that) was purchased in the form of a baby octopus at a local fish market. The octopi, along with the fish, were actually photographed outside because they really started to smell bad after sitting under a pair of hot lights. After gathering all of the photographic materials, we brought everything into Elements. In the following pages we'll explain in depth how everything came together to create this magical underwater scene.

1 We're using a background image of a coral reef. Unfortunately, our image also contains a scuba diver, who will need to be removed before we move on. Create a new layer in the Layers palette, and select the Clone Stamp tool. Starting with a very large, round, brush tip preset, set the opacity to 100% and ensure that the Use All Layers option is enabled. Zoom in on the diver.

2 Alt/Opt click on an area to the diver's left and then use this sampled area to paint over part of her. Frequently choose different source points and paint over the entire diver using the Clone Stamp. Switch to a smaller brush tip when you are working closer to, and cloning over, the coral.

3 No matter how careful you are when cloning, there will always be areas that could be better blended. For help with this, select the Healing Brush. Create a new layer in the Layers palette. Select a large, soft, round brush tip and enable the Use All Layers option. Use the Healing Brush exactly like the Clone Stamp to sample and paint over areas containing overly sharp divisions of color.

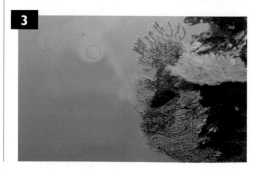

4 As you paint, you'll notice the automatic blending of texture, lighting, and shading. This is an excellent method for smoothing areas that you've cloned excessively. Take your time and sample from a variety of sources. You may have to paint over areas a few times to get them smooth, but the results are worth it.

5 The reason we have separated the cloning and healing into different layers is so that you can edit each layer individually. Now that you see the final results, use the Eraser to remove any unwanted areas from either layer. When you're happy with the results, flatten the image.

6 To heighten the contrast and darken the shadows quickly, duplicate the layer and change the blending mode to Hard Light. Reduce the opacity of the duplicate layer to 56% to soften the effect a little. Create a new Hue/Saturation adjustment layer.

7 Change the Hue to -13 so that the scene is a little greener than it was. Change the Saturation to -36 to lessen the intensity of color. Once you've adjusted the hue and saturation, create a new Levels adjustment layer in the Layers palette.

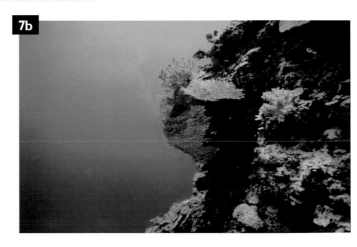

TIP

Healing Brush presets
You'll notice that when you access the brush tip preset picker while using the Healing Brush, it is quite different from what is offered when using other tools. The familiar list of strange and exotic brushes is absent and this small interface appears it its place. This interface allows you to use round brush tips only. However, there is still a great deal of flexibility when it comes to size, angle, spacing, and hardness. Try creating a few of your own.

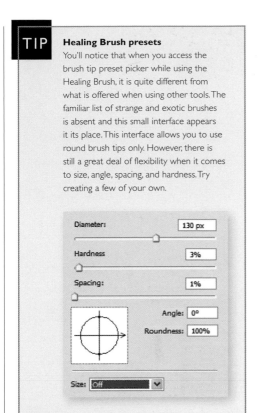

TIP

Jumping back and forth
Using the Clone Stamp and Healing Brush together is an excellent way to execute perfect repairs on sections of your images. When you're on a roll, you can switch back and forth between the tools. An easy way to jump back and forth is to use keyboard shortcuts to access the tools. Press "S" on the keyboard for the Clone Stamp, and press "J" for the Healing Brush.

MEDUSA UNDER THE SEA

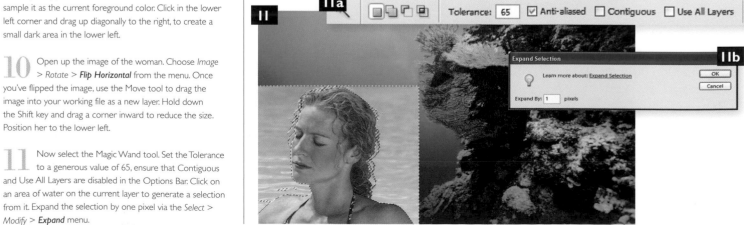

8 Drag the left and right Input Levels sliders toward the center of the histogram, increasing the contrast in all color channels. Create a new layer and select the Gradient tool. Select the Foreground to Transparent preset and the Linear gradient method. Set the opacity to 50%.

9 Hold down the Alt/Opt key to temporarily access the Eyedropper tool. Click on a dark area of the reef to sample it as the current foreground color. Click in the lower left corner and drag up diagonally to the right, to create a small dark area in the lower left.

10 Open up the image of the woman. Choose *Image* > *Rotate* > **Flip Horizontal** from the menu. Once you've flipped the image, use the Move tool to drag the image into your working file as a new layer. Hold down the Shift key and drag a corner inward to reduce the size. Position her to the lower left.

11 Now select the Magic Wand tool. Set the Tolerance to a generous value of 65, ensure that Contiguous and Use All Layers are disabled in the Options Bar. Click on an area of water on the current layer to generate a selection from it. Expand the selection by one pixel via the *Select* > *Modify* > **Expand** menu.

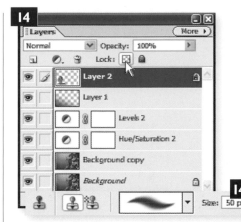

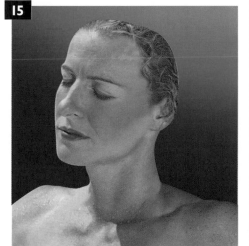

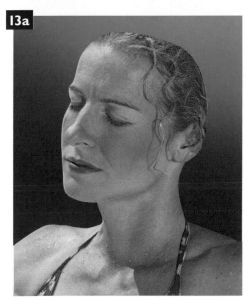

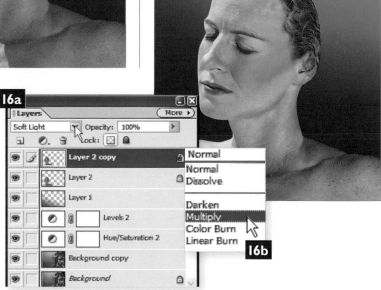

12 Press the Backspace key on your keyboard to delete the content of the selection, then type Ctrl/Cmd+D to deactivate the selection. Select the Eraser tool and choose a hard, round brush tip preset.

13 With the opacity set to 100%, zoom in closely and begin to smooth the rough edges created by the Magic Wand. Erase any leftover background, stray bits of hair, etc. Also, erase the back of her head—she won't be needing it!

14 Enable the transparency lock for this layer in the Layers palette. Select the Clone Stamp tool. Choose a soft, round brush tip preset of about 50 pixels. Use the Clone Stamp to clean the hair off of her forehead. Remove any stray bits, replacing them with sampled areas of skin.

15 When you have removed all of the stray hairs from around her face, use the Clone Stamp tool to replace her bathing suit with sampled bits of skin. Remember that you can use the Healing Brush to perform additional smoothing, just like with the water in the background.

16 When you're finished healing and cloning, duplicate the layer in the Layers palette. Change the blending mode of the duplicate layer to Soft Light. This saturates the color and increases the contrast, but we still need to darken certain areas of color so that she looks as if she belongs in her environment. Duplicate the top layer and change the blending mode to Multiply.

MEDUSA UNDER THE SEA

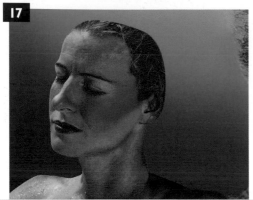

17 The blending mode change will leave her too dark. Select the Eraser tool. Using a large, soft, round brush tip and an opacity setting of 100%, erase areas of this layer that aren't in need of darker shadows, like her face and chest.

18 Ctrl/Cmd+click on the bottom-most layer thumbnail of the woman to generate a selection from its content. With the selection active, select the top-most layer in the Layers palette and then create a new Levels adjustment layer. Drag the left Input Levels slider inward to darken the shadows and drag the right Input slider just a little to the left to lighten the highlights.

19 Now open up the image of the octopus. Bring it into the working file as a new layer. Reduce the opacity of the layer so that you can see the underlying layers. Select the Move tool and proportionally reduce the size of the size of the bounding box. Position it over the woman's head and rotate it so that the tentacles look like her hair.

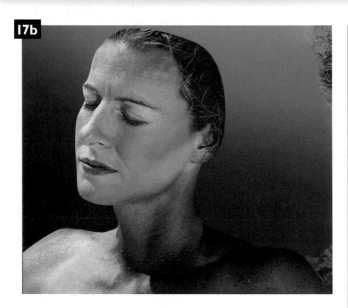

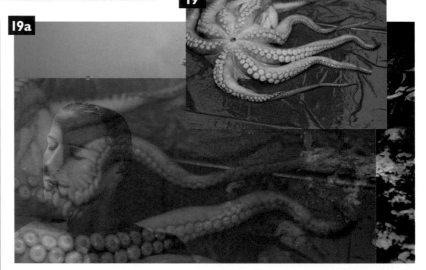

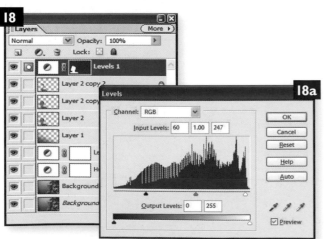

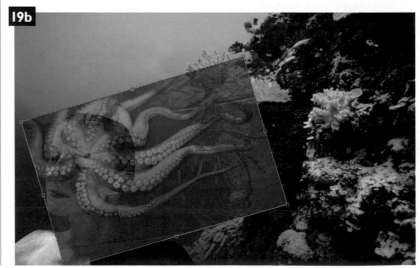

20

21
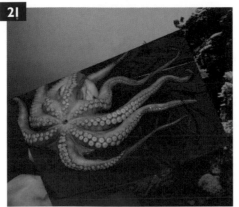

21b
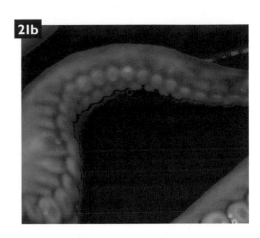

20a
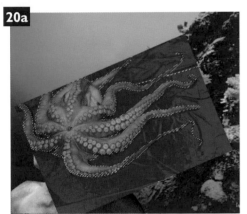

21a
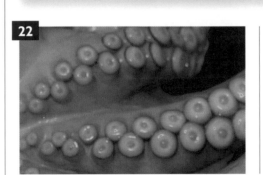

Size: 10 px ▶ Mode: Mask ▼ Hardness: 100% ▶ Overlay Opacity: 50%

22

23
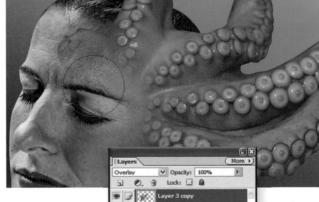

20b
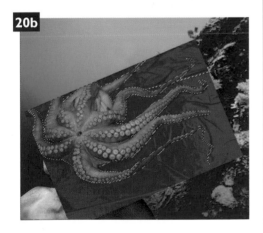

22a

Select	
All	Ctrl+A
Deselect	Ctrl+D
Reselect	Shift+Ctrl+D
Inverse	Shift+Ctrl+I
Feather...	Alt+Ctrl+D
Modify	▶
Grow	
Similar	
Load Selection...	
Save Selection...	

23a

23b

Layers — More ▶
Overlay ▼ Opacity: 100% ▶
Lock: ☒ ☐

Layer 3 copy
Layer 3
Levels 1
Layer 2 copy 2
Layer 2 copy
Layer 2
Layer 1
Levels 2
Hue/Saturation 2
Background copy
Background

20 Select the Magic Wand tool. Leave the Tolerance set to 65 and Contiguous disabled. Click on a pink area of the octopus to select it. Reduce the Tolerance to 30, then hold down the Shift key and click on an unselected area of darker pink to add it to the selection. Continue to Shift+click on unselected pink areas until you have selected most of the octopus.

21 Choose the Selection Brush tool set to Mask mode. Select a small, hard, round brush tip preset. Zoom in and paint over any areas of background that aren't already masked. When you have masked the entire background, look for areas within the octopus that are masked, but shouldn't be.

22 Hold down the Alt/Opt key while painting over these areas to remove any unwanted masking, ensuring that they will be included within the selection. Select the Eraser tool to convert the mask to a selection. Choose *Select > Inverse* from the menu to invert the selection.

23 Press the Backspace key to remove the content of the inverted selection and then type Ctrl/Cmd+D on the keyboard to deactivate the selection. Use a large, soft, brush tip preset and an opacity setting of 100% to erase areas on the layer that currently overlap her face. Duplicate the layer and change the blending mode of the duplicate layer to Overlay.

MEDUSA UNDER THE SEA

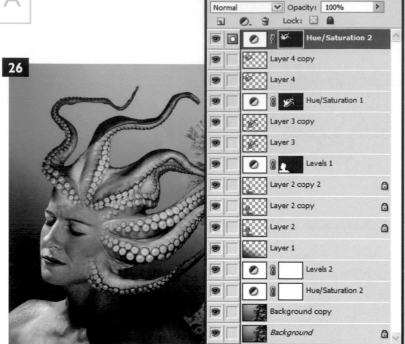

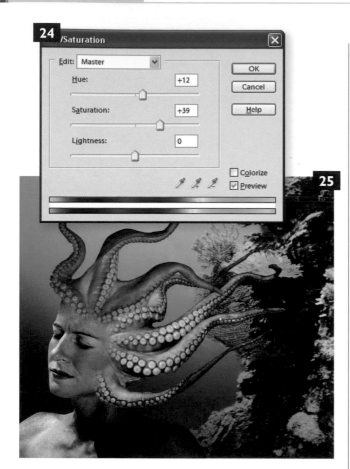

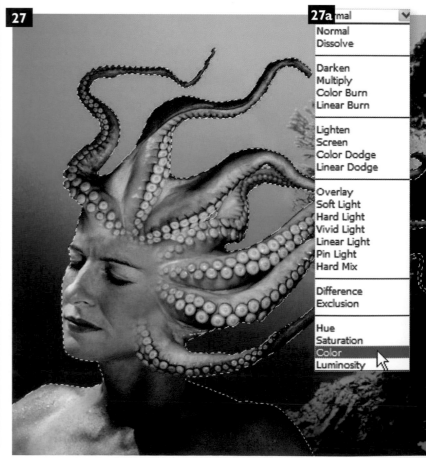

24 Ctrl/Cmd+click on the layer thumbnail to generate a selection from the layer's content. With the selection active, create a new Hue/Saturation adjustment layer. Change the Hue to +12 and the Saturation to +39.

25 Open up the second octopus image and drag it into the file. Resize it and position it over the top part of her head. Use the same Magic Wand/Selection Brush method to isolate it from, and remove the background. Use a soft eraser to remove the area where it overlaps her head.

26 Follow the same procedure as with the other octopus. Duplicate the layer, change the mode to Overlay and create a masked Hue/Saturation adjustment layer that performs the exact same adjustments. Ctrl/Cmd+click on the adjustment layer's mask in the Layers palette to generate a selection from it.

27 Holding down the Shift key, click on one of the other octopus layers and one of the complete woman layers to add the content of both to the active selection. Create a new layer in the Layers palette.

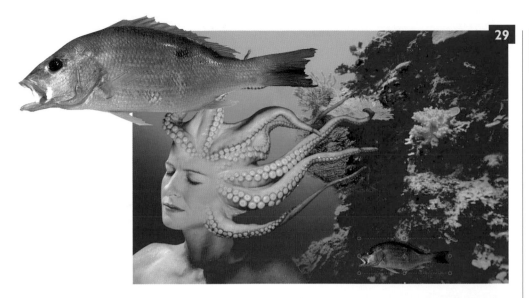

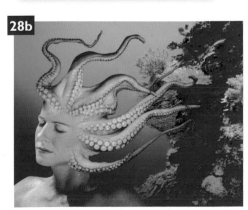

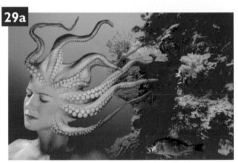

28 Sample a light blue color from the background with the Eyedropper tool. Fill the active selection with this color on the new layer. Deactivate the selection and reduce the opacity of the layer to 74%. Open an image of a fish. Happily, the one we're using has already been cut out from its background.

29 Drag the fish into your working file as a new layer via the Move tool. Reduce the size and position it against the reef. Duplicate the fish layer and change the blending mode to Soft Light. Then generate a selection from the fish layer and create a new layer above the two fish layers. Give this new layer a Color blending mode.

MEDUSA UNDER THE SEA

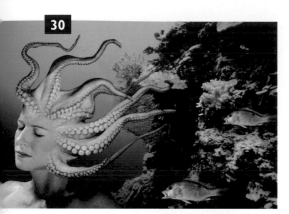

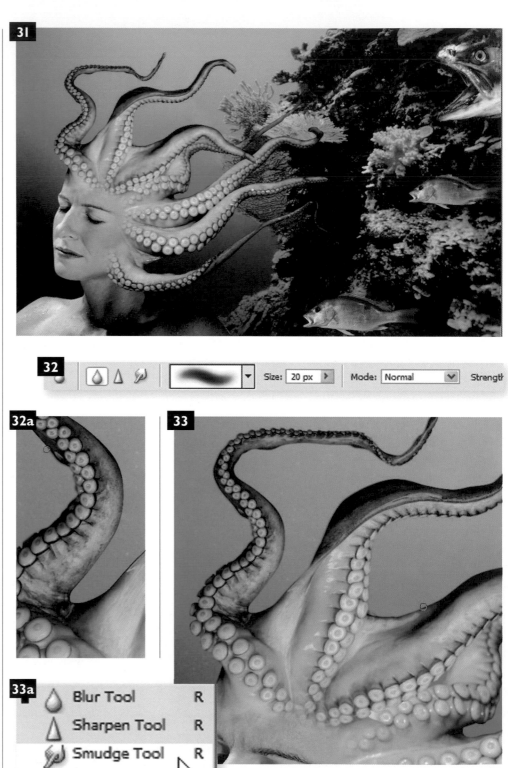

30 Fill the active selection on the new color layer with the same blue foreground color you used for the woman and tentacles. Deactivate the selection and then reduce the opacity of the layer to 64%. Use this same method to add another fish, this one turned blue, to the scene.

31 Our final image is of a large fish head. Open the file, and use the same method to bring the fish head into the scene, creating a duplicate layer with an altered blending mode, then generate a selection from it and fill it with blue on a color layer with reduced opacity.

32 Create a new layer in the Layers palette and select the Blur tool. Choose a small, soft, round brush tip preset and set the strength to 100%. Enable the Use All Layers function. Zoom in close on a sharp edge where the tentacles meet the background and paint over it on the new layer with the Blur tool.

33 Use the Blur tool to paint over every sharp edge where an object you've isolated meets the background. This will make elements look as if they belong within the scene and aren't merely pasted onto a background. When you're finished select the Smudge tool.

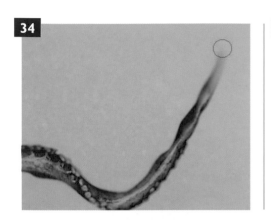

34 Specify a 40 pixel-wide, soft, round brush tip and set the Strength to 50%. Enable the Use All Layers function. Use the Smudge tool to smear blunt ends of things like tentacles, fish fins, and fish tails so that they are gradually blended into the background. Take your time and reduce the Strength setting for a less drastic effect.

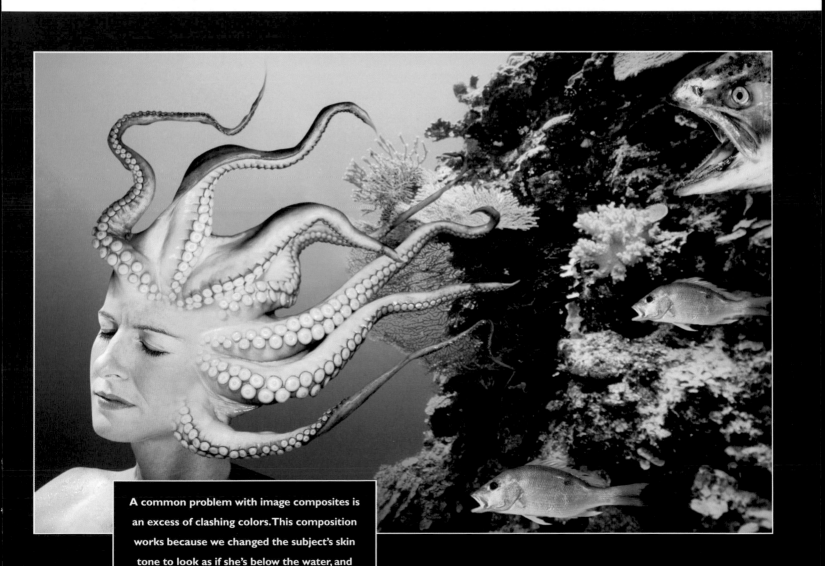

A common problem with image composites is an excess of clashing colors. This composition works because we changed the subject's skin tone to look as if she's below the water, and

TWO TOWERS BY THE SEA

The image we are creating here is intended to convey a sense of impending doom. The storm clouds and mist imply that danger may be only moments away. The two towering stone structures we are going to place on the cliffs will give the impression that they were built as watch towers to fight a centuries-old foe.

The feeling in this image is constructed entirely in Elements, as the source photos were all captured in pleasant enough weather. We'll show you how to combine them in a realistic way as well as reduce the color palette to give a blue-gray cast that certainly adds to the ominous mood. Finally, we'll explain in detail how to add the scratched surface to convey the feeling that we're looking out onto the scene from behind the aged glass of a castle window.

TIP

Canvas color

When you extend your canvas size, the extra area is filled with a flat color. There is a pull-down menu that lets you specify the color at the bottom of the Canvas Size dialog box. You choose the current foreground or background color, black, white, gray, or any color you desire from the picker.

1 Open the sky image. As the image area is not large enough to accommodate the other elements we plan to add, choose Image > Resize > *Canvas Size* from the menu.

2 In the Canvas Size dialog box, keep the Width setting, but increase the Height setting to 257mm. Click on the top center Anchor option so that the canvas will be added underneath. In this case, any of the top options would suffice because we aren't increasing the width. Press OK to increase the canvas size.

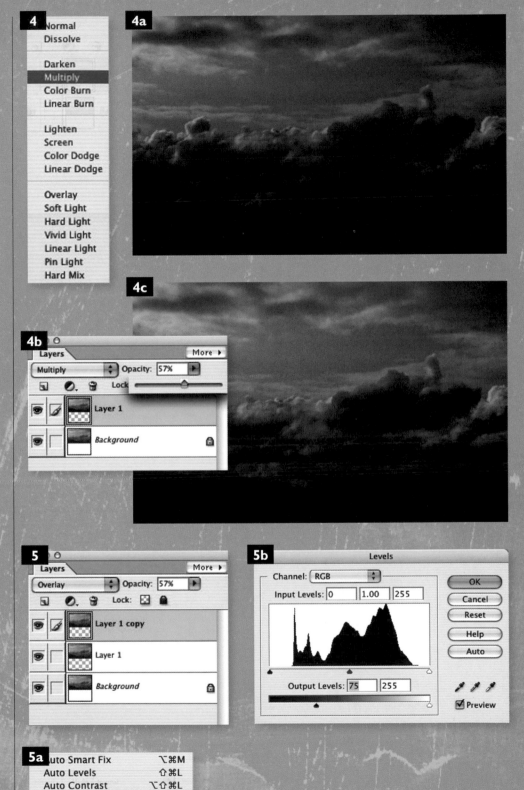

3 Choose the Rectangular Marquee tool and use it to draw a rectangular selection around just the sky portion of your background layer. To create a new layer containing a copy of the selection content choose *Layer > New > Layer Via Copy* from the menu.

4 We're going to use this layer to darken the sky on the layer underneath, so change the blending mode of the current layer to Multiply. As it appears far too dark, reduce the opacity of the layer in the Layers palette to 57%. This will help to lessen the effect.

5 Duplicate the layer and change the blending mode of the duplicate layer to Overlay. With the new layer selected, choose *Enhance > Adjust Lighting > Levels* from the menu. Drag the left Output Levels slider to the right to lighten the shadow areas of the layer.

TWO TOWERS BY THE SEA

6 Select the Eraser tool. Use a massive, soft, round brush tip preset and an opacity setting of 100%. Erase around the edges on this layer to reveal the dark Multiply effect underneath. After you erase the edges, increase the layer opacity a little.

7 When you are finished, choose *Layer > Flatten Image* from the menu to merge all of the layers into a single background layer. Choose *Filter > Blur > Gaussian Blur* from the menu. Enter a Radius of 3 pixels to slightly blur the image and remove the graininess.

8 Open up the cliffs picture file. Click the Automatically Tile Windows button so that you can see both images at the same time. Use the Move tool to click on the cliffs image and drag it into the working file as a new layer.

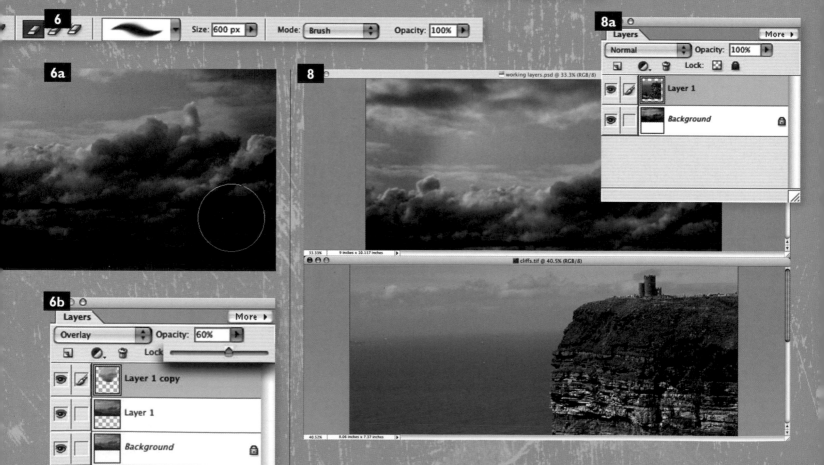

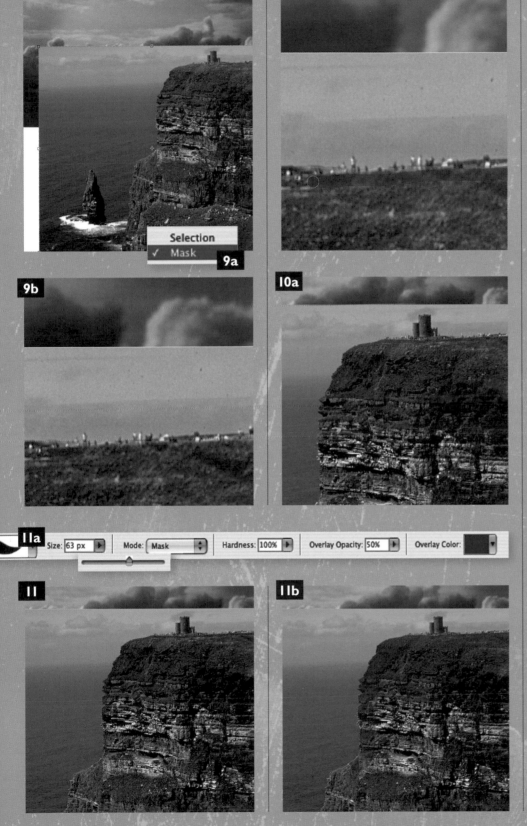

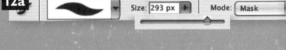

9 Drag the cliffs layer to the lower right of the image. Click the Selection Brush tool and choose a small, hard, round brush tip preset. Set the mode of the Selection Brush to Mask. Zoom in very close to the top of the cliff area at the right side.

10 Begin to paint a line just underneath the top of the land. This will represent the edge of the area we want to preserve. Continue to paint just within the edge of the cliff, ensuring that all of the tourists and the castle are above your painted line.

11 When you get about halfway down the cliff, stop. There is no need to paint all the way down. Increase the brush size considerably in the Options Bar. Use the bigger brush to paint along the inside of your initial stroke, making it thicker.

12 Once you've thickened the stroke, increase the brush tip size even more. Use this massive brush to paint the area underneath the top stroke and to the right of the edge stroke until it is a solid mass of masked area.

TWO TOWERS BY THE SEA

13

15

14

14a

15a

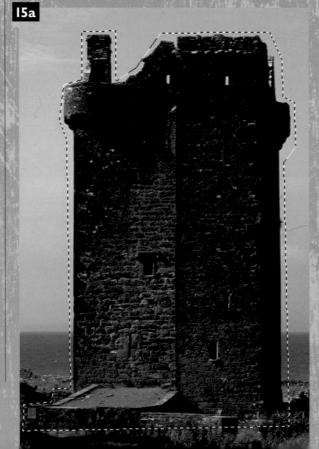

TIP

Selecting various lasso tools
There are a number of ways to select the various lasso tools. If you click on the Lasso tool button and hold, a pull-down menu is revealed, allowing you choose one of the three available options. Alt/Opt+clicking on the tool button will toggle through the lasso options as will typing the letter "L" on the keyboard.

13 Selecting the Eraser tool will convert the mask to a selection, leaving the area you painted as the area outside the selection and the unpainted area as the selected area. Choose a soft, round, brush tip preset. Increase the size of your brush tip to a massive 500 pixels and set the opacity to 100%.

14 Click once with the Eraser, slightly to the left of the castle, but within the selection. Hold down the Shift key and click again at the far left of the image on this same layer. These two points will automatically be joined, erasing everything in a perfectly straight line.

15 Now, simply click and drag to erase the area above the clifftop within the selection border. Press Ctrl/Cmd+D to deactivate the selection. Open the castle picture file. Select the Polygonal Lasso tool. Use it to draw a very rough, polygonal selection around the castle.

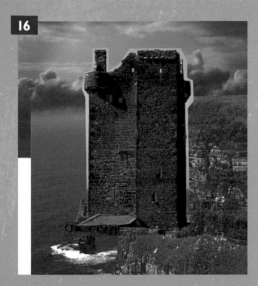

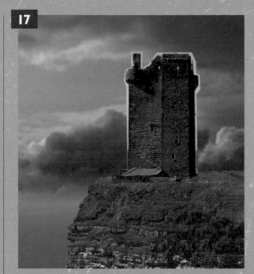

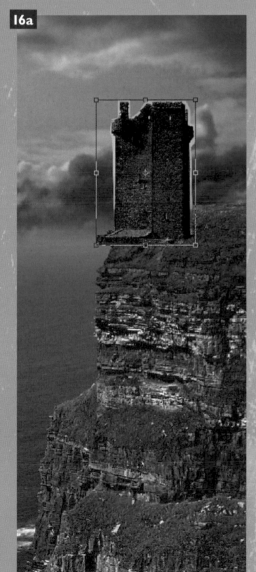

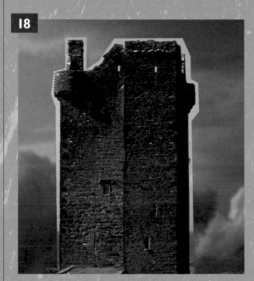

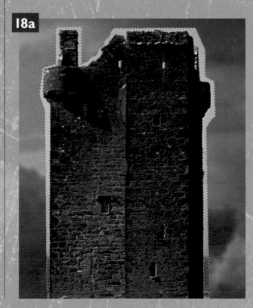

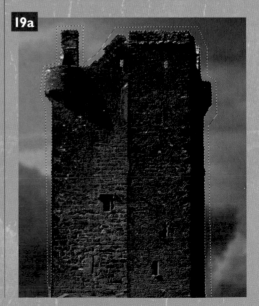

16 Copy the selected area by typing Ctrl/Cmd+C on the keyboard. Return to the working file and paste (Ctrl/Cmd+V). Obviously, the castle is too big. Type Ctrl/Cmd+T on the keyboard to access the free transform operation. Hold down the Shift key and drag a corner point inward to reduce the size.

17 Click and drag in the center of the bounding box to position it on top of the cliff. When you are happy with the size and positioning of the castle, press the Enter key on the keyboard to apply the transformation. Select the Magic Wand tool. Enter a Tolerance value of 15 and ensure that the Contiguous option is enabled.

18 Click on the blue sky area surrounding the castle to select it. Hold down the Shift key and click on the rest of the sky and water areas that remain unselected, not forgetting to click on the blue areas within the castle windows as well.

19 Choose *Select > Modify > Expand* from the menu and expand the active selection by one pixel. Expanding the selection ensures that there won't be any hairlines of light blue remaining after we delete the selected area. Press the Backspace key to remove the content of the selection.

TWO TOWERS BY THE SEA

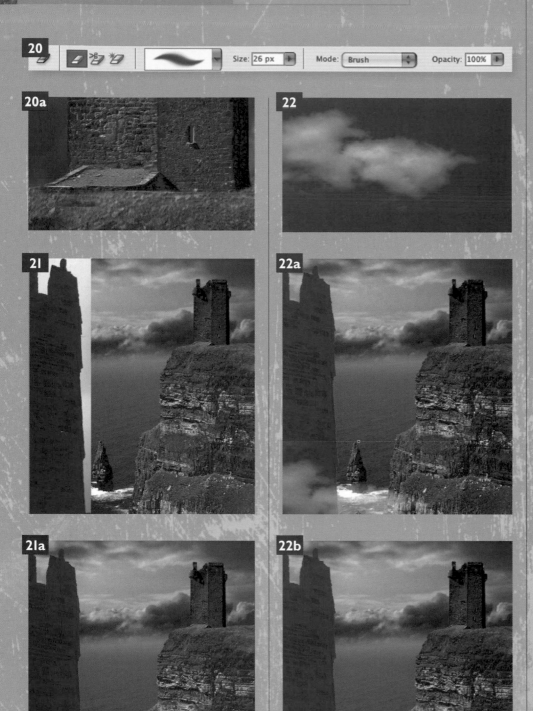

20 Deactivate the selection and select the Eraser tool. Reduce the size of the brush tip preset to allow you to use the Eraser to remove any remaining areas of background on either side of the background layer and also to soften the bottom, making the castle appear as if it belongs on the cliff.

21 Open up the tower picture file and drag it into the working file as a new layer. Use the Move tool to position it to the left of the image. Select the Magic Wand tool and use it to select the surrounding blue as with the previous castle. Expand the selection and delete it using the same methods. Deactivate the selection.

22 Open up the clouds picture file. Select the entire image, copy it, and then paste it into the working file as a new layer. Use the Move tool to drag it down to the lower left corner and change the blending mode to Screen. Reduce the opacity of the layer to 77%. Use the Eraser tool with a large, soft, round, brush tip to remove the hard edge on the layer.

23 Duplicate the clouds layer and drag the duplicate down in the Layers palette so that it rests below the tower layer. Use the Move tool to move the image up a little and to the right. Reduce the opacity of the layer to 63%.

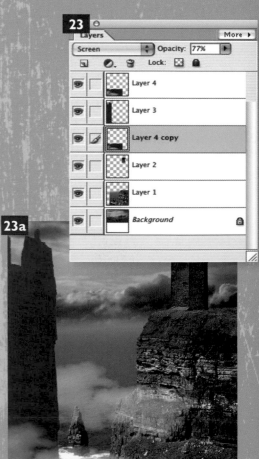

24
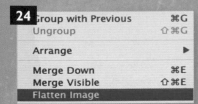

Group with Previous ⌘G
Ungroup ⇧⌘G
Arrange ▶
Merge Down ⌘E
Merge Visible ⇧⌘E
Flatten Image

24a

24b
Size: 19 px

25
Layers More ▶
Multiply Opacity: 100%
Lock:
👁 Background copy
👁 Background

25a

TIP

Moving layer content
Sometimes you'll want to move the content of a layer that resides underneath other layers, but annoyingly, every time you click, the overlapping layer is automatically selected and moved instead. A quick way to remedy this problem is to temporarily disable the visibility of overlaying layers while you're moving underlying layers.

26
26a
Solid Color...
Gradient...
Pattern...

Levels...
Brightness/Contrast...

27 Color Picker
Pick a solid color:
OK
Cancel
Help
H: 181 °
S: 11 %
B: 37 %
R: 85
G: 95
B: 95
555F5F
☐ Only Web Colors

27b Hue
Saturation
Color
Luminosity

27a

27 Choose a grayish-blue color from the picker and click OK. In the Layers palette, change the layer's blending mode to Color. Reduce the opacity of the solid color layer to 55%.

28 Open up the texture picture file. Tile the windows so that you can see this file as well as your working file. Use the Move tool to drag the texture into your working file as a new layer.

29 Hold down the Alt/Opt key and drag the top center handle of the bounding box upward. This will scale the contents of the box vertically and equally out from the center point. Click and drag inside the bounding box, positioning the layer content so that more extends beyond the canvas at the bottom, then at the top.

28

Layers More ▶
Normal Opacity: 100%
Lock:
👁 Layer 1
👁 Color Fill 1
👁 Background copy
👁 Background

28a

29

24 Choose *Layer > Flatten Image* from the menu to flatten all of the layers into a single background layer. Select the Blur tool and choose a small, soft, round brush tip. Leave the Strength set at 100% and use the Blur tool to soften the hard edge caused by the cliff layer.

25 Duplicate the background layer by dragging its icon onto the Create a New Layer button in the Layers palette. Change the layer blending mode to Multiply. Select the Eraser tool. Use a massive round brush tip and an opacity setting of 100% to erase the central area of this layer.

26 Reduce the opacity of the Eraser to 50% and then remove areas closer to the edges to create a gentle blending effect from light to dark. Create a new Solid Color layer from the menu in the Layers palette.

TWO TOWERS BY THE SEA

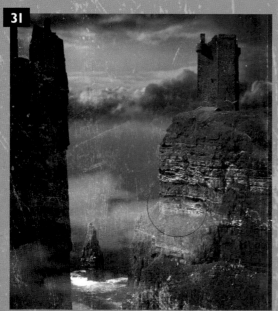

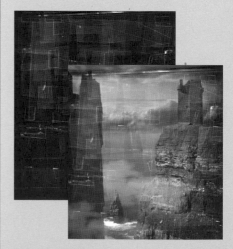

TIP

Surface textures

The texture we used in our main image was a photocopy of a black piece of paper that had been scoured with a piece of steel wool to reveal the white areas underneath. Creating textures to be scanned and incorporated into your images can be a lot of fun. Sometimes you'll be surprised at how cool some of the effects can be and how the feeling of your image is altered by using different textures.

Again, we've started off with a photocopy of a black piece of paper. This time we crumpled up the piece of paper and only scrubbed the black off the edges using steel wool. The paper was then flattened out and scanned. The effect of this texture is quite interesting; it could convey age by suggesting a spider web, or even be interpreted as lightning or electrical trickery caused by an evil wizard.

In this example we scanned a piece of crumpled graph paper. Increasing the contrast and then placing it over the same image in the same manner changes the feeling of the image completely. Now it could perhaps represent the coordinates of the castle on an ancient map.

Here we've got a full-color scan of some acetate sheets that were chopped up and then taped back together. You can have a lot of fun creating surface textures before you even get to the scanning stage. The effects caused by using a color image on a layer in Screen mode are quite interesting, especially the part along the top of the image.

30 Change the blending mode of the layer to Screen. Reduce the opacity of the layer to 79% to lessen the intensity of the scratch effect. Select the Eraser tool and choose a massive, soft, round brush tip and a low opacity setting of 25%.

31 Use the Eraser to remove areas of scratches from the layer. Concentrate mainly on the center of the image. Go over areas more than once if you want to erase them completely.

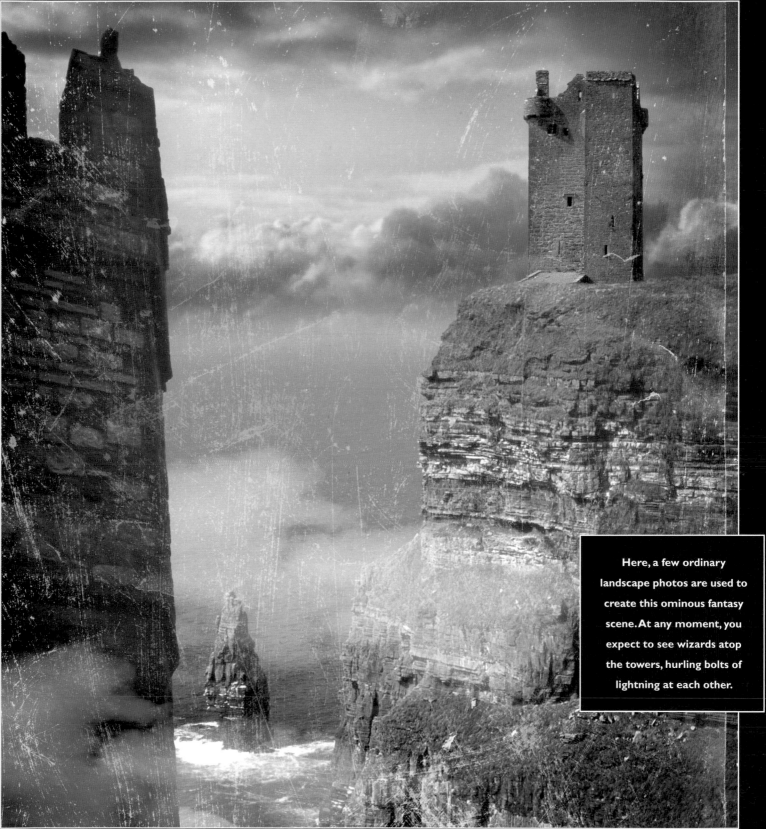

Here, a few ordinary landscape photos are used to create this ominous fantasy scene. At any moment, you expect to see wizards atop the towers, hurling bolts of lightning at each other.

THE PAINTINGS PAINT THEMSELVES

This fantastic scene begins with some photos of painted canvases in various stages of completion. Once photographed digitally, these canvases acted as the building blocks for this surreal scene. The central canvas resides upon an easel, as others float around it. A series of arm images appear to materialize from within the paintings themselves, daubing each other's pictures.

By now, you should be becoming quite familiar with compositing tools like layers as well as the various selection methods we've been working with. However, in this chapter, we'd like to draw your attention to a handful of brush tip presets. Within the preset picker reside a number of brush tips that resemble oil paint, watercolors, and other traditional art tools. These natural brush tips can be used in conjunction with a variety of tool options to create convincing brush strokes, adding a hand painted feel to your digital compositions.

1 Open the easel picture file. Ideally, this file needs to be a little wider for us to create our scene. To make the file wider, choose *Image > Resize > **Canvas Size*** from the menu. Click on one of the left anchors so that the extra canvas will be added to the right. Increase the width to 369mm wide and click OK.

2 Select the Polygonal Lasso tool and try to trace around the easel as closely as you can. In areas where you simply cannot trace it using this tool, select a little background along with the easel. Once you've returned to the starting point and closed the selection, click on the Subtract from Selection button in the Tool Options Bar.

2a Feather: 0 px ☑ Anti-aliased

1b as Size

Current Size: 30.1M
Width: 282.79 mm
Height: 266.7 mm

OK
Cancel

New Size: 30.1M
Width: 282.79 mm
Height: 266.7 mm
☐ Relative
Anchor:

Canvas extension color: Background

1a
Rotate
Transform
Crop
Divide Scanned Photos
Resize
Mode

Image Size...
Canvas Size...
Reveal All
Scale

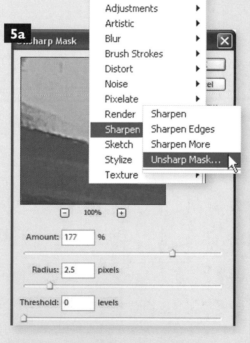

3 Use the Lasso with the subtraction feature enabled to subtract the hollow areas at the bottom of the easel. When you are finished, choose *Layer > New > Layer Via Copy* from the menu. When you've created a new layer, delete the background layer in the Layers palette, leaving the easel sitting against a transparent background.

4 Zoom in closely on an area that has a bit of background remaining. Select the Eraser and choose a hard, round brush tip preset. Set the opacity to 100% and use the Eraser to remove any unwanted bits of background. You can also round any corners that appear too sharp.

5 Choose *Filter > Sharpen > Unsharp Mask* from the menu. This image is soft because it was shot in RAW format with no in-camera sharpening enabled. Set the Amount to 177% and the Radius to 2.5 pixels. Once the layer is sharpened, duplicate it in the Layers palette, changing the blending mode to Soft Light, and reduce the opacity to 26%.

6 Select the bottom easel layer in the Layers palette and choose *Enhance > Adjust Color > Color Variations* from the menu. Leave midtones as the target area and click on the Decrease Blue option. Reduce the Amount a little and click on the OK button to alter the color of the bottom layer. Ctrl/Cmd+click on the layer thumbnail to generate a selection from it.

THE PAINTINGS PAINT THEMSELVES

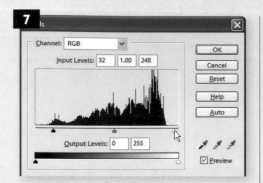

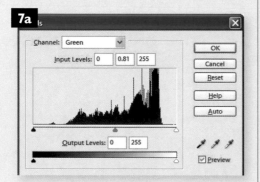

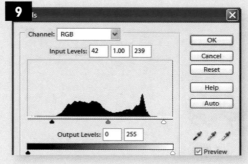

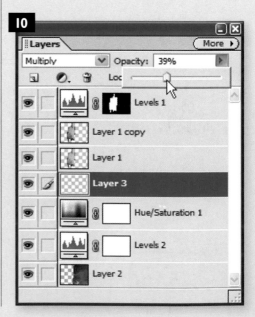

7 Select the top layer in the Layers palette, and with the current selection active, create a new Levels adjustment layer. Drag the left Input Levels slider to the right, darkening the shadows. Then drag the left slider to the right a little, brightening the highlights. Next, select green from the Channel menu and drag the middle slider to the right, decreasing the amount of visible green in the midtones.

8 We're using two photos of watercolor paint-spattered canvas to give a textured background to this image. Open up the first texture file, and use the Move tool to drag the paint image into your working file as a new layer. Position it so that it extends beyond the right edge and drag the layer to the bottom of the Layers palette. Hold down the Ctrl/Cmd+Alt/Opt+Shift keys and drag the upper right bounding box handle up and out to alter the perspective. Rotate it to match the angle of the easel and press the Enter key.

9 Create a new Levels adjustment layer. Again, drag the left and right input levels sliders inward to increase the contrast of the underlying layer. After that, create a new Hue/Saturation adjustment layer in the Layers palette. Change the Hue to +10 and increase the Saturation to +14, changing the red to a bright orange.

10 Hold down the Ctrl/Cmd key and click on the bottom layer thumbnail in the Layers palette to generate a selection from the layer content. With the selection active, create a new layer and drag it above the Hue/Saturation layer. Change the blending mode of the layer to Multiply and then reduce the opacity of the new layer to 39%.

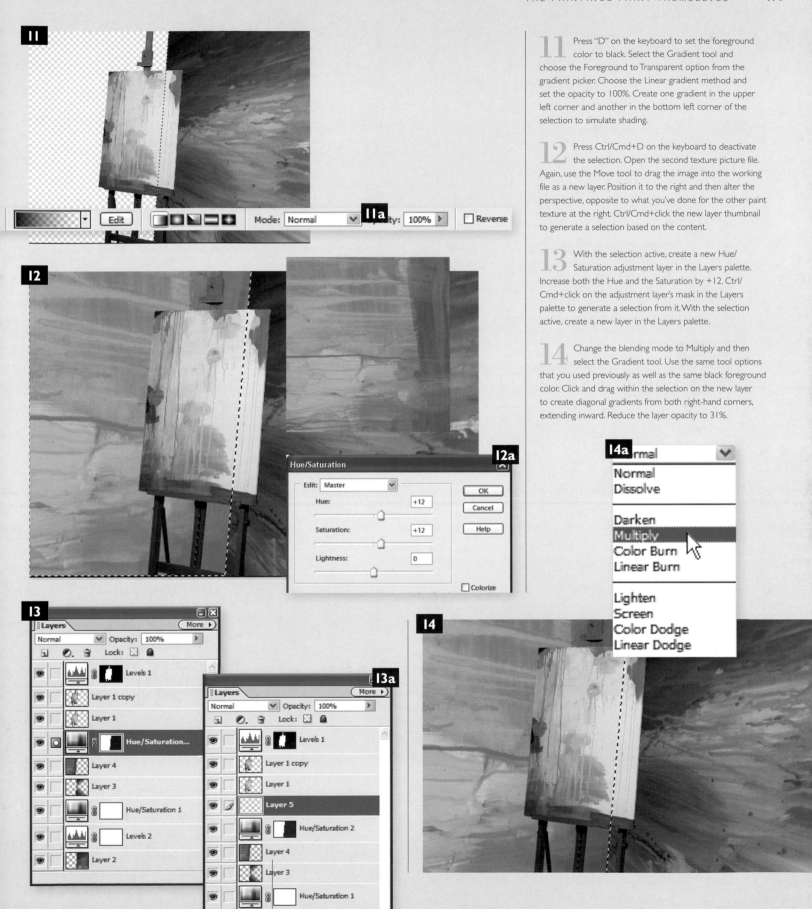

11 Press "D" on the keyboard to set the foreground color to black. Select the Gradient tool and choose the Foreground to Transparent option from the gradient picker. Choose the Linear gradient method and set the opacity to 100%. Create one gradient in the upper left corner and another in the bottom left corner of the selection to simulate shading.

12 Press Ctrl/Cmd+D on the keyboard to deactivate the selection. Open the second texture picture file. Again, use the Move tool to drag the image into the working file as a new layer. Position it to the right and then alter the perspective, opposite to what you've done for the other paint texture at the right. Ctrl/Cmd+click the new layer thumbnail to generate a selection based on the content.

13 With the selection active, create a new Hue/Saturation adjustment layer in the Layers palette. Increase both the Hue and the Saturation by +12. Ctrl/Cmd+click on the adjustment layer's mask in the Layers palette to generate a selection from it. With the selection active, create a new layer in the Layers palette.

14 Change the blending mode to Multiply and then select the Gradient tool. Use the same tool options that you used previously as well as the same black foreground color. Click and drag within the selection on the new layer to create diagonal gradients from both right-hand corners, extending inward. Reduce the layer opacity to 31%.

THE PAINTINGS PAINT THEMSELVES

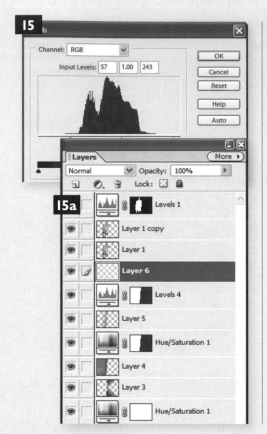

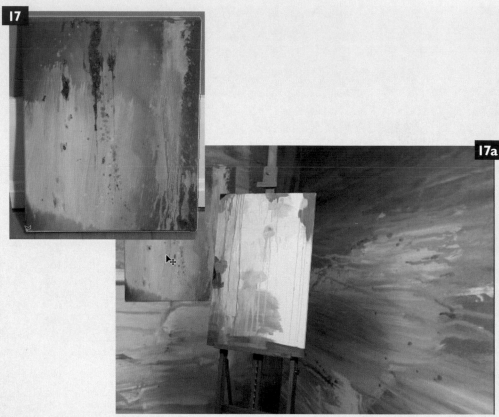

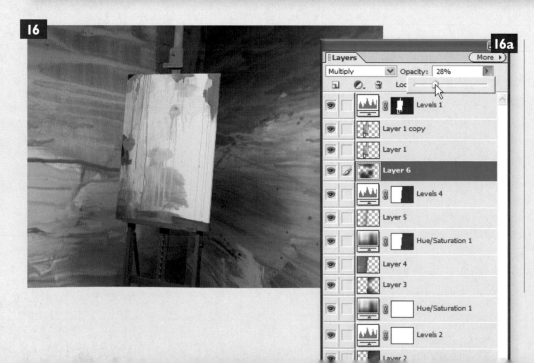

15 With the current selection still active, create a new Levels adjustment layer in the Layers palette. Severely darken the shadows, then lighten the highlights a little using the Input Levels sliders. Create a new layer in the Layers palette and change the blending mode to Multiply. Select the Gradient tool. Leave the tool options set as they were, except choose the Radial method instead of Linear.

16 Using a black foreground color, draw a series of radial gradients on the new layer to enhance the shadows you've created. When you're finished, reduce the opacity of the layer to 28%.

17 We'll add another two images of oil paintings into our composition. Open the first oil painting and then select the Polygonal Lasso tool. Use this to click and drag, creating a closed selection border around the edge of the canvas. Ctrl/Cmd+click inside the selection border and drag the content of the selection into the working file.

18

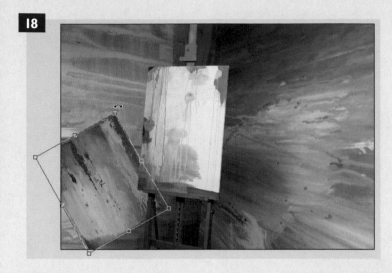

19

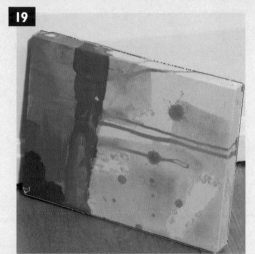

19a

20

20a

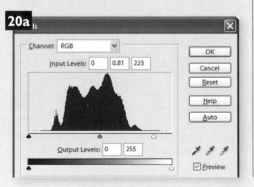

18 Type Ctrl/Cmd+F to sharpen the content of the layer using the Unsharp Mask settings you used to sharpen the easel. Select the Move tool and position the canvas on this layer to the lower left. Rotate it and reduce the size just a little.

19 Open the second oil painting file. Again, use the Polygonal Lasso to trace around the canvas. Use the Move tool to drag it into the working file. Reduce the size a little, rotate it slightly and position it in the lower right of the scene. Once you've positioned it, type Ctrl/Cmd+F to sharpen this canvas as well.

20 Ctrl/Cmd+click on the layer thumbnail in the Layers palette to generate a selection from this small painted canvas layer. Drag the right Input Levels slider to the left to brighten the highlights, then drag the middle Input Levels slider slightly to the right, to darken the midtones.

21 Create a new layer in the Layers palette and then select the Brush tool. Press "D" on the keyboard to set the foreground and background colors to their default settings of black and white, then press "X" on the keyboard to invert them so that white becomes the current foreground color.

22 Choose the Oil Pastel Large brush tip preset from the default brushes within the preset picker. In the tool Options Bar, increase the brush size to 150 pixels and reduce the opacity to 25%. Begin by painting a few strokes around the edge of the images on your new layer.

21

22

22a

22b

THE PAINTINGS PAINT THEMSELVES

23 Continue to paint strokes all around the edge of the image, coming in closer at the upper right. Overlay brush strokes to get a more opaque effect in certain areas. Then, from the brushes preset picker, select the Oil Heavy Flow Dry Edges preset. Increase the brush tip size to 150 pixels in the Options Bar.

24 Click the More Options button to access the brush dynamics settings. Increase the Scatter amount to 4% and set the Angle to -52°. Now use the new brush to paint around the far edges of the entire image so that there is a painted white border surrounding everything.

25 Create another new layer in the Layers palette. Again, within the brush preset picker, choose the Oil Pastel Large brush tip preset. Increase the size to 140 pixels this time and set the opacity to 20% in the Options Bar. Hold down the Alt/Opt key and click on a very light orange color to sample it as the current foreground color.

26 Begin to paint strokes over the orange background on the new layer. Focus on edge areas just inside the newly painted white border. Build up strokes and don't be afraid to overlap the top corner of the canvas on the easel. Sample a green color from the left and use it to paint over green background areas in the same way.

27

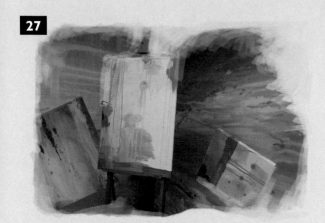

The Impressionist Brush

Residing directly beneath the Brush tool within the Brushes pop-up menu is the Impressionist Brush. Painting over your images with this brush creates stylized brush strokes using the colors and details of your image to create the look of an Impressionist painting. When you have the Impressionist Brush selected, take a peek under the More Options button in the Options Bar.

	Brush Tool	B
	Impressionist Brush	B
	Color Replacement Tool	B

These options directly affect the behavior of your brush, and vary the Impressionist styles that result. Using this brush is quite different from the method of painting within this chapter, but definitely worth experimenting with.

Style:	Tight Short
Area:	50 px
Tolerance:	0%

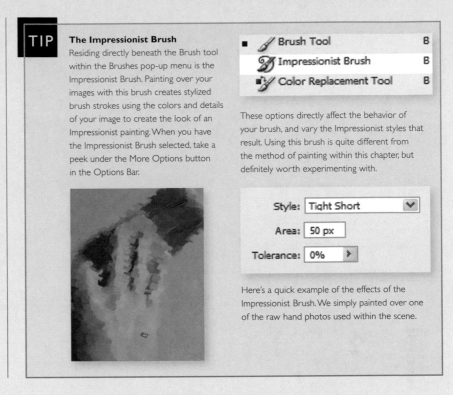

Here's a quick example of the effects of the Impressionist Brush. We simply painted over one of the raw hand photos used within the scene.

27b

27a

27 Use this method to sample various colors from within the image and paint them around the border and over the top of some of the canvas edges on this layer. Once again, choose the Oil Heavy Flow Dry Edges preset from the list of default brush tip presets. Create another new layer in the Layers palette.

28 Click on the More Options button in the Options Bar to access the Brush Dynamics settings. Reduce the spacing to 1% and set the angle to 0°. Increase the size to 171 pixels and set the opacity to 30%. Sample colors from within the image and paint a series of short strokes on this new layer.

29 Open the first arm picture file. We want to isolate the hand and brush with a selection border, but the trouble here is that the background is too similar in color and value to the arm. As a result, an automatic selection generated from either the Magic Wand or Magnetic Lasso tool will require far too much correction to be worthwhile.

29

28

Learn more about: Additional Brush Options

Spacing:	1%
Fade:	0
Hue Jitter:	0%
Hardness:	
Scatter:	0%
	Angle: 0°
	Roundness: 72%

☐ Keep These Settings For All Brushes

28b

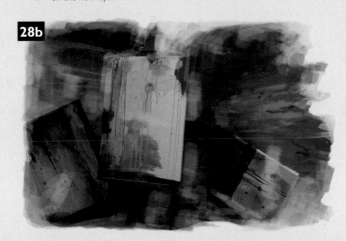

28a

Size: 171 px Mode: Normal Opacity: 30% Tablet Options: ▼ More Options:

THE PAINTINGS PAINT THEMSELVES

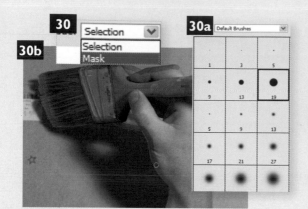

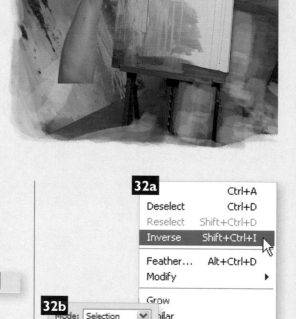

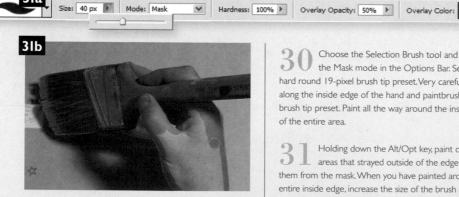

TIP

Pressure sensitivity
If you like the idea of painting digitally, you may want to look into acquiring a pressure-sensitive tablet. Not only is the feeling of painting with a tablet much more natural than painting with a mouse, but Elements also supports pressure sensitivity. The Tablet Options in the Options Bar allow you to specify exactly which aspects of your brush strokes are controlled by the pressure you exert upon the drawing tablet.

30 Choose the Selection Brush tool and select the Mask mode in the Options Bar. Select the hard round 19-pixel brush tip preset. Very carefully, paint along the inside edge of the hand and paintbrush using this brush tip preset. Paint all the way around the inside edge of the entire area.

31 Holding down the Alt/Opt key, paint over any areas that strayed outside of the edge to remove them from the mask. When you have painted around the entire inside edge, increase the size of the brush and paint over the entire inside area so that all of it is masked.

32 When you've finished painting, change the Mode back to Selection in the Options Bar. Choose *Select > Inverse* from the menu to invert the selection. Copy the contents of the selection and return to your working file. Paste the hand and brush into your working file as a new layer.

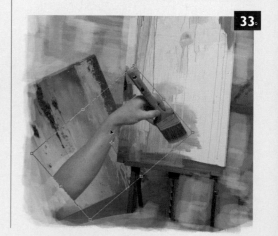

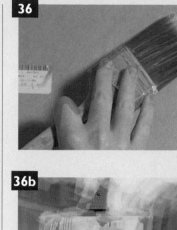

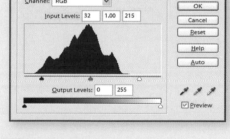

33 Choose *Image > Rotate > **Flip Layer Horizontal*** from the menu to flip the hand sideways. Select the Move tool, then click and drag outside the bounding box to rotate the hand and brush. Position it so that the arm is emerging from the left canvas and the brush is touching the middle canvas.

34 Choose *Enhance > Adjust Lighting > **Levels*** to make the familiar lighting changes, dragging the two outer Input Levels sliders toward the center to increase the contrast. Select the Eraser tool. Choose a large, soft, round brush tip preset and a low opacity setting.

35 With this Eraser, gently move over the hard edge of the arm, fading it into the underlying canvas. Reduce the opacity even further if the blending effect isn't smooth enough. Open up the second arm picture file and choose the Selection Brush. Set the brush to Mask and choose a small, round, hard brush tip preset.

36 Paint around the inside edge of the arm and brush, just as you did previously with the other arm image. Then increase the size of the brush and completely mask the area. When the area is masked, switch back to Selection mode to convert the mask to a selection. Invert the selection, copy the content and then paste it into the working file as a new layer.

THE PAINTINGS PAINT THEMSELVES

37

37a

38

38a

37 Position the arm so that it appears as if it is emerging from the canvas to the right. Perform another Levels adjustment and then use the Eraser to blend it into the underlying canvas. Open the third arm picture file. Using the same methods, add this arm to the main canvas in the scene.

38 Create a new layer in the Layers palette and select the Brush tool. Choose the Oil Medium Wet Flow brush tip preset. Set the size of the brush to 40 pixels. Sample a light skin color by holding down the Alt/Opt key and then paint a few strokes over the arm on the new layer, using an opacity setting of 30%.

TIP

Brush dynamics

There are a number of dynamic brush controls as well as functions that allow you to precisely control the various aspects of your brush strokes within the More Options button in the Options Bar. And although you won't use all of them often, you should definitely try experimenting with each control at least once.

1 Spacing controls the spacing between the brush marks within your strokes. A setting of 1% returns a very smooth stroke.

2 Fade sets the number of steps a stroke takes before fading to transparent.

3 Hue Jitter allows you to set the rate controlling how often the color of the stroke is altered by switching back and forth between foreground and background color.

4 Hardness allows you to specify how soft the edges of your stroke will be, if at all.

5 Scatter allows you to control the distribution of your brush marks within a stroke. A high value produces a more chaotic stroke.

6 Angle and roundness of your stroke can either be adjusted numerically or by dragging the dots or arrow within the angle icon.

7 When you hit upon a winning combination of settings, save it by clicking this checkbox.

💡 Learn more about: <u>Additional Brush Options</u>

Spacing:	25%	**1**
Fade:	0	**2**
Hue Jitter:	0%	**3**
Hardness:	100%	**4**
Scatter:	0%	**5**

Angle: 0°
Roundness: 100% **6**

☐ Keep These Settings For All Brushes **7**

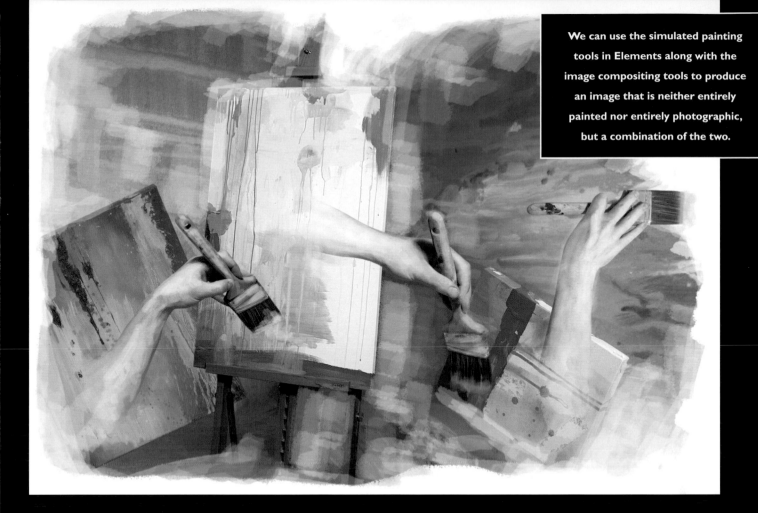

We can use the simulated painting tools in Elements along with the image compositing tools to produce an image that is neither entirely painted nor entirely photographic, but a combination of the two.

39 Continue to Sample various colors from within the image and paint a series of strokes over the top of the hands and paintbrushes on the new layer. Try painting some brush strokes over the ends of the paintbrushes to make them appear loaded with paint.

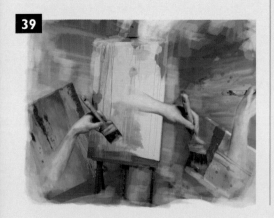

40 When you're finished, create a new Hue/Saturation adjustment layer in the Layers palette. Increase the Saturation by +20 to brighten the overall image. Finally, create a new Levels adjustment layer in the Layers palette. Drag the right Input Levels slider over to the left to further increase the highlights in your surreal painted scene.

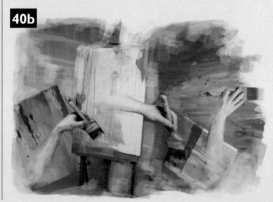

THE CLAIRVOYANT

Objects swirl around the room as our clairvoyant gazes into the crystal ball. The room is quite dark, illuminated only by a surreal green light. Is he making contact with those that have gone before? No, the artificial lighting is the product of the Elements Lighting Effects filter. This allows you to create and control multiple light sources, giving you the power to illuminate your scene any way you wish.

Combining the parts of the figure with dark gradients allows us to create an artificial psychic being who gazes into the crystal ball. But even the crystal ball is not of this world. It was created entirely in Elements by combining selection tools, filters, layers, and gradients.

The objects circulating around the room started out as basic photos. But by altering their perspective, stacking up duplicate layers with different blending modes, and carefully applying the Gaussian Blur filter, we made them look as if they are genuinely part of this eerie supernatural scene.

1 The first thing you'll need to do is create a new file. Choose *File > New > Blank File* from the menu and set the dimensions to 235mm wide, 267mm high, with a resolution of 300 pixels per inch. Select a muted blue color from the picker as the foreground color. Press Alt/ Opt Backspace to fill the background layer with the current foreground color.

2 Choose *Filter > Render > Lighting Effects* from the menu to launch the Lighting Effects filter. Click on the swatch in the Light Type section to open the picker. Select a bright green color to alter the color of the initial light. Click on the circle in the center of the light and drag it up and to the left.

3 When the handle at the end of the line becomes visible, click it and drag it upward. This will change the direction of the light so that it shines downward. Drag a side handle inward to reduce the width of the light and drag the handle at the lower left toward the center of the light to make it shorter.

4 Reduce the Intensity of the light to about 25. Hold down the Alt/Opt key, then click and drag on the center of the light to copy it. Rotate it so that it shines more or less in the opposite direction. Adjust the size of the light as needed. Drag the light icon into the Preview area to create a new light.

5 Change the light type to Omni. Reduce the Intensity and drag one of the handles inward to make it smaller. Change the color of the light to yellow by clicking on the swatch in the Light Type section of the filter. Press OK to apply the filter and render the lighting effect on the background layer.

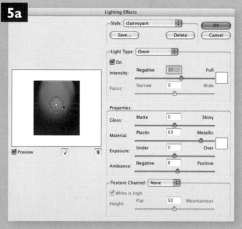

THE CLAIRVOYANT

8 Lasso Tool L
 Magnetic Lasso Tool L
 Polygonal Lasso Tool L

6

6b
Lighten
Screen
Color Dodge
Linear Dodge

Overlay
✓ Soft Light
Hard Light
Vivid Light
Linear Light
Pin Light
Hard Mix

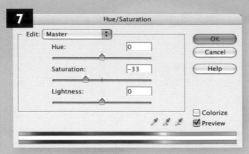

7 Hue/Saturation

Edit: Master

Hue: 0
Saturation: -33
Lightness: 0

OK
Cancel
Help

☐ Colorize
☑ Preview

6a

7a

8a

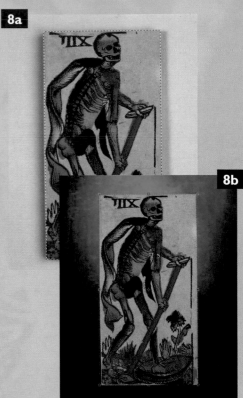

8b

9

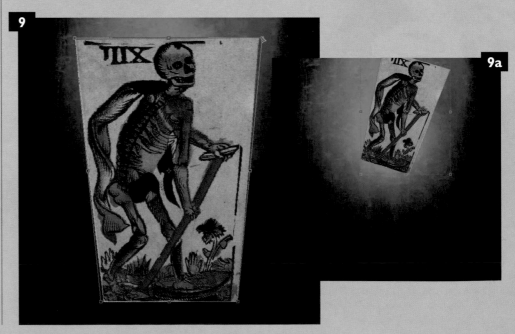

9a

6 Open an image of textured paper to use as a background. Use the Move tool to drag the paper into the image as a new layer. Hold down the Shift key and rotate it 90°. Drag the corner handles of the bounding box outward until it covers the canvas. Change the blending mode of the layer to Overlay in the Layers palette.

7 Create a new Hue/Saturation adjustment layer in the Layers palette. Because the image is a little too vibrant, reduce the Saturation to 33. We now have a dimly lit, richly textured background, setting the mood for our scene.

8 Open the first tarot card image file. Use the Polygonal Lasso to draw a rectangular, closed selection surrounding only the card. Use the Move tool to drag the content of the selection into the working file as a new layer.

9 Hold down the Ctrl/Cmd+Alt/Opt+Shift keys at the same time and drag one of the top corner handles outward. This will alter the perspective of the bounding box content, making it narrower toward the bottom. Use the Move tool to drag it upward on the background and rotate it. Reduce the size of the selection by dragging the corner points inward.

10 Choose *Filter > Adjustments > **Invert*** from the menu to invert the colors of this layer, and create a color film negative effect. Select the Eraser tool and choose a soft, round, brush tip preset. Increase the size and then reduce the opacity to 50%. Gently erase areas of the tarot card so that it blends in nicely with the background texture and lighting.

11 Change the blending mode of the layer to Luminosity and reduce the opacity to 56%. Duplicate the layer and change its blending mode to Normal. Use the Eraser on the duplicate layer to gently erase most of the layer content, leaving only the head and shoulders.

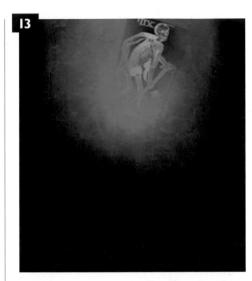

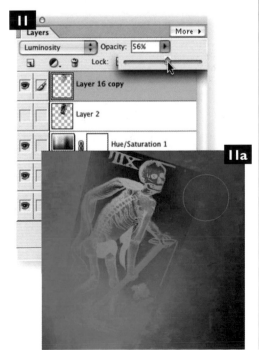

12 Choose *Filter > Blur > **Gaussian Blur*** from the menu and blur the content of this layer using a Radius of 5 pixels. Create a new layer in the Layers palette and select the Gradient tool. Choose the Foreground to Transparent gradient preset and the Linear method. Hold down Alt/Opt and click on a dark area of the image to select it as the current foreground color.

13 Click and drag on a diagonal, about halfway up from bottom to top, creating an abrupt gradient on the left-hand side of the new layer. Do exactly the same thing on the other side, creating a mirror image of that gradient on the same layer. Switch the gradient to the Radial method in the Options Bar. Click and drag, creating a radial gradient in the center of the layer.

THE CLAIRVOYANT

17

17a

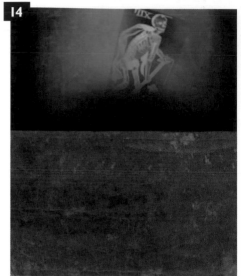

14

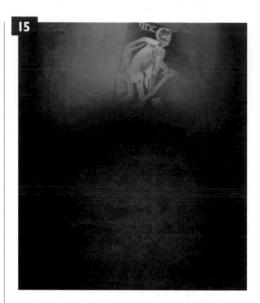

15

14a

14b

15a

16

16a

| Normal |
| Dissolve |
| |
| Darken |
| Multiply |
| Color Burn |
| Linear Burn |
| |
| Lighten |
| Screen |
| ✓ Color Dodge |
| Linear Dodge |
| |
| Overlay |
| Soft Light |

14 Open the textured paper image file again and use the Move tool to drag it into the working file as a new layer. This time, do not rotate it, but adjust its size so that it fits along the bottom half of the image. Enable the transparency lock in the Layers palette, then enable the Reverse option for the Gradient tool in the Options Bar.

15 Click and drag outward from the center on the paper's surface, creating a gradient that goes from transparent at the center to black around the edges. Select the Move tool and then adjust the perspective of the paper in exactly the same way as for the tarot card. Drag the top center point downward to reduce the vertical size.

16 Disable the transparency lock in the Layers palette and select the Eraser tool. Using the same options choices, erase a soft, circular dip in the top of the paper. This will be the area behind the crystal ball. Create a new layer and change the layer blending mode to Color Dodge. Select the Gradient tool. Disable the Reverse option in the Options Bar.

17 Hold down the Alt/Opt key to sample a color from the paper and then create a radial gradient on the new layer that overlaps the paper, creating a glow effect. Select the Move tool and alter the perspective and size of the glow so that it matches up with the paper layer. Duplicate the layer and reduce the opacity of the layer to 59%.

18 Open the image file of the head. Choose the Lasso tool and specify a feathered edge of 10 pixels in the Options Bar. Draw a close selection around the head, roughly defining the shape of the headdress and shoulders as well. Use the Move tool to drag the head into the working file as a new layer. Position in the center of the image.

19 Duplicate the layer, change the blending mode to Soft Light and reduce the opacity of the layer to 40%. This makes the face appear more vivid against the background. Open the image file of the left hand and, using the Lasso tool, with the same Feather setting, draw a selection loosely around the hand area.

20 Use the Move tool to drag the selected area into the working file as a new layer. Position it to the left and slightly below the head. Open the image file of the right hand and use the same method to select the hand and drag it into the working file as a new layer. Position it to the right and slightly beneath the head.

21 Now that we have the clairvoyant and his room, we need to provide him with a crystal ball to gaze into. Select the Elliptical Marquee tool. Hold down the Alt/Opt and Shift keys while clicking and dragging outward from a central point to create a perfectly circular selection.

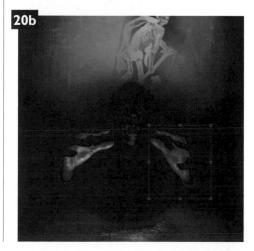

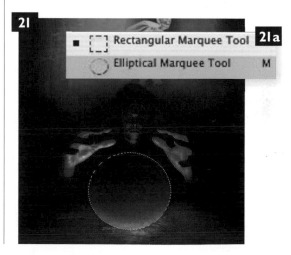

THE CLAIRVOYANT

23a

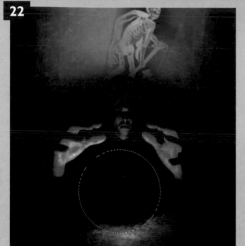

22

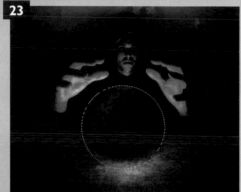

23

25 Gaussian Blur

OK
Cancel
☑ Preview

100%

Radius: 10 pixels

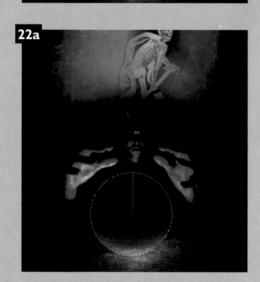

22a

23b

24

24a

24b

25a

22 Create a new layer and set the foreground color to white. Select the Gradient tool and specify a low opacity setting of 25%, ensuring that it is still set at Foreground to Transparent. Create a couple of linear gradients similar to the black ones you created earlier for the background. Switch to the Radial method and create a gradient at the top in the center.

23 Reduce the opacity of the layer to 20% and then create another new layer. Use the Gradient tool to create a few more radial gradients to act as highlight areas. Select the Brush tool and choose a soft, round, brush tip preset. Increase the size to 300 pixels and set the opacity to 25%. Use the brush to paint highlights around the inside edges of the selection.

24 Create a new layer and select the Lasso tool. Ensure that the Feather option is set to 0, draw some rough highlight shapes on the new layer and fill them with white. Deactivate the selection and use the Gaussian Blur filter to blur the content of the layer by 25 pixels. Create another white radial gradient over the first highlight gradient toward the upper left.

25 Duplicate the bottom crystal ball layer in the Layers palette. Use the Gaussian Blur filter on the duplicate layer to soften the entire layer, using a Radius of 10 pixels. Open the image file of the skull. Use the Move tool to drag it into the working file as a new layer.

26 Reduce the size of the skull proportionately and position it in the center of the crystal ball. Change the blending mode of the layer to Lighten and duplicate the layer. While holding down the Alt/Opt key, drag a vertical midpoint outward to horizontally scale the skull out from the center. Reduce the opacity of the layer to 31%.

27 Open the image file of the Ouija board. Use the Move tool to drag it into the working file as a new layer. Rotate it and alter the perspective as you did with the initial tarot card and the paper layer. Select the Eraser tool. Using the same settings you used to erase areas of the layer, soften the Ouija board, making it fade gently into the background.

28 Duplicate the layer and change the blending mode to Overlay. Reduce the opacity to 46%. Use the Gaussian Blur filter to blur the content of this layer using a 5 pixel Radius. Open the image file of the pointer. Use the Move tool to drag the pointer into the working file. Reduce the size, rotate it, and position it in the lower right corner.

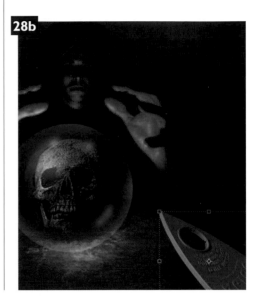

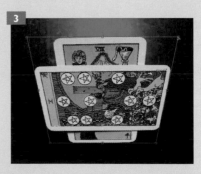

TIP

Advanced transformation keyboard shortcuts

Whether you're performing transformations via the Free Transform option or by using the Move tool's bounding box, these keyboard commands will save time and make the process feel much more intuitive.

Holding down Ctrl/Cmd while dragging on a corner handle of the bounding box allows you to freely distort the content of the bounding box.

Holding down the Ctrl/Cmd key, drag the midpoint handle on one the sides of the box to skew the content of the bounding box.

Holding down Ctrl/Cmd+Alt/Opt+Shift while dragging a corner point allows you to alter the perspective of the bounding box content.

THE CLAIRVOYANT

29 Again, use the Eraser to remove areas and soften the edges of the pointer. Duplicate the layer, leaving the blending mode set to Normal. Apply a 5-pixel Gaussian Blur effect to the layer. Now open the second tarot card image file.

30 By now you'll have noticed a pattern emerging here. Use the Move tool to drag the tarot cards layer into the working file. Hold down the Shift key and drag a corner of the bounding box inward to proportionally reduce the size. Position it in the upper right of the image. Change the blending mode to Luminosity and the opacity to 68%.

31 Use the Eraser on this layer to to soften edges and gently remove sections of the cards. Duplicate the layer and change the blending mode to Overlay. Open the third tarot card image file. You guessed it, use the Move tool to drag it into the working file.

32 Hold down the Ctrl/Cmd key and drag the upper right bounding box handle inward, distorting the cards. Rotate the bounding box, reducing the size proportionately, and position it in the lower left corner. Use the Eraser on this layer to blend the imagery into the rest of the image.

33 Change the blending mode of the layer to Luminosity. Duplicate the layer, change the blending mode of the duplicate layer to Soft Light and apply a 5-pixel Gaussian Blur to the contents of the layer. Create one more new layer and drag it to the top of the Layers palette.

34 Choose the Blur tool. Select a soft, round, brush tip preset and set the size of the tip to 50 pixels. Set the strength to 100% and ensure that the Use All Layers function is enabled. Zoom in on the sharp edge of the crystal ball. Paint over the hard edge with the Blur tool to soften it.

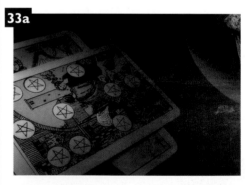

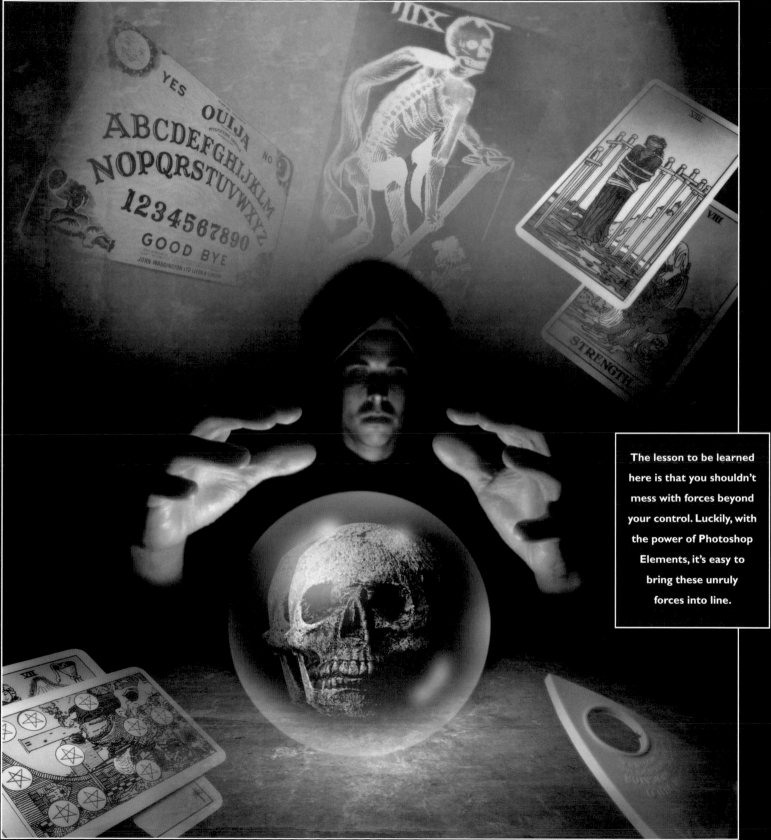

The lesson to be learned here is that you shouldn't mess with forces beyond your control. Luckily, with the power of Photoshop Elements, it's easy to bring these unruly forces into line.

CYBERNETIC SCENE

Half-human, half-machine, the cyborg is a staple of science fiction. This mixture never reflects well on the human half, the resulting hybrid nothing more than an insect-like clone, devoid of individual consciousness or freewill.

In this cybernetic scene, we've used a portrait shot of a woman, plus some basic images of cables, hoses, and computer parts, to create a female cybernetic drone attached to the supercomputer of an alien ship. She is staring at us through a doorway we've created out of an image of concrete pillars; in front of her is a transparent plasma screen containing an active matrix of the alien grid that we've created with selections and strokes on a few layers. The Lens Flare filter enabled us to create a sharp glow, emanating from her eyes and other select components, giving us the impression that she's just spotted some intruders. Time to run.

1 Open the image file of the wires. This will be the background layer but we need to make the image a little wider. Choose *Image > Resize > Canvas Size* from the menu. Click on the right, middle anchor and then increase the width to 328mm.

2 Open the image file of the column. Use the Move tool to drag it into the working file as a new layer and position it at the left edge of the image. Create a new layer in the Layers palette and select the Gradient tool. Select the Linear gradient method and the Foreground to Transparent gradient preset in the Options Bar.

3 Using a black foreground color and an opacity setting of 100%, draw a gradient on the new layer from the top downward, finishing about one-third of the way down. Then draw a diagonal gradient inward from the lower left corner. Reduce the opacity of the layer to 50% and change the blending mode to Multiply.

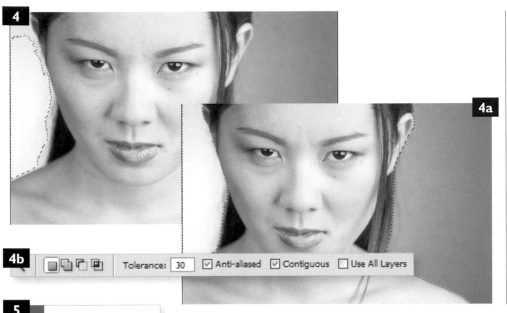

4 Open the image file of the head. Select the Magic Wand tool, enable the Contiguous option and set the Tolerance to 30. Click on an area of the background to the left. Holding down the Shift key, click on any areas of the background that remain unselected. Use this method to add the background at the right to the selection.

5 When you've selected as much of the background as you can, choose *Select > Inverse* from the menu to invert the selection. Copy the selected area and then paste it into the working file as a new layer. Hold down the Ctrl/Cmd key, then click and drag on the head to position it a little left of center. Select the Eraser tool and choose a soft, round brush tip preset.

6 Use the Eraser to paint over any hard edges to soften them, then increase the size of the brush tip and erase the edges of the hair on both sides so that the edges are very soft. Create a new Hue/Saturation adjustment layer in the Layers palette.

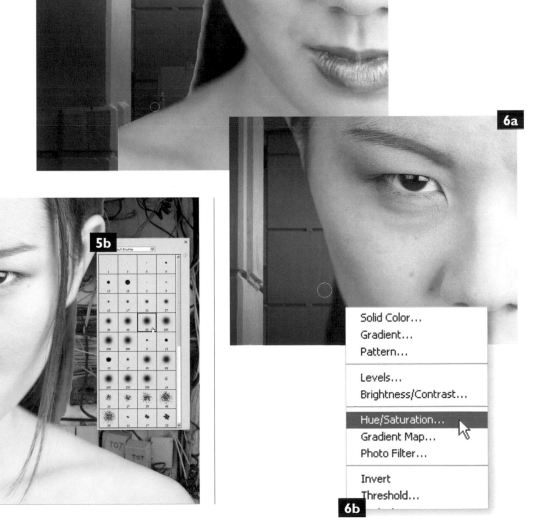

CYBERNETIC SCENE

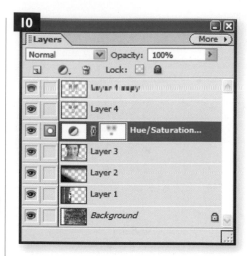

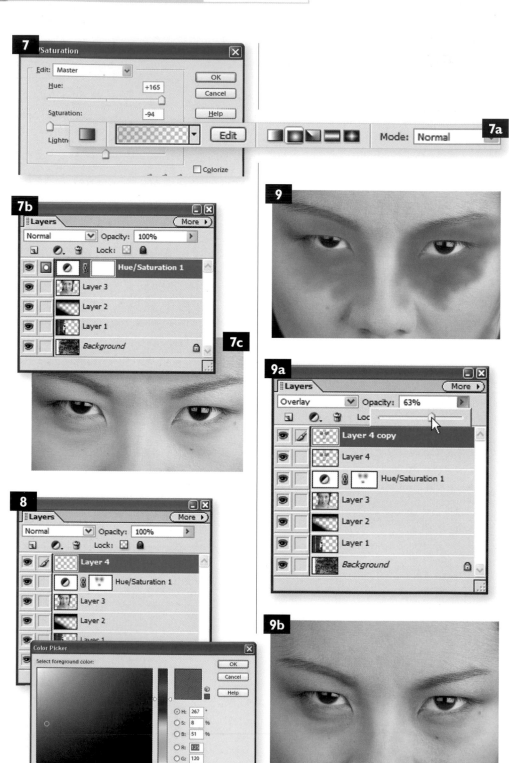

7 Adjust the hue to +165 and decrease the saturation to -94. This will turn the woman a perfect cybernetic shade of gray. Select the Gradient tool. Choose the Foreground to Transparent gradient preset with the Radial method. Reduce the opacity to 25%. While using a black foreground color, click and drag on the layer mask over each eye, to mask the hue/saturation effect.

8 Create a new layer in the Layers palette and select the Brush tool. Choose the 100-pixel, soft, round brush tip preset. Set the brush opacity to 50%. Click on the foreground color swatch to open the picker. Select a muted purple color from the picker.

9 Paint around the eyes on the new layer, then reduce the opacity and lightly paint the shaded areas under the cheekbones. Change the blending mode of the layer to Overlay. Duplicate the layer and reduce the opacity of the duplicate layer to 63%.

10 Select the Hue/Saturation adjustment layer's mask in the Layers palette. Use the paintbrush with the current tool settings to paint over her lips within the mask, masking the desaturation and hue adjustment. Select the Magic Wand tool and zoom in on her eyes.

TIP

Color and masks

When you are painting with a color, for example the dull purple we're using here, and select an adjustment layer mask, take a look at the color swatches. They will temporarily revert to black and white because adjustment layer masks operate using only grayscale. When you target a regular image layer, your colors will revert back to normal.

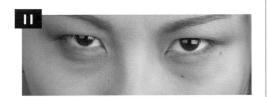

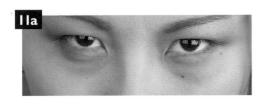

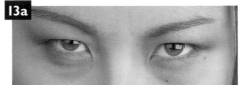

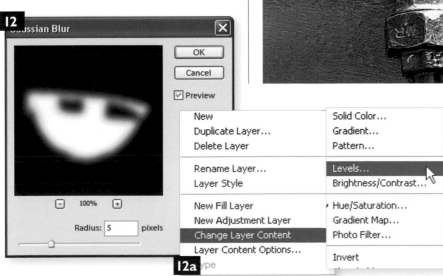

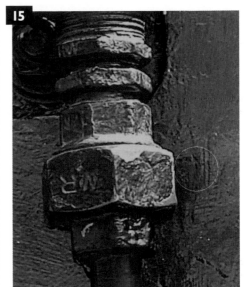

11 Enable the Use All Layers function in the Options Bar and then click on the iris in her eye. Hold down the Shift key and click on her other iris to add it to the selection. With the new selection active, create a new Hue/Saturation adjustment layer in the Layers palette. Change the Hue to +22, increase the Saturation to +71 and increase the Lightness by +5.

12 With the adjustment layer's mask targeted in the Layers palette, choose *Filter > Blur > **Gaussian Blur*** from the menu. Enter a value of 5 pixels. This will soften the edges of the masked area. Duplicate the adjustment layer and then choose *Layer > Change Layer Content > **Levels*** from the menu.

13 Drag the left and right Input Levels sliders toward the center of the histogram to increase the contrast. Drag the left slider further inward to brighten the highlights, revealing more detail in her eyes.

14 Open the image file of the hose and choose the Selection Brush tool. Select a hard, round brush tip preset and set the size to about 40 pixels. With the hardness set at 100, zoom in and begin to paint the inside edge of the hose and attachment. Increase and decrease the size of the brush as required to cover the hose and attachment completely.

15 In the areas where you have painted over the edge or want to remove the mask for some reason, hold down the Alt/Opt key and paint over them. This will remove any unwanted masking. When you've edited the mask to your satisfaction, change the Selection Brush back to Selection mode in the Options Bar. This will generate a selection around the unmasked area.

CYBERNETIC SCENE

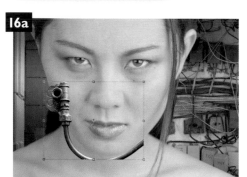

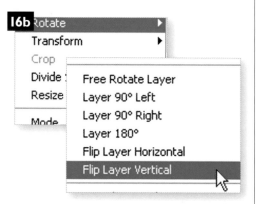

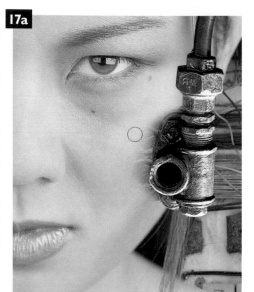

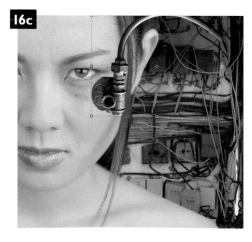

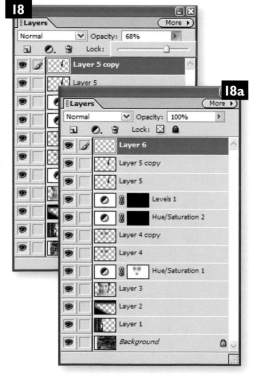

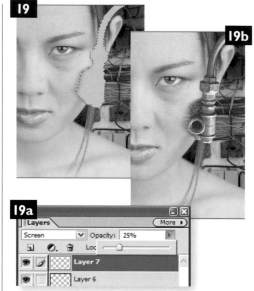

16 Choose *Select > **Inverse*** from the menu to invert the selection. Select the Move tool and drag the content of the selection into the working file as a new layer. Choose *Image > Rotate > **Flip Layer Vertical*** from the menu. Drag the flipped layer up and to the right.

17 Hold down the Shift key and drag a bounding box corner outward, increasing the size of the hose. Position it so that it overlaps her cheek, and select the Eraser tool. Choose a large, soft, round brush tip preset, and, using an opacity setting of 50%, gently erase the edges that overlap her cheek to soften them.

18 Change the layer blending mode to Luminosity and then duplicate the layer. Change the blending mode of the duplicate layer back to Normal and reduce the opacity to 68%. Hold down the Ctrl/Cmd key and click on the Duplicate Layer thumbnail to generate a selection from the content of the layer. With the current selection active, create a new layer in the Layers palette.

19 Use the Eyedropper to sample a gray color from the image. Type Alt/Opt+Backspace to fill the active selection with the current foreground color on the new layer. Change the layer blending mode to Screen and reduce the opacity to 25%. Type Ctrl/Cmd+D to deactivate the selection.

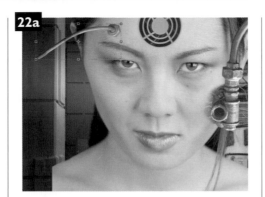

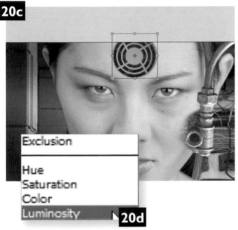

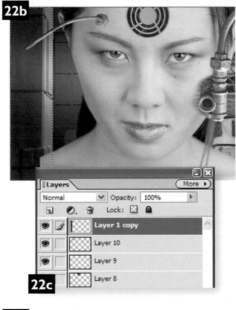

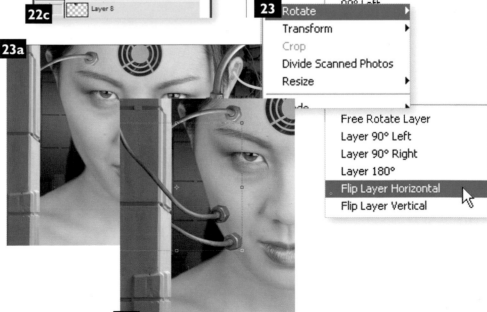

Cable 1

Cable 3

Cable 2

20 Open the image file of the computer. Select the Elliptical Marquee tool and set the Feather value to 3 pixels in the Options Bar. Hold down Shift and draw a circular selection around the top fan, then use the Move tool to drag it into the working file. Position it over her forehead and increase the size proportionately. Change the layer blending mode to Luminosity.

21 Return to the computer image and use the Selection Brush to paint a mask over the gray cable. Use the same method you used to select the hose and drag it into the working file. Use the Move tool to position it over her ear, rotate it, and adjust the size. Then use the Eraser with a soft brush tip to blend the edges into her ear.

22 Open up the first of your three cable image files. Use the Move tool to drag one into the working file as a new layer. Position it in the upper left of the image so that it touches her forehead. Target the layer containing the concrete columns in the Layers palette and use the Polygonal Lasso to draw a selection around the column to the left. With the selection active, choose *Layer > New > Layer Via Copy* from the menu. Drag the new layer to the top of the stack.

23 Duplicate the new layer and choose *Image > Rotate > Flip Layer Horizontal* from the menu. Use the Move tool to drag the column on this layer to the far right. Open the second image file of cables. Use the Move tool to bring the cables into the working file as a new layer. Carefully position them so that the chopped cable end touches the concrete column edge.

CYBERNETIC SCENE

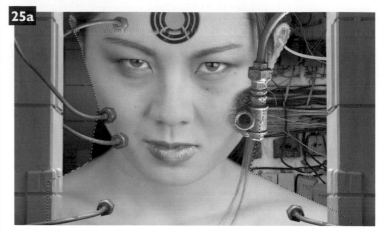

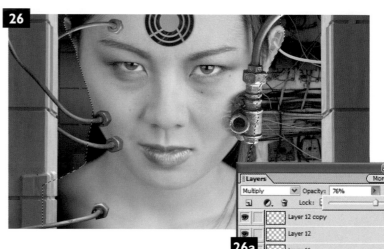

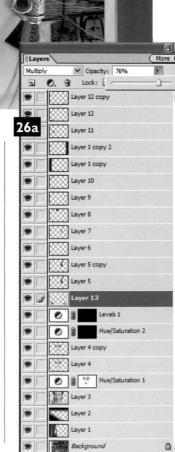

24 Open the third cable image file. Again, drag the layer into the working file, though this time position it in the lower left. Duplicate the layer, flip it horizontally, and position the duplicate layer at the lower right. Drag it just a little lower.

25 Create a new layer and drag it down in the Layers palette so that it is sits just above your Levels adjustment layer. Change the blending mode to Multiply and select the Gradient tool. Choose the Foreground to Transparent option and select the Linear method in the Options Bar. Hold down the Ctrl/Cmd key and click on the head layer to generate a selection from it.

26 Ensure that your new layer is still targeted in the Layers palette. Then, using a black foreground color, create a couple of linear gradients within the selection, over her shoulders from the outside inward. Deactivate the selection and then reduce the opacity of the layer to 76%.

27 Create another new layer directly on top of this layer and set the blending mode to Multiply. Switch the gradient method to Radial. Draw a radial, black to transparent gradient under each cable end on this layer, then reduce the opacity of the layer to 50%. When you're finished, choose *Layer > Flatten Image* from the menu.

28 Choose *Filter > Render > Lens Flare* from the menu. Click in the hose hole in the Preview area to place the flare effect there. Leave the Brightness set at 100% and choose the Movie Prime lens type. Click OK to render the lens flare.

29 Choose *Filter > Render > Lens Flare* from the menu again, only this time, position the flare over one of the eyes in the Preview area and reduce the Brightness to 51%. Click OK to apply the filter and then repeat the process again to add a lens flare over the other eye. Launch the Lens Flare filter one more time, this time placing the flare in the center of the fan on her forehead. Change the Brightness to 71% and select the 50–300mm Zoom option.

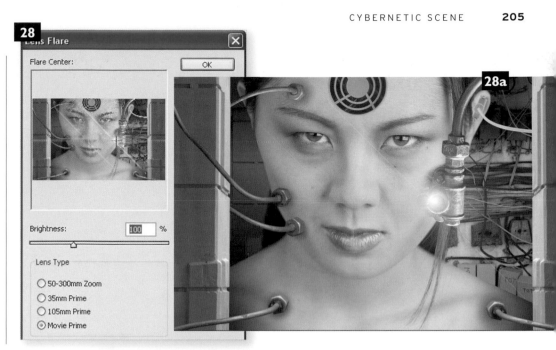

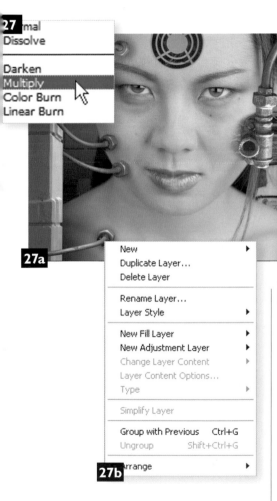

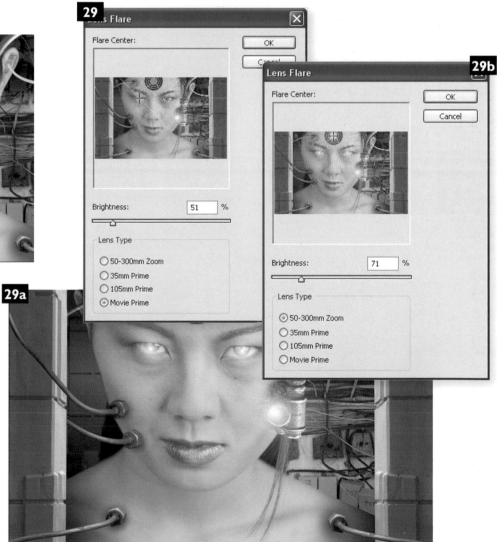

CYBERNETIC SCENE

30 Create a new layer in the Layers palette and then select a light blue foreground color from the picker. Use the Rectangular Marquee tool to draw a selection border, then choose *Edit > Stroke(Outline)Selection* from the menu. Enter a width of three pixels and choose Inside as the Location.

31 Use this method to draw numerous rectangle and circle shapes on this layer, and stroke them with the same blue color. When you're finished, change the blending mode to Overlay. Duplicate the layer and then launch the Gaussian Blur filter. Blur the content of the layer using a Radius of 5 pixels.

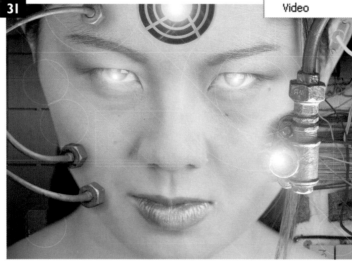

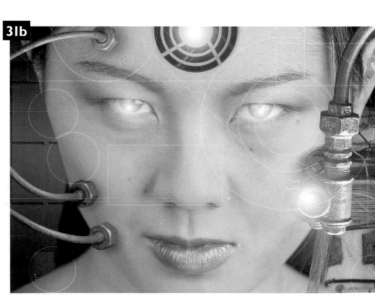

32 Create another new layer with an Overlay blending mode. This time, select a pink foreground color from the picker. Again, draw a series of selections on this layer and apply a stroke to the inside of them. Then duplicate this layer too and apply a 5-pixel Gaussian Blur effect to the duplicate layer.

33 Create one more layer and change the layer blending mode to Overlay. This time, draw a series of smaller square and round selection borders and instead of adding a stroke, fill the selections with either pink or blue as you draw them. You can fill an area with the current foreground color by typing Alt/Opt+Backspace.

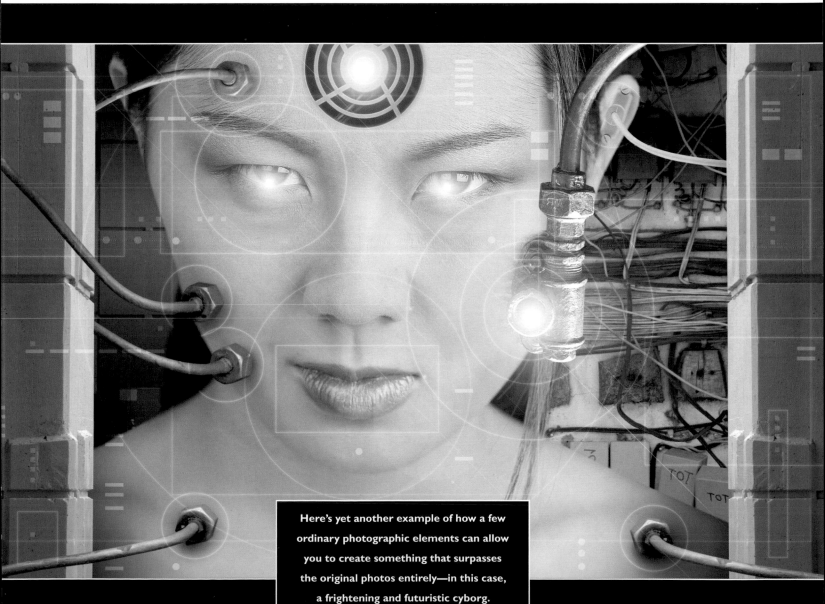

Here's yet another example of how a few ordinary photographic elements can allow you to create something that surpasses the original photos entirely—in this case, a frightening and futuristic cyborg.

DRIVING YOUR SPACESHIP

The ultimate dream car, for many people, is a vintage Corvette Stingray. But why stop there? If you're going to dream, then dream big and customize your car. Remove the wheels, weld metal plates over the wheel wells, add a rocket thruster, and voilá, you've got yourself an interstellar spaceship with retro appeal. Just be careful of the asteroid belt on your morning commute.

Starting with an ordinary photo, we'll use the Clone Stamp on a series of layers to reshape the car and remove the wheels, plus we'll use selection and paint tools to create a rocket thruster, complete with extremely hot exhaust. The outer space background scene is the combination of a series of star layers and layers that represent nebulas or gas fields in space. Employing tools like the Gradient tool, the Brush, and the Clouds filter, we'll show you exactly how to create galaxies of your own in no time. Want to add some asteroids? No problem, you can create a convincing asteroid belt by simply tossing a handful of stones on your ordinary desktop scanner. So gear down, and let's get on the move.

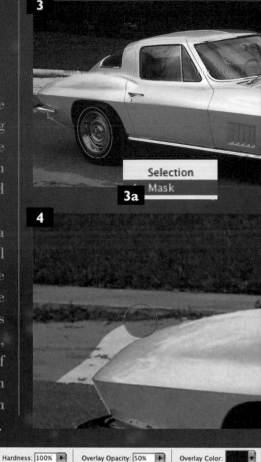

3

3a Selection / Mask

4

4a Size: 40 px | Mode: Mask | Hardness: 100% | Overlay Opacity: 50% | Overlay Color:

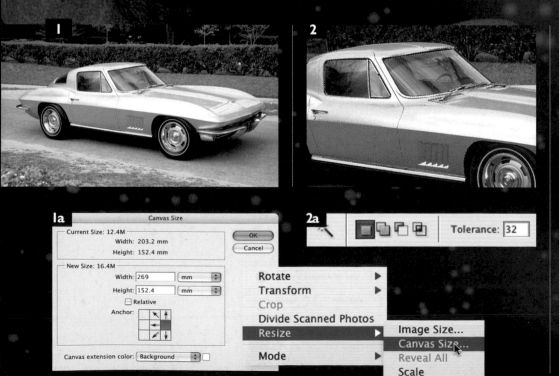

1

2

1a Canvas Size
Current Size: 12.4M
Width: 203.2 mm
Height: 152.4 mm
OK
Cancel
New Size: 16.4M
Width: 269 mm
Height: 152.4 mm
□ Relative
Anchor:
Canvas extension color: Background

2a Tolerance: 32

Rotate ▶
Transform ▶
Crop
Divide Scanned Photos
Resize ▶ Image Size...
Canvas Size...
Reveal All
Mode ▶ Scale

1 The first thing you'll need to do is open the image file of the car. We need to add some extra space to the left of the image so choose *Image* > *Resize* > *Canvas Size* from the menu. Click on the middle left anchor and then increase the Width to 269mm.

2 Select the Magic Wand tool. Leave the Tolerance set to the default value of 32 and ensure that the Contiguous option is enabled in the Options Bar. Click anywhere on the metal surface of the car to select it., then hold down the Shift key and begin clicking on other areas of the car to include them within the selection.

3 When you've selected as much of the car as you can without selecting too much of the background, choose the Selection Brush. Change the Mode of the Selection Brush to Mask. and immediately, you'll see which areas are outside the current selection and which are part of it.

4 Select a hard, round brush tip preset of about 40 pixels in diameter. Use it to paint over areas of the background that are accidentally included in the selection, carefully masking them. Use this method where necessary until the entire background is masked.

5

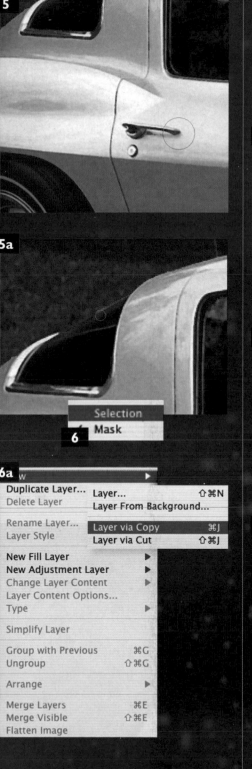

5a

Selection
Mask

6

6a

Duplicate Layer...	Layer...	⇧⌘N
Delete Layer	Layer From Background...	
Rename Layer...	Layer via Copy	⌘J
Layer Style	Layer via Cut	⇧⌘J
New Fill Layer	▶	
New Adjustment Layer	▶	
Change Layer Content	▶	
Layer Content Options...		
Type	▶	
Simplify Layer		
Group with Previous	⌘G	
Ungroup	⇧⌘G	
Arrange	▶	
Merge Layers	⌘E	
Merge Visible	⇧⌘E	
Flatten Image		

7 **7a** **7b** **8** **8a**

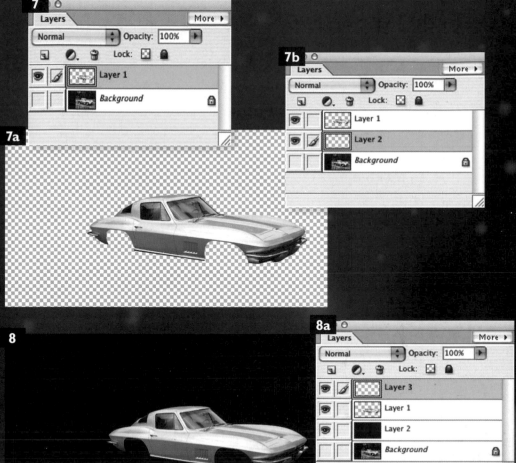

8b

5 Once you have masked the entire background, hold down the Alt/Opt key and paint over any areas of the car that are currently masked. Increase or decrease the size of the brush as required. Also use this method to smooth any rough edges.

6 Change the Selection Brush mode back to Selection to convert the mask to a selection border. Then choose *Layer > New > Layer Via Copy* from the menu to create a new layer containing only the selection contents.

7 Switch off the background layer in the Layers palette to ensure that you have selected the car properly. Erase any stray bits of background that remain, then create a new layer and drag it beneath the car layer. Press "D" on the keyboard to set the foreground color to default black.

8 Type Alt/Opt+Backspace to fill the layer with black. Create a new layer and drag it to the top of the Layers palette. Choose the Selection Brush tool, switch the Mode to Mask, and use it to paint over the wheel well areas. Paint over both wheels and be careful to create a sharp edge along the bottom.

DRIVING YOUR SPACESHIP

9

9a

All	⌘A
Deselect	⌘D
Reselect	⇧⌘D
Inverse	⇧⌘I
Feather...	⌥⌘D
Modify	▶
Grow	
Similar	

10

10a

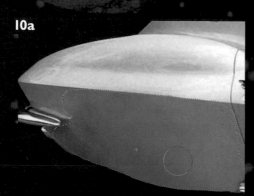

11

11a

✓ Place in Palette Bin	
Layers Help	
Help Contents	
New Layer...	⇧⌘N
Duplicate Layer...	
Delete Layer	
Delete Linked Layers	
Delete Hidden Layers	
Rename Layer...	
Simplify Layer	
Merge Linked	⌘E
Merge Visible	⇧⌘E
Flatten Image	

11b

Layers — More ▶
Normal — Opacity: 100%
Lock:
- Layer 1
- Layer 2
- Background

12

Size: 100 px — Mode: Selection — Hardness: 100%

12a

12b

9 When you have painted over both wheel areas, select the Clone Stamp tool. This will automatically convert the mask to a selection. Choose *Select > **Inverse*** from the menu to invert the selection so that your wheel areas are selected. Ensure that the Use All Layers function is enabled in the Options Bar.

10 Zoom in on one wheel area first. Alt/Opt+click on an area of neighboring metal to sample it, then click and drag over the open wheel area on your new layer. Use this method with varying soft brush tip sizes to cover the area. You may wish to use a lower opacity setting to blend colors together.

11 Use the same method to cover the other wheel as well. When you are happy with the coverage of both wheel areas, type Ctrl/Cmd+D to deactivate the selection. Link this layer to the car layer in the Layers palette and merge them. Enable the transparency lock for this new layer.

12 Choose the Selection Brush tool. Leave the Mode set to Selection and use a hard, round, brush tip preset to paint a quick selection on the side of the car, directly in front of the air vents. Select the Brush tool and choose a soft, round brush tip preset. Paint black inside the selection with a low opacity setting, to create a recessed area.

13

13 Deactivate the selection and then using the same paint brush, color, and opacity setting, paint along the bottom of the wheel areas to add shading. Choose the Selection Brush tool again. Use a hard, round tip preset and paint two highlight areas.

14 Hold down the Alt/Opt key and paint over areas of the selection to remove them, allowing you to create sharp points. Select the Brush tool and type "X" to switch the foreground color to white. Use the Brush tool, with the same settings, to paint highlights within the selected areas.

15 Deactivate the selection and choose the Blur tool. Use the Blur tool to paint over the sharp edges of the highlight areas to soften them. Create a new layer and place it beneath the car layer in the Layers palette. Choose the Selection Brush tool and use the same tool options as you used previously.

16 Paint a rough selection that will define the shape of your rocket booster. Use the Alt/Opt paint method to remove areas, allowing you to create sharp edges and refine the shape. Use the Eyedropper tool to sample a gray color from the car and fill the active selection with it on the new layer. Use the Brush tool to add subtle shading with colors sampled from the car.

DRIVING YOUR SPACESHIP

17

17a

18

18a

19

20

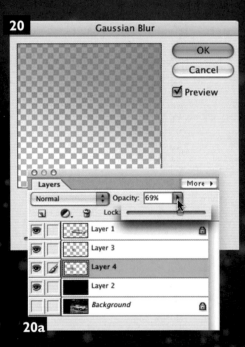

20a

20b

20c

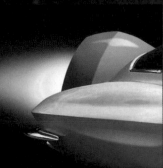

17 Temporarily select a hard, round brush tip preset and an opacity setting of 100. Use a sampled medium gray color to paint a stripe that follows the contour of the shape, then switch back to a soft, round, brush tip preset and a lower opacity setting, then sample some darker colors and shade the bottom. Deactivate the selection when finished.

18 Use the same method as you did for the sides to create a highlight on the new shape. Paint the selection shape, modify it, and then brush in some white highlights. Deactivate the selection and then use the Blur tool to soften the edges. Create a new layer and drag it beneath the current layer in the Layers palette.

19 Draw a rocket exhaust shape with the Polygonal Lasso tool. Select the Gradient tool and choose the Foreground to Transparent preset and the Linear method. Click and drag, using an orange foreground color, to create a gradient from the car outward within the selection. Deactivate the selection when finished.

20 Use the Gaussian Blur filter to blur the gradient using a Radius of 35 pixels. Reduce the opacity of the layer to 69%. Create a new layer and use the same method to create a smaller, yellow gradient on the new layer, then use the Radial gradient method, with no selection active, to add a small white radial gradient at the right of the flame.

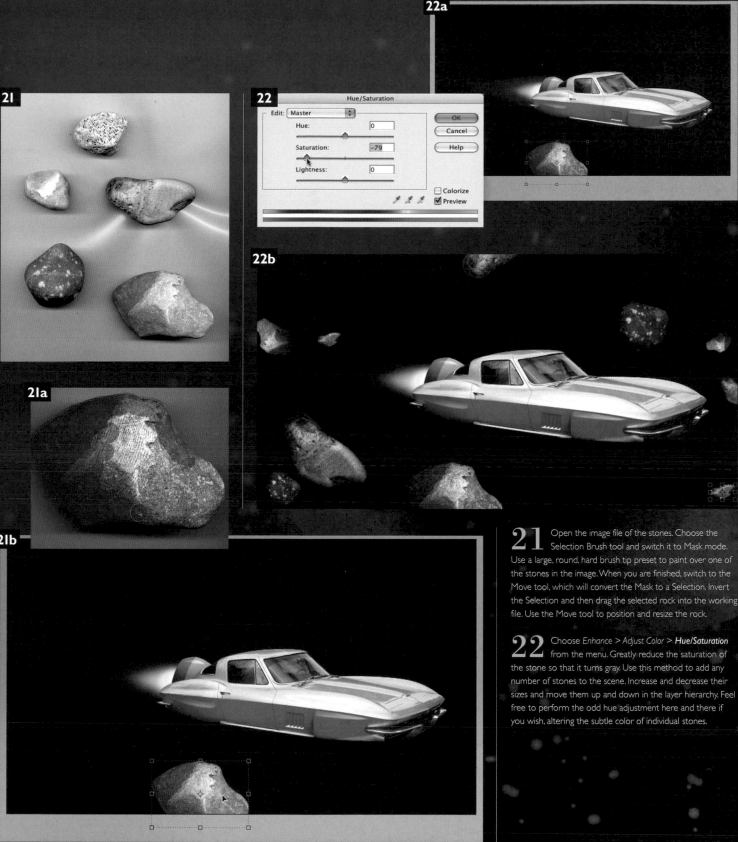

21 Open the image file of the stones. Choose the Selection Brush tool and switch it to Mask mode. Use a large, round, hard brush tip preset to paint over one of the stones in the image. When you are finished, switch to the Move tool, which will convert the Mask to a Selection. Invert the Selection and then drag the selected rock into the working file. Use the Move tool to position and resize the rock.

22 Choose *Enhance > Adjust Color > **Hue/Saturation*** from the menu. Greatly reduce the saturation of the stone so that it turns gray. Use this method to add any number of stones to the scene. Increase and decrease their sizes and move them up and down in the layer hierarchy. Feel free to perform the odd hue adjustment here and there if you wish, altering the subtle color of individual stones.

DRIVING YOUR SPACESHIP

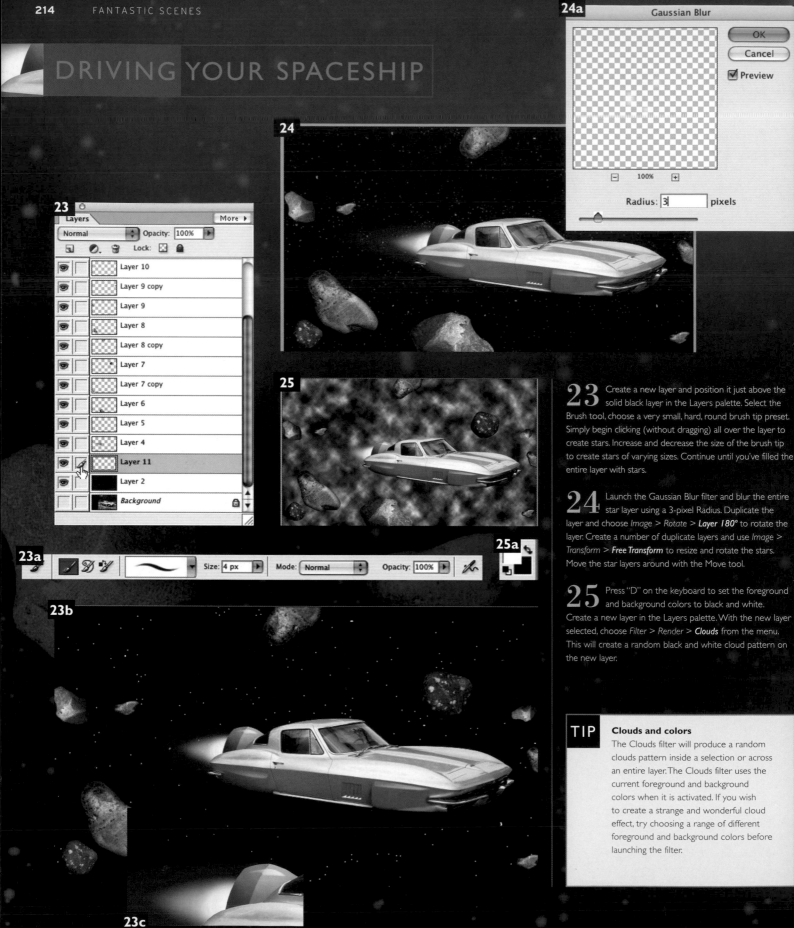

24a Gaussian Blur

OK

Cancel

☑ Preview

100%

Radius: 3 pixels

23 23a 23b 23c

24

25 25a

23 Create a new layer and position it just above the solid black layer in the Layers palette. Select the Brush tool, choose a very small, hard, round brush tip preset. Simply begin clicking (without dragging) all over the layer to create stars. Increase and decrease the size of the brush tip to create stars of varying sizes. Continue until you've filled the entire layer with stars.

24 Launch the Gaussian Blur filter and blur the entire star layer using a 3-pixel Radius. Duplicate the layer and choose *Image > Rotate > Layer 180°* to rotate the layer. Create a number of duplicate layers and use *Image > Transform > Free Transform* to resize and rotate the stars. Move the star layers around with the Move tool.

25 Press "D" on the keyboard to set the foreground and background colors to black and white. Create a new layer in the Layers palette. With the new layer selected, choose *Filter > Render > Clouds* from the menu. This will create a random black and white cloud pattern on the new layer.

TIP **Clouds and colors**
The Clouds filter will produce a random clouds pattern inside a selection or across an entire layer. The Clouds filter uses the current foreground and background colors when it is activated. If you wish to create a strange and wonderful cloud effect, try choosing a range of different foreground and background colors before launching the filter.

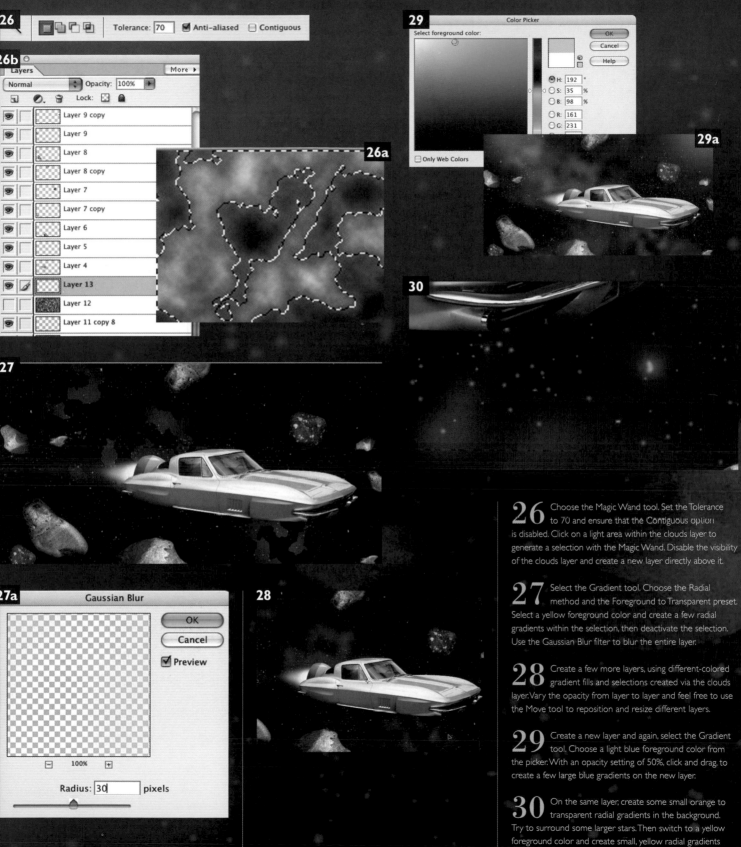

26 Choose the Magic Wand tool. Set the Tolerance to 70 and ensure that the Contiguous option is disabled. Click on a light area within the clouds layer to generate a selection with the Magic Wand. Disable the visibility of the clouds layer and create a new layer directly above it.

27 Select the Gradient tool. Choose the Radial method and the Foreground to Transparent preset. Select a yellow foreground color and create a few radial gradients within the selection, then deactivate the selection. Use the Gaussian Blur filter to blur the entire layer.

28 Create a few more layers, using different-colored gradient fills and selections created via the clouds layer. Vary the opacity from layer to layer and feel free to use the Move tool to reposition and resize different layers.

29 Create a new layer and again, select the Gradient tool. Choose a light blue foreground color from the picker. With an opacity setting of 50%, click and drag, to create a few large blue gradients on the new layer.

30 On the same layer, create some small orange to transparent radial gradients in the background. Try to surround some larger stars. Then switch to a yellow foreground color and create small, yellow radial gradients in the center of each of your orange gradients.

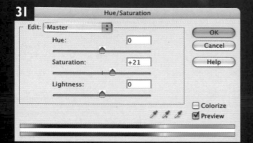

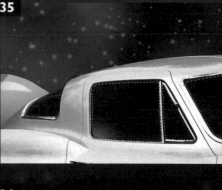

31 Create a new Hue/Saturation adjustment layer and increase the Saturation by 21, so that all of the colors in the outer space background appear more vivid. Create a new layer and drag it to the top of the Layers palette. Select the Magnetic Lasso tool, leaving the tool options set at their default settings.

32 Click and drag, following along the inside edge of one of the windows, allowing the Magnetic Lasso to work its magic. When you have selected one window, hold down the Shift key and select the other two with the Magnetic Lasso. Don't strive for perfection at this point; simply create a rough selection around the windows.

33 Choose the Selection Brush tool and select Mask mode. Use a small, hard, round brush tip preset to edit and refine the selection, similar to the technique used when selecting the car. When you're finished, switch back to Selection mode.

34 Use the Eyedropper tool to sample a dark blue color from the reflection in the rear window and then fill the active selection with this color on your new layer by pressing Alt/Option+D. Select the Gradient tool. Leave the tool options set as they were.

35 Sample purple and blue colors from the background and create a series of subtle colored gradients within the selection. Create a new layer in the Layers palette. Select the Brush tool and use the same tool options as you used previously to create the stars, but reduce the size of the brush tip.

36 Set the foreground color to white and then paint some stars within the active selection on the new layer. Again, vary the size a little here and there. Use the Gaussian Blur filter with a 3-pixel Radius to soften the stars within the selection. Use the Eraser tool, with a large, soft, round brush tip to remove stars that are too bright.

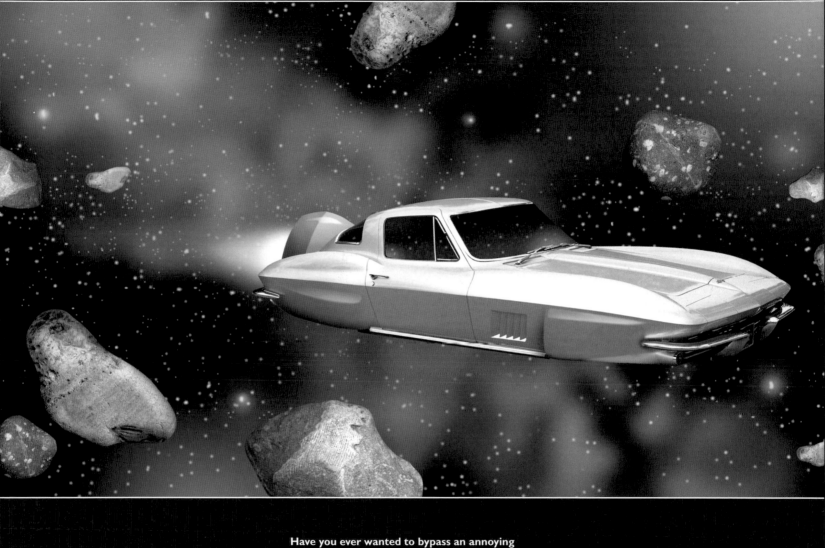

Have you ever wanted to bypass an annoying

traffic jam? Wouldn't it be great if there

were a way to propel you car up and out of

the atmosphere? Well, today you're in luck.

Welcome to the Elements auto shop. Here,

we'll outfit your car with a rocket booster,

reference

GLOSSARY

Adjustment layer Adjustment layers give you the ability to make non-destructive tonal or color adjustments to underlying image layers. The majority of the usual command-based adjustments are available as adjustment layers, such as Levels, Curves, and Hue/Saturation. The advantages of adjustment layers are twofold. First, you can make adjustments to an image without permanently affecting the layers below, and further adjustments can be made at any point during image-editing by simply double-clicking the adjustment layer in the Layers palette.

Alpha channel An Alpha channel is a special channel in addition to the standard Red, Green, and Blue channels, which stores information relating to pixel transparency. When you save a selection, or add a layer mask, you'll see an Alpha channel in the Channels palette relating to this saved selection or mask.

Blending modes Blending modes allow you to blend individual layers with the layers below. You select a particular blending mode in the Layers palette. By default, a new layer is always set to Normal mode, where the pixels on the layer have no interaction with those on the layer below. The actual science of blending modes is very complicated indeed, and by far the best method of using blending modes is by trial and error. By experimenting with different blending modes you can often create some very successful and unexpected effects.

Canvas Size The Canvas Size command adds your chosen amount of extra space around the outside of an image. By default, the size of the available canvas is limited to the actual outer boundaries of the original image. You can choose how much extra canvas to add, and where around the image to add it in the Canvas Size dialog.

Contiguous Contiguous is an option available with the Magic Wand tool. This indicates that any similarly colored pixels must be touching each other or interconnected before they are selected together with the tool. Unchecking this option indicates that similarly colored pixels should be selected together regardless of whether they are interconnected or not.

Dodge tool A tool that harks back to the days of traditional darkroom techniques, which can be used to selectively lighten the tones in a particular area of an image. The effect of the tool itself can be limited to the shadows, midtones, or highlights of an image via the Range option. The strength of the tool is controlled via the Exposure slider.

Eyedropper A tool used to sample colors from an image or from anywhere on the desktop. The sampled color will be used as the current Foreground color. The tool itself can sample the color of a single pixel, or the average color within a predetermined group of neighboring pixels.

Expand Found via *Select > Modify > Expand*, this command will expand the outer edge of the current selection by anything from 1 to 100 pixels.

Feather A command that softens the edges of a selection by a selectable number of pixels. The pixels around the edge, within the given pixel radius, are made progressively softer toward the outer edge of the selection.

Flatten The Flatten command, available via *Layer > Flatten Image*, collapses all visible layers into a single Background layer, enabling the saving of the file to a file type that does not support images containing separate layers, such as JPEG. Once a file has been flattened, the individual layers are no longer accessible, so it's best practice to save a version of the file first with layers intact as a native PSD file type, and then saving the flattened image under another name.

Fuzziness The Fuzziness slider, available in the *Select > Color Range* dialog, controls the degree to which colors matching the current Foreground color are selected by the Color Range selector. A high Fuzziness value will select all colors within an image that are similar to the current color, a very low value will select just those pixels that are a near exact match to it.

Gamma Gamma describes the brightness of the midtone of a grayscale tonal range. In a tonal adjustment command, such as Levels, the midtone point below the histogram is more accurately described as the Gamma slider.

Gaussian blur One of the collection of Blur filters that can be found via *Filters > Blur*, also one of the most commonly used Blur filters for accurate and infinitely adjustable blurring on an image or layer. The filter blurs an image by applying low frequency detail to it.

Grayscale What we generally think of as the black-and-white display within Elements. In this mode, an image can contain a maximum of 256 shades of gray. You can convert a color image to grayscale via *Image > Mode > Grayscale*. When an image is converted to grayscale, all color information is discarded.

Histogram A map of the distribution of pixels throughout the 256 levels of brightness within a digital image (available via *View > Histogram*). The intensity of each level is represented across the graph itself from the darkest at the left to the lightest at the right. The amount of pixels at any particular value is shown by the vertical axis of the graph at that particular point. The graph itself can indicate, among other things,

whether or not the highlights or shadows in the image are clipped, and this can be corrected by sliding the respective highlight and shadow sliders to the start of the histogram at each of these extremes.

Hue A value that determines the actual color we perceive. In essence, the value that makes Red appear as red, and Blue appear as blue. Where two colors are mixed, the hue changes accordingly. The actual hue of a color within an image can be adjusted via the *Enhance > Adjust Color > Adjust Hue/ Saturation* command.

Inverse An option available via *Select > Inverse*, where the current selection is literally reversed, and unselected areas become selected and vice versa.

Invert Available via *Filter > Adjustments > Invert*, this command inverts all of the colors and tones within an image, resulting in what we perceive as a negative image in regard to film photography.

Lasso A lasso designates a selected area within an image, enabling changes to be made to this selected area only. The lasso itself is shown by a dotted line, otherwise known as "marching ants." Typically, you would use the Lasso tool to generate this type of selection.

Layers Layers are at the heart of image manipulation in Elements, and can be thought of as separate sheets of acetate or duplicate images stacked on top of the original Background layer. By using layers, you can manipulate or paint onto an image without actually affecting a single pixel on the underlying layers. When you copy and paste parts of an image, the pasted image data is contained on a new, separate floating layer. Individual layers can be moved within the layer stack in the Layers palette, where the topmost layer will always appear to be in front of any underlying layers. When a new layer is added, it is completely blank until image data is added to it. Any parts of a layer that contain no image data remain completely transparent.

Lens flare The Lens Flare filter, accessible via *Filter > Render > Lens Flare*, mimics the effect of a light shining directly into a camera lens. Within the Lens Flare dialog, you can control the position and intensity of the flare itself, and even reproduce the effect of a flare though lenses of various focal lengths.

Opacity Opacity refers to the extent to which an upper layer obscures the content of the layer below it. The opacity of the pixels on a layer can be increased or reduced in the Layers palette. By default, a layer's pixel content has 100% opacity, so that any pixels on this layer completely hide the pixels on the layer beneath it, not withstanding the effects of any applied layer blending modes.

The opacity of some of Elements' tools can also be modified, such as the Brush tool.

Pixel A pixel is the very stuff of digital imaging. Any digital Elements image, or digital camera image is made up of millions of pixels, each one carrying specific color and brightness information. Although each pixel is a square block of color, when enough pixels are grouped together at a suitable resolution, the human eye interprets the collection of individual pixels as an image.

RGB color mode The default color mode used within Photoshop Elements.

Saturation Saturation refers to the vividness of any particular color. Just as desaturation removes color, increasing the saturation value of a color makes it move vivid and increases the purity. You can increase the saturatation of colors within an image on a global scale by going to *Enhance > Adjust Color > Adjust Hue/Saturation* and make adjustments to the Saturation slider. To make targeted saturation adjustments, use the Sponge tool.

Transparency Parts of a layer that contain no image data are considered by Elements to be completely transparent. Elements supports 256 levels of Transparency, ranging from a fully opaque color or layer through to completely transparent. Transparency is indicated in Photoshop Elements by a checkerboard pattern, which can be seen around the layer's content in the Layers palette, or when the Background layer contains no image data.

Unsharp mask (USM) One of the Sharpen filters within Elements and one of the most flexible and frequently used. The filter itself works by creating halos around the perceived edges in an image, giving the impression of increased sharpness. Although the filter is very effective, it must be used subtly to avoid these halos becoming too exaggerated and obvious.

INDEX

ACKNOWLEDGMENTS

Thanks to:

Garrick Webster for taking an illustrator and turning him
into a writer. Phil Cheesbrough for introducing my work
to Europe and the United Kingdom. Rob Wright for giving
me the commissions every illustrator dreams of. My Mom,
for always making sure that I received art supplies for
Christmas each year. My dog Lucy for making sure that I
get up out of my chair at least once a day and go for a walk.
Andrea Thompson, Dan Oliver, Dan McNamara, Joe Russ,
Gillian Carson, Vicki Atkinson, Steve Luck, Paul Newman,
Ben Renow-Clarke, and all of the editors that I've worked
with that take what I've written and turn it into something
that people can understand. All of my friends and family
who have graciously donated their modeling services for my
photos, no matter how uncomfortable the poses had to be.
Dave McKean, Jeff Soto, H.R. Giger, Mark Ryden and all of
the other brilliant artists whose work has inspired me and
helped to spark ideas over the years.

And finally, a huge thanks goes out to my wonderful wife
Janet. Without her support and encouragement I doubt that
I would have ever had the initiative and confidence to go
ahead with any of the things I've done that have mattered.